NO FLASH, PLEASE!

Underground Music in Toronto 1987-92

Anvil Press Publishers Inc.
P.O. Box 3008, Main Post Office
Vancouver, B.C. V6B 3X5 Canada
www.anvilpress.com

Library and Archives Canada Cataloguing in Publication

Von Essen, Derek, author
 No flash, please! : underground music in Toronto 1987-92 / Derek von Essen and Phil Saunders.

ISBN 978-1-77214-037-8 (paperback)

 1. Alternative rock music–Ontario–Toronto–History and criticism.
I. Saunders, Phil (Philip A.), author II. Title.

ML3534.6.C2V94 2016 782.4216609713541 C2016-901141-0

Printed and bound in Canada
Book design by Derek von Essen
Represented in Canada by the Publishers Group Canada
Distributed by Raincoast Books

 Canadä

The publisher gratefully acknowledges the financial assistance of the Canada Council for the Arts, the Canada Book Fund,
and the Province of British Columbia through the B.C. Arts Council and the Book Publishing Tax Credit.

NO FLASH, PLEASE!

Underground Music in Toronto 1987-92

Photographs by
DEREK von ESSEN

*

Text by
PHIL SAUNDERS

anvil
PRESS

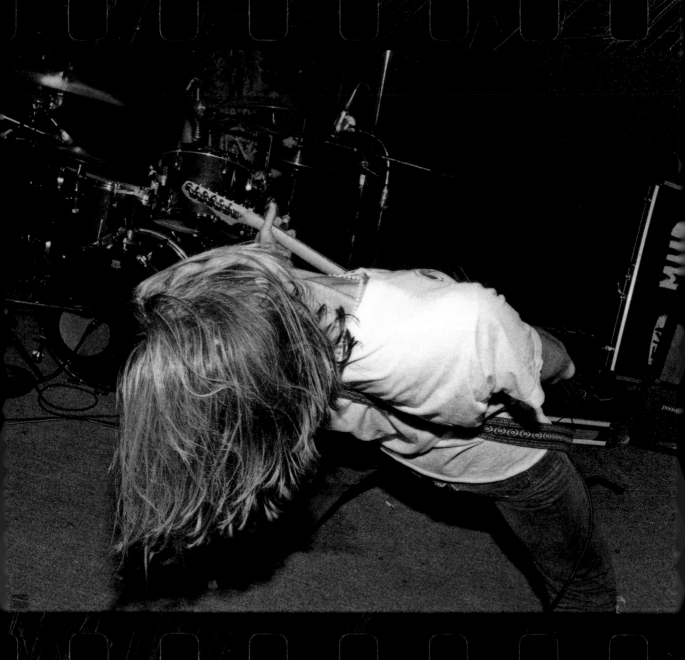

MUD

Fender

SWITTON

POOWLEMS

7

30

30A

Mark Arm & Steve Turner of MUDHONEY | OCTOBER 24, 1989

DEREK von ESSEN

On December 19, 1980 my older sister Sandy took me (at thirteen years old) to see Rough Trade at the Masonic Hall in Toronto. Up to that point my appreciation for music was limited to everything KISS released, K-Tel collections and a wide array of fifties oldies. But that night it all changed. Enlightened by the sort of music they performed, especially *how* Carole Pope performed—her sexuality, her between-song banter (love, sex, acceptance, be a good person…) and her power to hold the audience in her hand—I became hungry for new music, gained an openness to lifestyles that still make my parents cringe and learned to appreciate people who push boundaries to create their art. There are a few defining moments I can pinpoint in my life, but that night was the catalyst for one I believe shaped an abundant amount of choices made in the years to follow. The power and personal imprint one performance can have on a stranger became evident to me. Thanks Carole. Thanks Sandy.

This coming-of-age narrative arc has been played out in many films of the last thirty years: nerdy kid sits in his bedroom, puts a record on the turntable and plays a piece of music that transports him or her someplace else. Wondrous, enlightening, riveting, emotional, expressive and full of SOUND. For some, they want to become musicians. Not me. I wanted to *capture* it and show the world who these people were. To put a picture to those sounds.

Fast-forward to 1987 with a Ricoh 35mm SLR camera around my neck and *The Joy of Photography* under my arm. The camera quickly became a part of me, and bringing it to clubs seemed a natural step and within months I was shooting bands a few nights a week. Being twenty years old, and no longer living in suburbia, I was able to attend however many shows I wanted to. Cover at the door was cheap, and even cheaper when swapping photos for records and tapes, cover charges, T-shirts or beer tickets. These were small clubs, all with less than a two-hundred person capacity, some as low as sixty. But no one was counting back then. Photo passes weren't necessary, and encountering another person with a camera was rare,

so there was a freedom in shooting, which one wouldn't find today. Though I did on occasion blast my subjects with a flash, I preferred to shoot stealth, without a flash, using high-speed film (Kodak T-Max 3200). Attracted to the low cost of developing and printing black and white film at home, I quickly grew to love its rich tones, contrasts, historical character and, especially, the fact that everyone looks better in black and white.

My love for quirky Canadiana, non-conformists and do-it-yourselfers, plus a habit of cheering for the underdog, made it easy to find new independent music in the city. There were many musicians playing in multiple bands, seemingly supporting each other and performing with little competitiveness. While working at Records on Wheels on Bloor Street (nights) and Sam the Record Man warehouse (days), I was exposed to a lot of music, particularly demo tapes, 7" singles and indie releases by bands who would consign their material. Bands depended on word-of-mouth and cool gig posters to get people out to shows. Some gained notoriety and success, some passed on, but many just remained local favourites, with some left behind only because of bad luck or timing. Yearning to be a musician, but not feeling up to the task, I chose them as photo subjects, focusing on live performances from 1987-92.

In the end, I shot thousands of photos at hundreds of shows, sometimes printing a selection for the bands, and eventually just archiving the negatives. In preparation for this book, I went through binders of negatives to compile a selection of images, many of which have never been seen before. In the eighties, my photos appeared in a variety of newspapers and magazines, band promotional 8x10s and some album artwork. But most of it was just filed away after tinnitus made itself apparent in the nineties, and stage access for live music photographers became all the more challenging unless armed with proper credentials. Every roll of film—and only a handful of times did I ever shoot more than one a night—tells a story of one night on stage in the life of a particular band. The first frame of a typical contact sheet one could find a somewhat fresh-faced band, playing into the lights, looking a little awkward, then gradually turning on to the audience's energy, and transforming into performers with passion, charisma and unreserved showmanship. I captured all these images in live performance while watching the bands through the eyepiece of a camera, constantly framing them, and taking mock snapshots with my eye before finally pressing the trigger—in the end, it's only 1/60th of a second out of the 4,000 seconds in an average set time. There are so many "before" and "after" moments that no one captures. For some, that photograph is the memory: that one static moment of many, carried forward during a subject's lifespan.

Not every photo here is great, but *No Flash, Please!* is as much a visual chronicle of my time shooting bands in Toronto, as it is a personal keepsake of all the amazing performances I feel lucky to have witnessed. I still get a rush when I hear bands tuning at soundcheck. The excitement brews for what's to come and I doubt that will ever end.

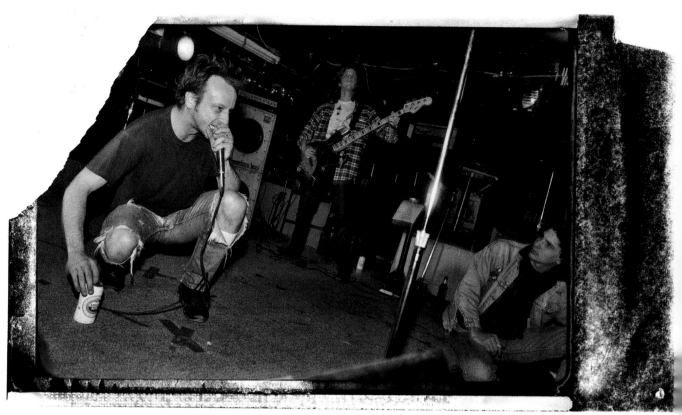

Phil Saunders (right) at JESUS LIZARD | MAY 11, 1990

PHIL SAUNDERS

I arrived in Toronto in May of 1986 from London, Ontario. I had no idea who I was, or anything about the bands and scene in which I was about to be swimming. I vaguely recall heading down to The Rivoli to see Sturm Group my first night in town. You see, I'd written an article in the student newspaper, the *Western Gazette* (Western University student newspaper). I had originally thought a music degree would help me achieve my lofty dream of becoming the next rock writer for the *Village Voice* or *Downbeat Magazine*. I was impatient. I dropped out and headed for the big city.

I showed up in Toronto soon after writer Howard Druckman wrote a scathing review in *The Nerve* (a punk monthly), about a *Toronto Star* writer's lacklustre report on an Echo and The Bunnymen show I'd also attended. His aggressive attack on the writer was exactly the voice I'd hoped to contribute to the conversation. You see, my arrogance at twenty had been equally fueled by Lester Bangs, Greg Tate, Johnny Rotten and Miles Davis. I wanted to shake things up and shout at the moon.

I soon realized that my writing chops were limited at best, but among the resources I encountered was Ryerson University's weekly, *The Eyeopener*. After going to the production offices *The Nerve* shared with the paper, I met *Nerve* editor Dave "Rave" MacIntosh and then

contributor Dave Bidini. I was also introduced to fellow London transplant Scott Woods, who, as one of my early editors, remains among my most important early writing mentors. After attending a *Nerve* editorial meeting, I was introduced to photographer and writer Rick McGinnis, writer Tim Powis, photographer Chris Buck and curmudgeonly scribe Phil Dellio. They became my gurus. By 1987, I counted among my friends indie music aficionados Myke Dyer, Chris Austin, Brian Taylor, Chris Twomey, Adam Sewell and a whole host of characters who I now recognize as the men and women who taught me everything I know about music. The women, artist Caroline Azar, bassist Beverly Breckenridge, editor Shelley Youngblut, bassist Corinne Culberston, editor Nancy Lanthier, bassist and writer Merrie-Ellen Wilcox, guitarist Sara Montgomery and radio broadcaster Lisa Rosen-Runge, taught me how to be a man in a scene that absolutely needed more women.

It was, however, Montreal's *Rear Garde*, led by Rip Chordz singer and guitarist Paul Gott and Warren Campbell, that exposed me most significantly as a rock writer. Complemented by my time working at CHRY-FM, York University's Campus Community Radio Station, I was allowed to spill the most amount of ink, which eventually helped land me a job at the Record Peddler shop, a pillar of the music scene at the time. I covered everything and wrote some of the most hideously self-indulgent prose of my career during those years. Not unlike the bands I was covering, it allowed me to be passionate and creative and helped launch a career as a journalist that lasted two decades.

But I was more than an average sycophant. I was also an indie concert promoter, record producer, industry gadabout and proudly a thorn in the side of much of the mainstream trends of the day. That's not to say I'm an expert. I just did stuff. I am, however, someone who stood on the sidelines and watched as bands came and went. I witnessed meteoric rise and tragic demise. Some friends died, some became very famous and rich, others got married, took on mortgages and a few even became pillars of the community. Many continue to be my dear friends and trusted advisors. Many of those people contributed to this book. I could not have done it without them.

The intent of my words in this book is to celebrate the work of Derek von Essen. His surprise phone call offering me this project was like a bolt of lightning. A frequent collaborator of mine during those formative years, his ability to capture the images, smells and sounds of the period through an array of gritty photos taken with an eye and passion that is unique has undeniably fed a lasting and valuable record of a special time in Toronto's randomly generated musical subculture. But this was also a very personal journey. I gave my soul to the music during most of this period. The death of Kurt Cobain really affected me. I'd lost others to heroin or mishap over the years, but Kurt's death seemed, I dunno … enough. That said, we all enjoyed the music. We still do, so please, witness the majesty and enjoy the ride. And celebrate a time of unbridled, innocent fun and amazing music.

It's alive, it's alive...

Clubs that established themselves during this period as the most open and available venues for live music were Lee's Palace (Bloor and Bathurst), Albert's Hall (Bloor and Brunswick), Sneaky Dee's (College and Bathurst), Grossman's (Spadina and Cecil), the Silver Dollar (Spadina and College), both walking distance from the grand dame of the live venues, the El Mocambo, teetering on the edge of Kensington Market (a hotbed of short-lived venues like the Siboney), then the Cameron House (west of Queen and Spadina), the Rivoli (east of Queen and Spadina), the still-venerable Horseshoe Tavern, right on the corner (Queen and Spadina) and, finally, but not insignificantly, the Cabana Room, where a traditional Greek man by the name of Jimmy Scopas single-handedly championed any musicians who wanted to get on stage, and spawned, without exaggeration, the careers of a handful of seminal groups at the time, including Blue Rodeo, L'Étranger, the Rheostatics, Fifth Column, Shadowy Men on a Shadowy Planet, The Lawn, The Pursuit of Happiness and on and on the list goes.

Now, it is very important at this juncture to acknowledge the role of venues and people who forged the foundation for what would be one of the most active and vibrant live-music scenes in Toronto history. By 1987, venues such as the Edge (opened by famed promoters The Garys, who were recognized early for booking punk bands) and the legendary punk venue the Turning Point had closed, and Larry's Hideaway (located down the street from Maple Leaf Gardens and the most active of punk, hardcore and alternative music venues) had become a staple of an active live music scene. Although Larry's was one of the toughest venues in town, its convenient location away from all the noise of Yonge Street, made it a perfect place for inconspicuous punk rebellion. But among the most often-referenced venues from the mideighties is the Beverley Tavern, located at Beverley and Queen Street West: in part a watering hole for students from the nearby Ontario College of Art and in part a prime location for startup bands looking for a place to give it a whirl.

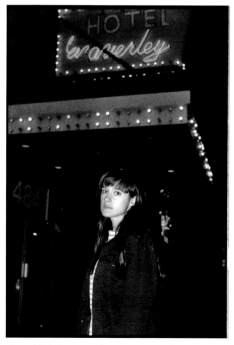

above: Music fan, Leslie Ann Burgess outside the Silver Dollar on Spadina | AUGUST 22, 1988

left: Doorman Scott Hyrtle at Stratengers on Queen Street East | NOVEMBER 3, 1990

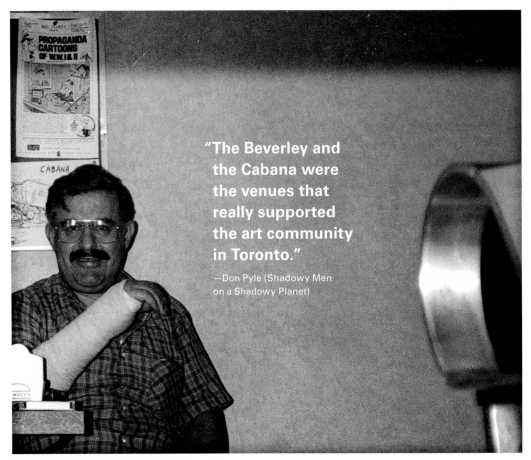

"The Beverley and
the Cabana were
the venues that
really supported
the art community
in Toronto."
—Don Pyle (Shadowy Men
on a Shadowy Planet)

Jimmy Scopas of the Cabana Room | OCTOBER 31, 1986

These venues soon became known for a certain energy. The Rivoli drew the hipster crowd, until Carson Foster started booking bands and coordinating with local promoters to book higher-profile ones that were developing an audience. Examples of bands that played the Rivoli are Shadowy Men on a Shadowy Planet, Fifth Column, The Jesus Lizard, Nomeansno, Change of Heart, Kyuss and Sloan, and for a long time the famous Kids in the Hall comedy troupe performed there Monday nights, certainly raising the profile of the venue among new audiences.

The Horseshoe Tavern, owned in part by Kingston, Ontario, comedian Dan Aykroyd for a period, was already established after the seeds had been planted by The Garys, who booked it regularly between 1978 and 1979. So when the club owner started booking bands himself in the mideighties, it was a combination of filling up bills Monday to Saturday that weren't taken by touring bands brought through by independent promoters like Elliott Lefko and others. Such was the demand for bands that Lefko split his time between RPM club (more of a jaunt from the vibrant Queen/Spadina club scene and known more as a

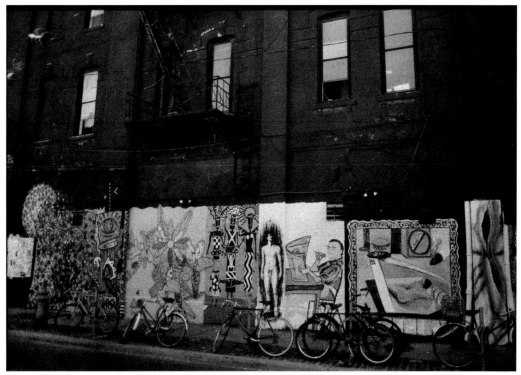

Side wall of the Cameron House | 1987

dance bar on the weekends that booked live music through the week) and a new venue that sprung up around 1988 called the Apocalypse Club, further West of the Spadina core in Little Italy. For a short time, a revived Silver Dollar at Spadina and College became Lefko's flagship venue, with performances by such luminaries as Tav Falco's Panther Burns, Pussy Galore, Schoolly D, The Mentors, Henry Rollins and fIREHOSE. But venues like the Horse-shoe, the Cameron and the Rivoli dominated the live music scene for more than a decade. Another venue that got a lot of action was the Diamond Club (today called the Phoenix Concert Theatre) on Sherbourne Street (east of Jarvis and again, more far-flung than the thriving Queen and Spadina scenes).

When there was nothing to do on any given night, you could head to the Cameron and see just about anything. The Cabana Room, located in the Spadina Hotel, remained the most interesting place to see bands until the early nineties, as did the El Mocambo, especially after Groovy Religion vocalist William New took over bookings and continued with his now-legendary Elvis Mondays, which never failed to provide the next big thing—or the last big thing, performing in a completely different setting. To this day, New's Elvis Mondays remain the shining example of the diversity and camaraderie that was the Toronto music scene and, thanks to New's elusive approach to promotions, remained the longest surviving example of the do-it-yourself ethos.

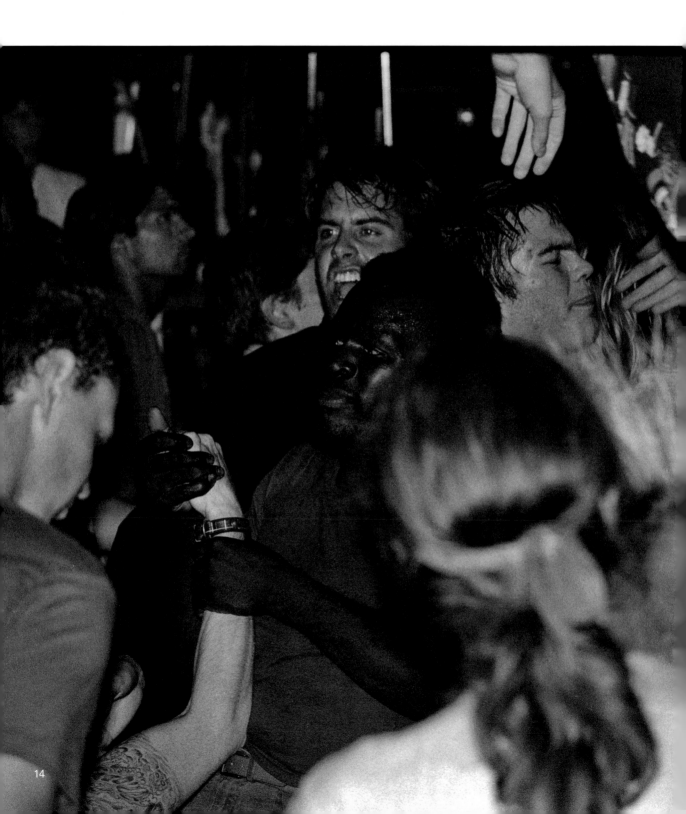

The Pit

A proper mosh pit was considered a disciplined affair in the mid- to late-eighties punk scene. Empowering the pulsating rhythm of the music through the audience, without the violence that characterized the slam dancing of the punk era a decade earlier. Despite the many examples of how pits could be civilized, they still turned ugly as the popularity of the music grew in the early nineties. In Toronto's punk scene, however, there was a small but committed group of mosh pit police led by wrestler Ken Huff. Normally attired in a leopard skin vest, some cutoff jeans and a torn T-shirt, Ken would weave his way through the crowd, often stopping to pick someone up or remove anyone who clearly had no idea what was happening, mistaking the pit for an opportunity to kick ass. Ken rarely got in a fight, usually hugged the person as they left the club and thanked them for coming out. If things got ugly, a cadre of smiling punks, such as Black Anthony, who could be seen watching from the wings, or perhaps members of the notorious BunchoFuckinGoofs, old guard punks that nobody messed with, backed up Ken. Indie punk promoters would ensure Ken and Anthony were there, or would hire pit police to do casual security detail for a free entrance.

When larger shows started to happen, there was often a confrontation between the band and the hired professional security staff. Among the most memorable were Fishbone and

left: Black Anthony with crowd assistance at THE DICKIES | AUGUST 15, 1988
below: ROLLINS BAND | MARCH 15, 1990

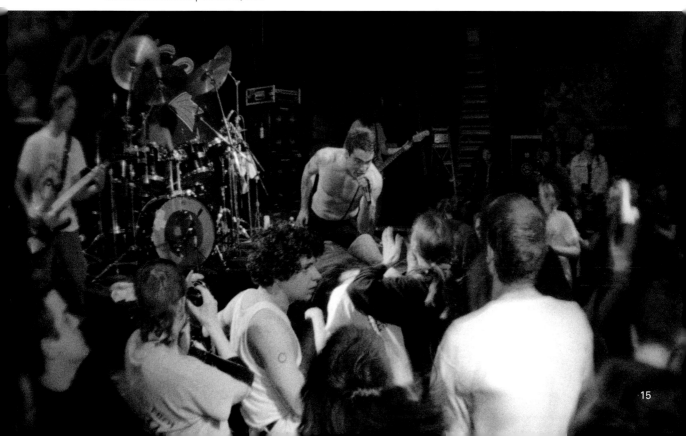

Red Hot Chili Peppers—both bands emerged from the LA punk scene, one of the most violent punk scenes in American Hardcore Punk history, most notably the Black Flag riot that involved the LA Police. Both bands played Toronto to huge crowds and hectored security at their shows when it was clear that the contracted staff were incapable of understanding the phenomenon of an engaged punk rock crowd. The situation of artists telling security to stop beating up audience members while attempting to remove them continues to this day. However, former Black Flag singer Henry Rollins famously didn't allow stage security at his shows. The option for people on stage were one of two: Come close to Henry and get a punch in the jaw, come close to bassist Andrew Weiss, and receive an unwelcomed French kiss— not what most predominantly male Rollins fans would expect. Today, security at punk shows—who have no idea what's going on—invariably eject people for many more arbitrary reasons than misunderstanding proper pit protocol. The peaceful mosh pit is now a thing of the past.

Audience at THE DICKIES | AUGUST 15, 1988

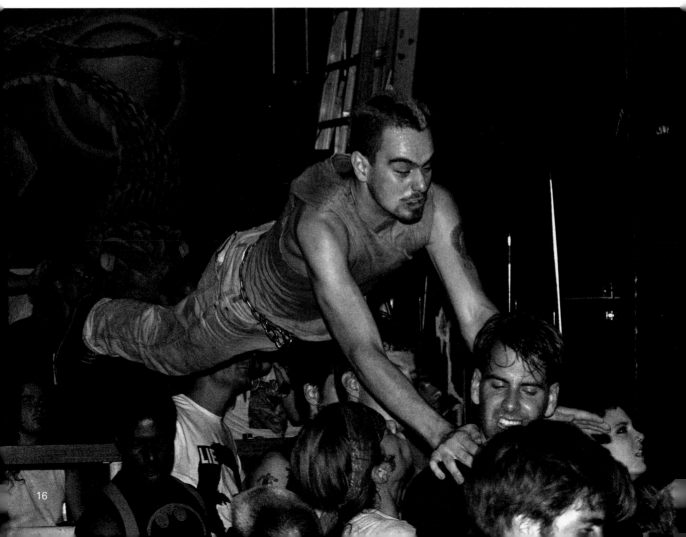

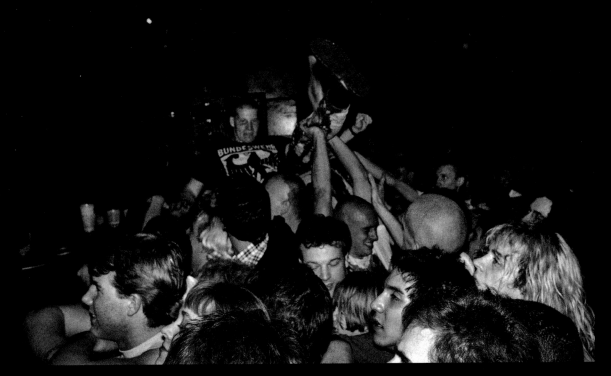

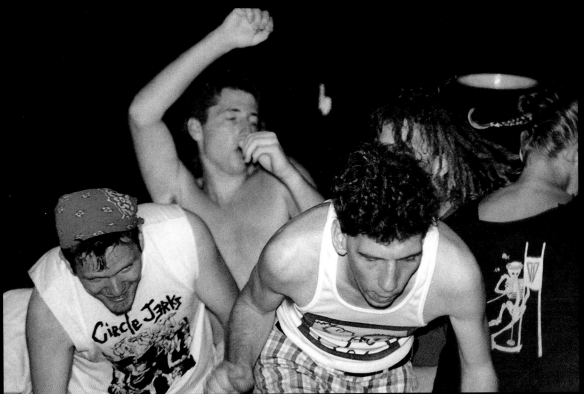

top: The pit at THE BUTTHOLE SURFERS | NOVEMBER 10, 1988 *above:* Audience at THE DEAD MILKMEN | JULY 20, 1987

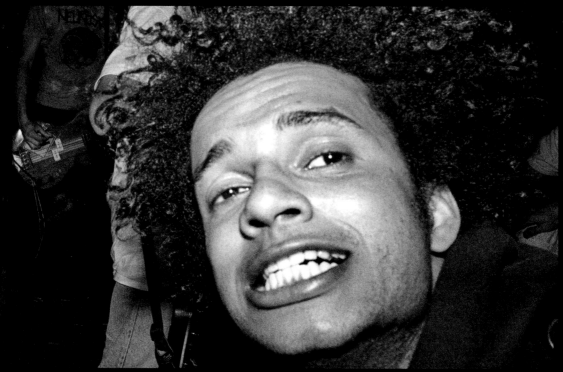

Audience at THE DOUGHBOYS | APRIL 21, 1988

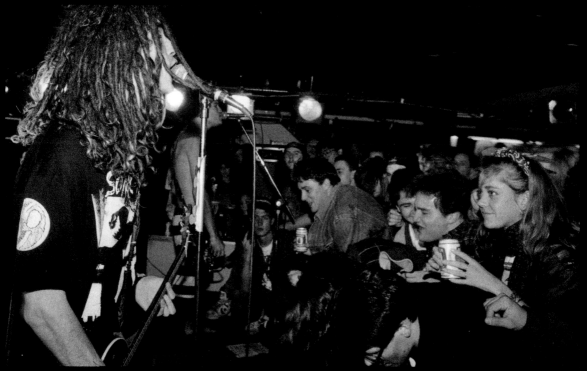

THE DOUGHBOYS | NOVEMBER 10, 1989

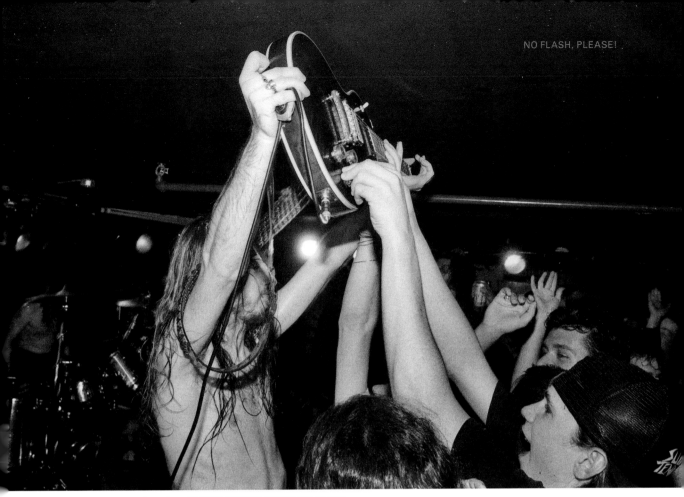

Jonathan Cummins of THE DOUGHBOYS | NOVEMBER 10, 1989

The Metalheads

The show was Overkill, opening for Motörhead, opening for Slayer during the South of Heaven tour around 1987 at the Concert Hall (AKA The Masonic Temple) in Toronto. Motörhead appropriately claimed to be the loudest band on the planet at the time. When they hit the stage, people, mostly very young kids from the suburbs, started to throw themselves from the balcony, about fifteen to twenty feet from the main floor. The crowd in the balcony would look down to see if these people got up again or, more importantly, whether their fall hadn't broken the neck of an unsuspecting fan standing on the floor below. To say metalhead fans took their music seriously is an understatement. Seeing Slayer and Motörhead in downtown Toronto on a weekend was like witnessing the most important thing that had ever happened to those kids from the suburbs since birth, and they showed their appreciation, sometimes at a horrible cost to themselves and the unfortunate people standing below their illustration of appreciation. At another Motörhead show, someone made the mistake of thinking Lemmy would appreciate a punk rock spit in the face...Lemmy famously said, "...the blokes who spit on me? Find 'em, waste 'em." The love was not always reciprocal.

"There were about a
hundred or so people
that seemed to go to
every show."
—Ian Blurton

BIG DADDY CUMBUCKETS | FEBRUARY 10, 1989
Ian Blurton, guitar

The Hipsters

When Nirvana played Lee's Palace in 1990, it was the band's first show in Eastern Canada. It was a so-called "Discovery Tuesday," promoted by Elliott Lefko and Matt Cohen. It was five bucks to get in. The crowd that came out were mostly the type that would go to shows based on the hype the band had gotten in the magazines *Maximum Rocknroll, Flipside,* or because they had spent enough time in Vortex Records on Queen Street West to realize that this sound coming out of Seattle was worth checking out. The band was also making headlines in the UK, thanks to the benediction of Sonic Youth and their previously baptized sonic disciples Dinosaur Jr.

The dance floor in front of the stage was dotted with tables and chairs. Nirvana hit the stage after locals Heimlich

"Audiences on Queen West were notoriously cool and difficult to engage; that's why I used to berate them from the stage."

—Ian Blurton (Change of Heart, C'mon, Public Animal, etc.)

"Stuff happens at shows, but I never felt like I didn't belong there."

—Louise Kiner (Grinch, John Drake Escapes among other bands)

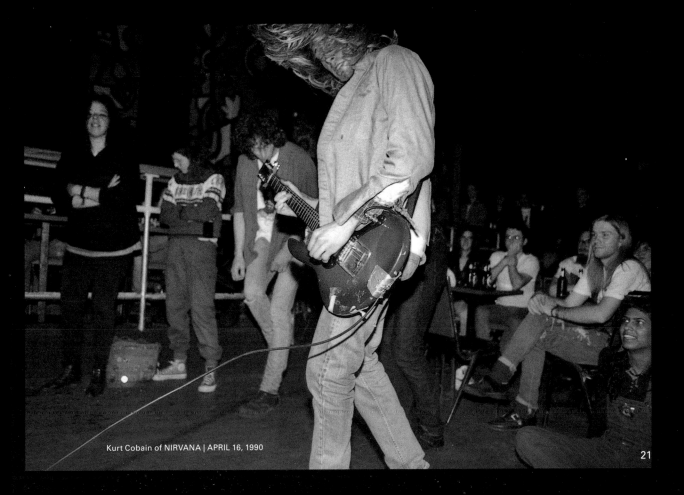

Kurt Cobain of NIRVANA | APRIL 16, 1990

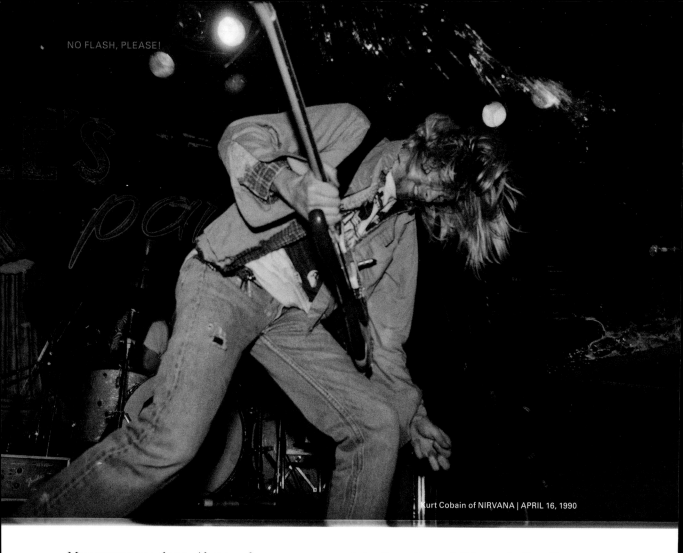

Kurt Cobain of NIRVANA | APRIL 16, 1990

Maneuver were done. About a dozen or so songs into the set—and this was before Dave Grohl had joined the band—Kurt Cobain was clearly frustrated with the lack of engagement from the audience. After performing one song while strolling around the dance floor in front of a seated audience, he returned to the stage with a table and a chair, placed a jug of beer on the table, began playing the song "Blew" from *Bleach*, ending it by tipping the table with the head of his guitar, spilling the jug all over the stage, followed by walking around the floor grabbing beer bottles off audience member tables and throwing them at the stage. The first smashed on the crash symbol of drummer Chad Channing, another unceremoniously punctured the pristinely painted Lee's Palace lettering on the wall behind the stage, as Lefko and Cohen stood powerless with looks of grave concern from stage right. Word was, Nirvana was paid five hundred dollars for the show that night.

Less than a year later, they sold out a venue twice the size and the crowd carried Kurt around the pit while he played his guitar not unlike Cleopatra entering the throne room. Dave Grohl had joined the band by then. Nirvana was paid considerably more and they became the number one band in America four months later, a mere six months after their landmark album *Nevermind* was released in North America.

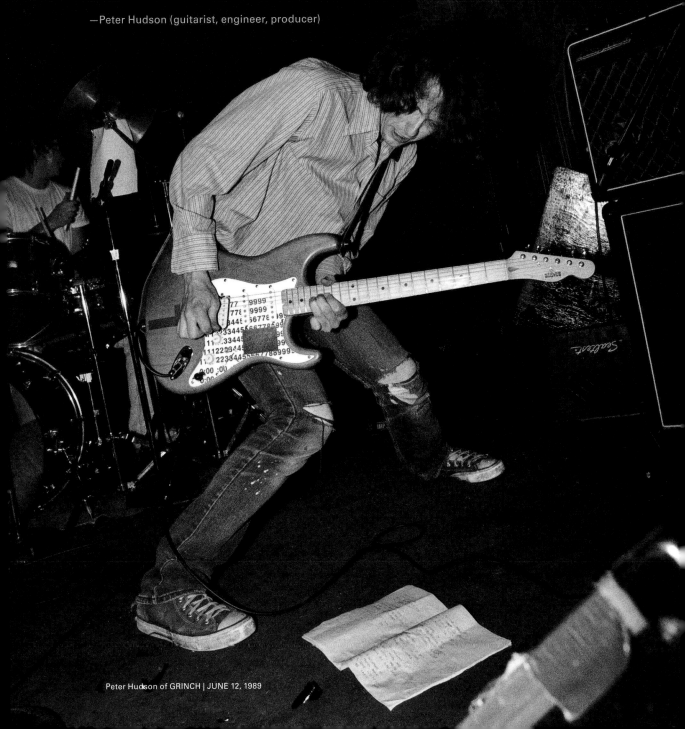

"The eighties were a time of DIY. You just did it yourself if you wanted people to hear your music. You made the posters, pressed the records, printed the artwork, distributed cassettes, dubbed the cassettes for friends and shared the music. It was just out there."

—Peter Hudson (guitarist, engineer, producer)

Peter Hudson of GRINCH | JUNE 12, 1989

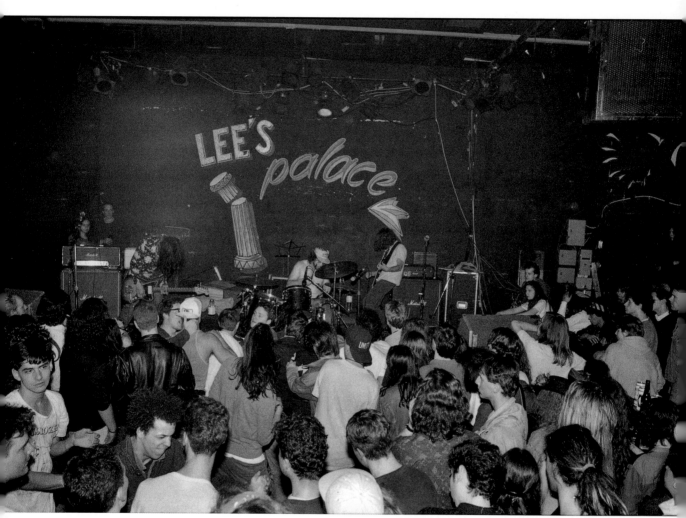

DINOSAUR JR | MARCH 31, 1989
No Flash, Please! author Phil Saunders at left

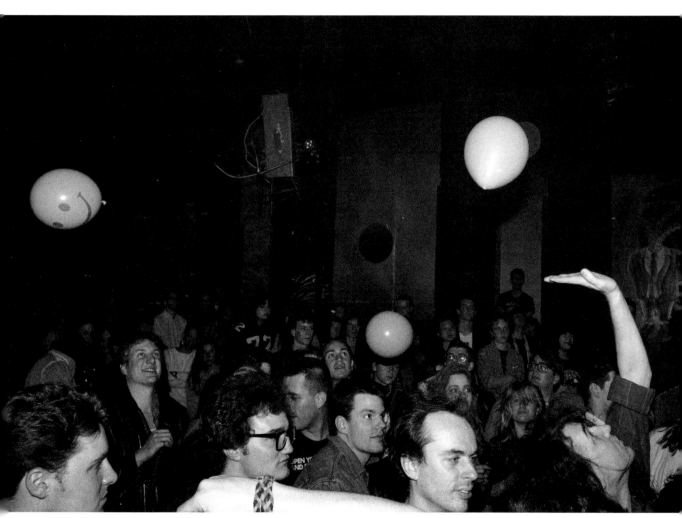

Audience and balloons during SUPERFLY | MARCH 31, 1989

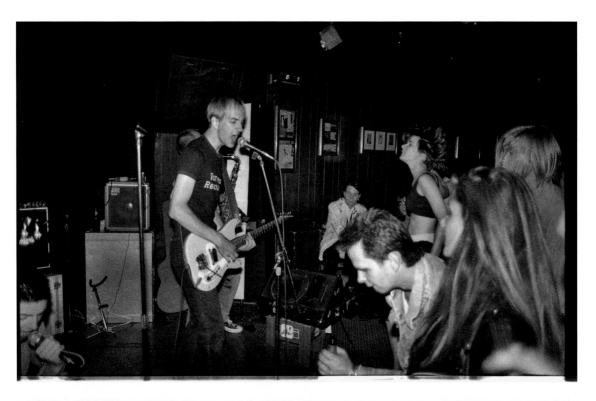

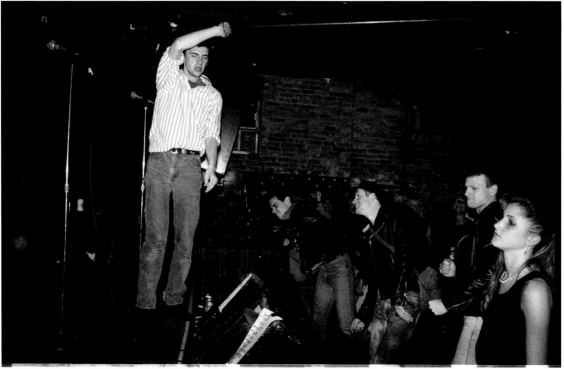

top: THE DUNDRELLS | OCTOBER 5, 1987 *above:* THE DUNDRELLS | SEPTEMBER 19, 1987

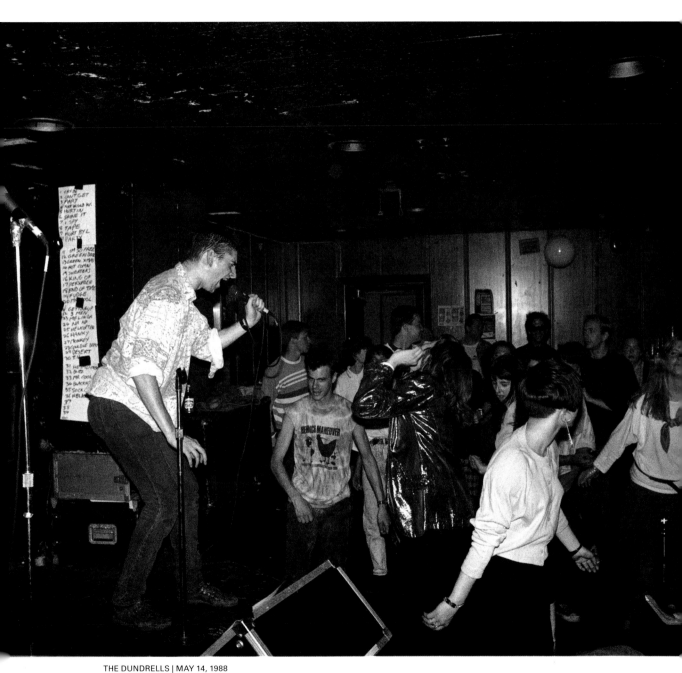

THE DUNDRELLS | MAY 14, 1988
The moment when audience members turn to see former Dundrells guitarist Ashley Thomas (on hiatus) return to the stage, while local promoter Elliott Lefko wears his sunglasses at night.

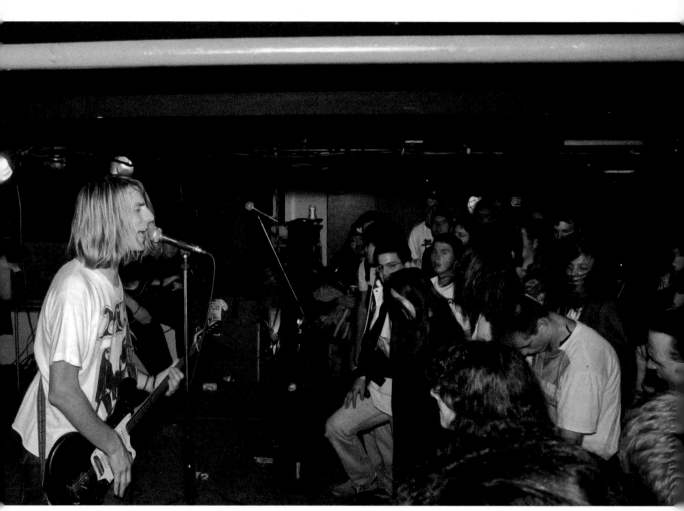

MUDHONEY | OCTOBER 24, 1989

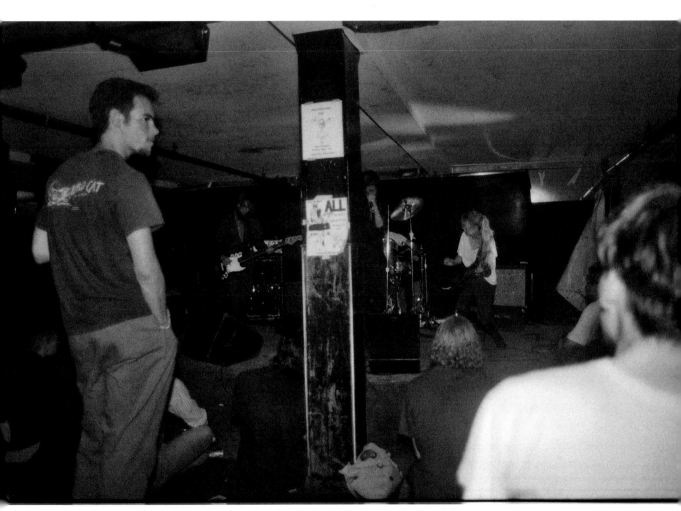

Audience viewpoint of THE LAUGHING HYENAS | MAY 20, 1989

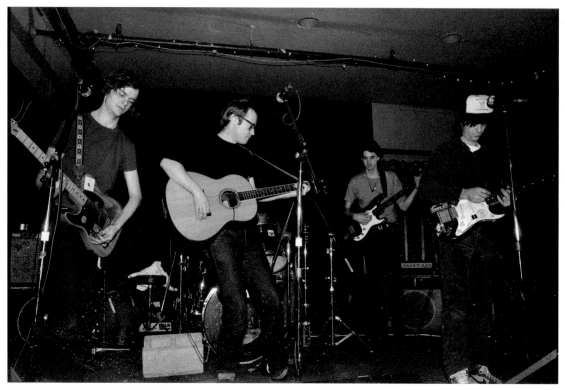

SCOTT B SYMPATHY | DECEMBER 8, 1989
The "classic" line-up, comprised of players from multiple bands: (L-R) Ian Blurton, Scott Bradshaw, Terry Carter, John Borra, Gord Cumming

Community

Not unlike the early days of British Progressive Rock that turned into Glam Rock characterized by Roxy Music and David Bowie, the Ontario College of Art in Toronto was a catalyst for music and creativity in the mideighties. Many bands would showcase at the regular OCA shows. Among them were L'Étranger, Shadowy Men on a Shadowy Planet, the Rheostatics, The Dundrells, and Fifth Column.

All radically different sounding bands, there was a constant and free cross-pollination of musicians across the community. Tim Vesely, known more for his work with the Rheostatics, played a spell with L'Étranger when bassist Charlie Angus left the band; Beverly Breckenridge who played bass in Fifth Column, also pitched in on bass with Phono-Comb when bassist Reid Diamond switched to guitar. Phono-Comb comprised members of the Shadowy Men and Dallas Good from The Sadies. Everyone recorded at Dundrell's guitarist Peter Hudson's studio, called Halla Music, which operated in any space Peter was living at the time. Hudson's current collection of master tapes is like an aural history of the underground scene in Toronto during this period. A community approach and resource sharing is what sustained the Toronto music underground.

SHADOWY MEN ON A SHADOWY PLANET in Columbia, Missouri | FEBRUARY 26, 1992

Let's take it on the road

Soon there was a tour map: a handy one as it turned out for Canadians, as networks began to expand, and corridors emerged from Chicago to Toronto, and from New York to Montreal via Boston. The Windsor-Montreal corridor became a common route for bands across the region. In Vancouver, it was the corridor to Seattle. Some rock writers have said, half-jokingly, that the grunge-music eruption of the early nineties was most influenced by Vancouver bands such The Young Canadians, D.O.A. and Slow, while the California hardcore scene was impacted by Victoria, BC natives Nomeansno. There was no question that bands in Montreal and Toronto were rising around the same time as those in Washington DC, New York, Chicago and Boston, and as they toured, played and were exposed to each other. Scenes started to explode everywhere.

The renaissance (as it's been referred to by southern Ontario rock scribes Jason Schneider, Michael Barclay and Ian Jack in their relentless historical foray *Have Not Been the Same*, named for the song by snarky Vancouver punk rockers Slow) was underway, and there was no shortage of bands traipsing through Toronto's vibrant bar scene looking to be heard, move product and generate a buzz.

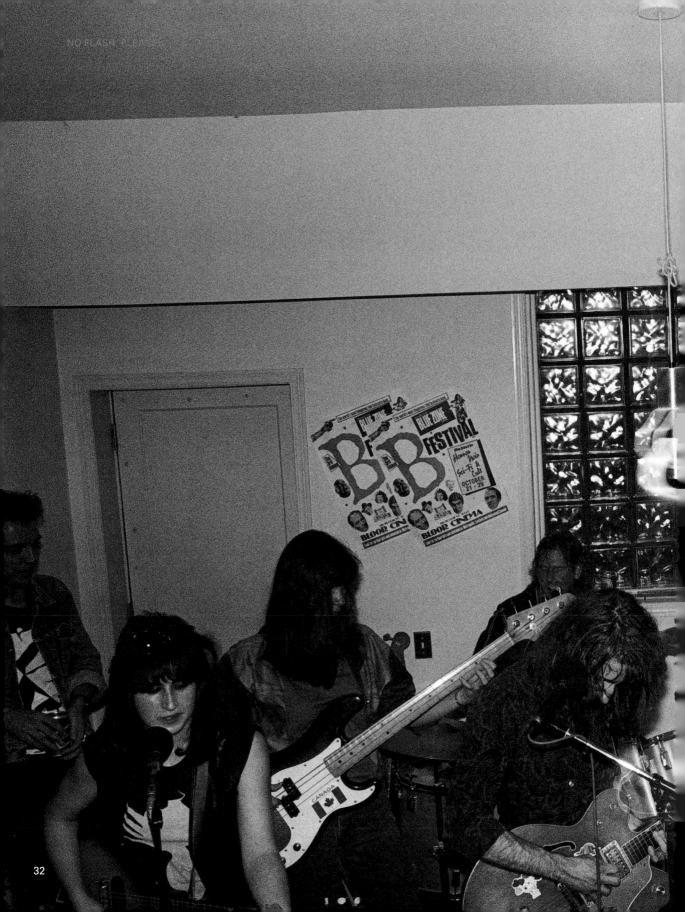

Melonie Ceresne dancing with JOHN DRAKE ESCAPES | ©OCTOBER 1, 1988

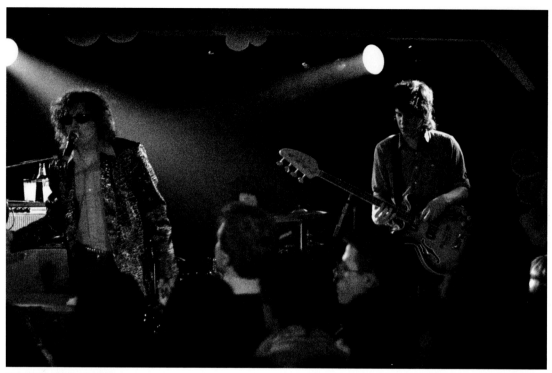

THE LYRES | APRIL 10, 1987

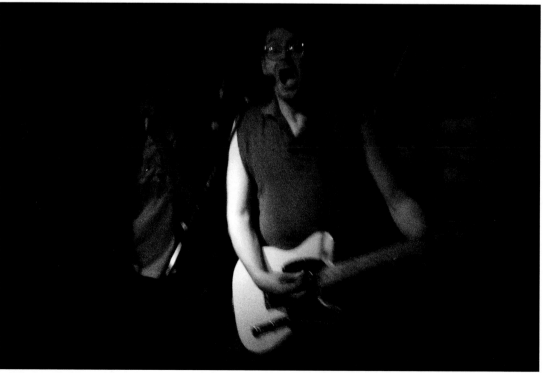

SUPREME BAGG TEAM | MAY 1, 1987

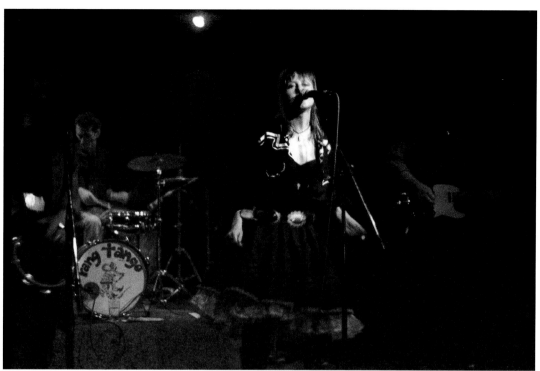

RANG TANGO | JUNE 12, 1987

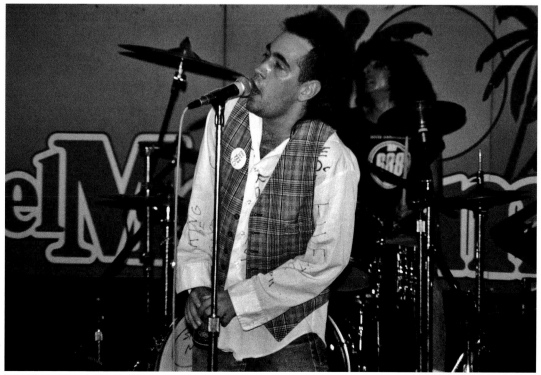

THE DEAD MILKMEN | JULY 20, 1987

It is hard to understand why **The Lawn** did not emerge more strongly from a scene that it so represented. With a sound that lay somewhere between Pere Ubu, REM, Fairport Convention and The Gun Club, its sound was absolutely unique. The band self-released *Peace in the Valley* in 1988 and later released *Debussy Fields* on an affiliate of A&M Records championed by visionary east-coast marketer and A&R man Dave Porter. *Debussy Fields* received widespread campus-radio play, but the band never drew many people outside of the Queen West community. That said, across the spectrum The Lawn is considered among the most innovative and strident groups to come out of the Cabana Room scene nurtured by Jimmy Scopas. Singer and slide guitarist Gord Cumming remains a fixture on the scene, playing with singer-songwriter Scott Bradshaw and occasionally getting together with brothers Patrick Gregory (guitarist) and Richard Gregory (bassist) and drummer Mike Duggan to remind us all why The Lawn were one of the greatest bands of the period.

Gord Cumming & Patrick Gregory of THE LAWN | MAY 2, 1987

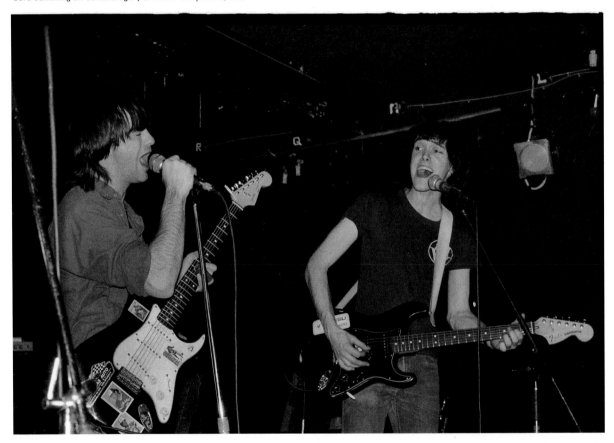

JR GONE WILD | AUGUST 28, 1987

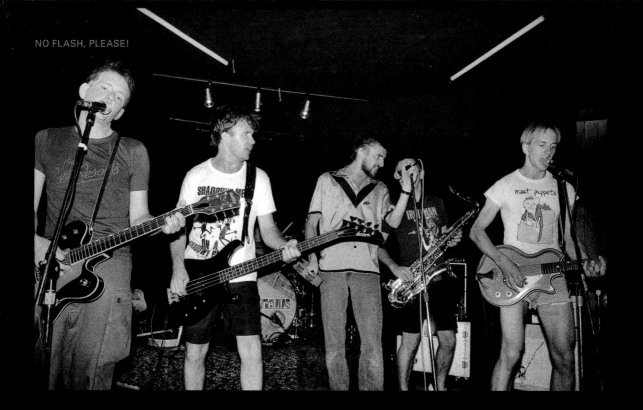

Made up of a rabble of musicians, self-described as two cheeseballs, one pretzel and three spice rings, **The Dundrells**, like many bands of this period, were first inspired by punk and garage music, mostly because they found it easy to play. Three chords and a reasonable ability to keep time, and you could play a set. But what made The Dundrells special was how they embraced their audiences. The band's sound was a cross between the Ramones and The Troggs, while also influenced by one of Toronto's great sixties' garage bands, The Ugly Ducklings. The comedic, sometimes theatrical stage antics of singer Garry Welsh with guitarists Ashley Thomas and Peter Hudson (both often playing instruments one might find under a glass display case), bassist Richard Higham, drummer Terry Kelly, and saxophonist Andy Thorndyke, would—without fail—have the dance floor filled before the first song ended. Their music appeared mostly on cassette, but a single, entitled "Nothing on TV," remains one of their shining moments. Their appearance on the compilation entitled *It Came from Canada*, curated by Tony Dewald and Gerard Van Herk of Deja Voodoo—along with Dewald and Van Herk's Og Music imprint, which dominated the Canadian garage music scene at the time—certainly helped build the band's reputation. It is important to highlight a number of cassette labels active during this period that supported bands such as The Dundrells. *What Wave* in London, Ontario, *Feline Frenzy* and *Hide* in Toronto were the musical fuel that ran the garage-music movement of the eighties and nineties. The Dundrells, however, remain an obscure and pristine example of a band that made a splash on Queen Street, but not much further afield. However, Dundrells' guitarist and producer, Peter Hudson, who worked with a whole host of bands from the period, remains a primary figure in documenting the independent music scene in Toronto during one of its most fertile periods.

THE DUNDRELLS with guitarist Ashley Thomas *(right)* taking it to the audience | JULY 18, 1987

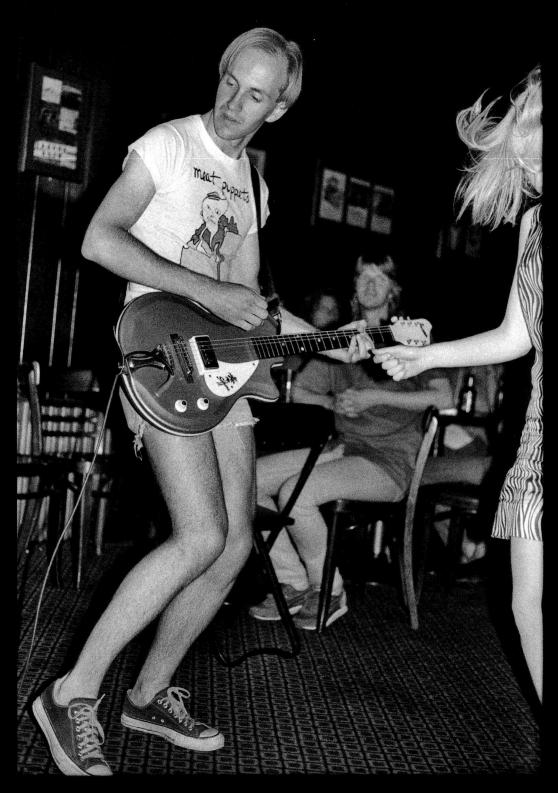

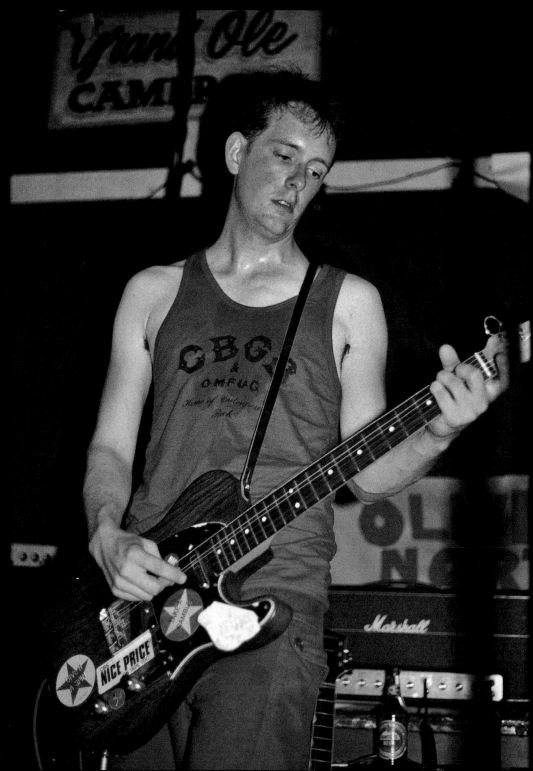

Peter Hudson of THE DUNDRELLS | AUGUST 7, 1987

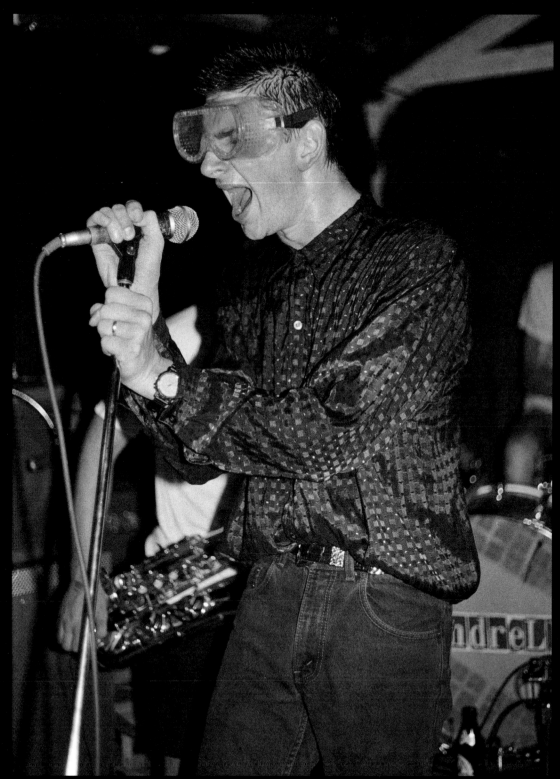

Garry Welsh of THE DUNDRELLS | AUGUST 7, 1987

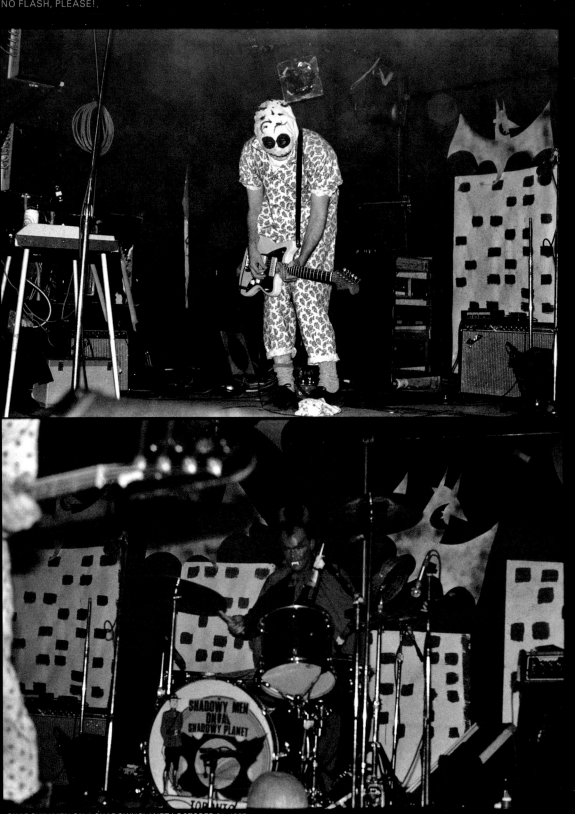

NO FLASH, PLEASE!.

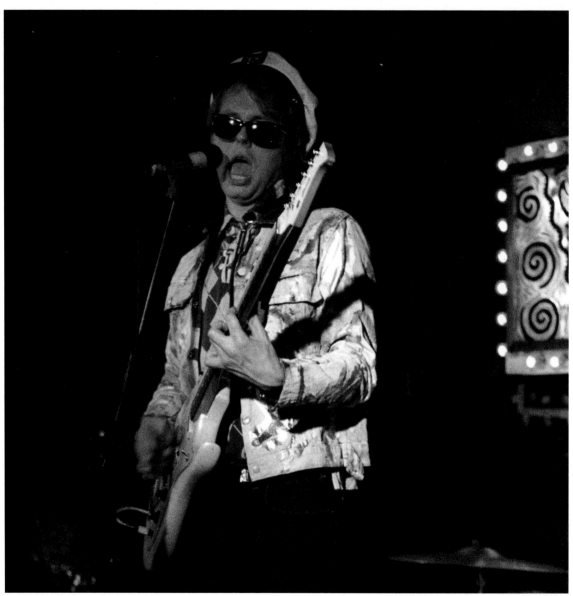

CHRIS HOUSTON | NOVEMBER 14, 1987

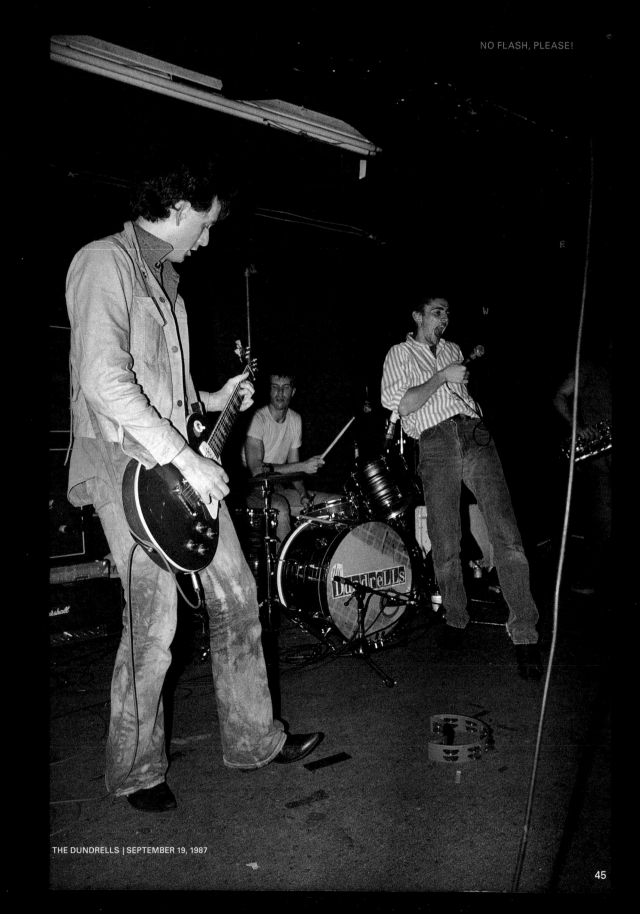

THE DUNDRELLS | SEPTEMBER 19, 1987

Mike McDonald of JR GONE WILD and Moe Berg of THE PURSUIT OF HAPPINESS at the Horseshoe Tavern | SEPTEMBER 16, 1987

left: Dave Bookman performing in The Bookmen, before his popular CFNY Radio DJ days and Nu Music Night showcases | DECEMBER 17, 1987
right: Denise Donlon, who would eventually become head of Sony Music Canada, during her Much Music and The New Music veejay days | 1988

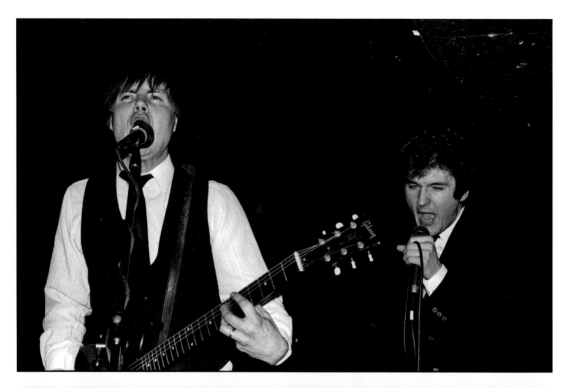

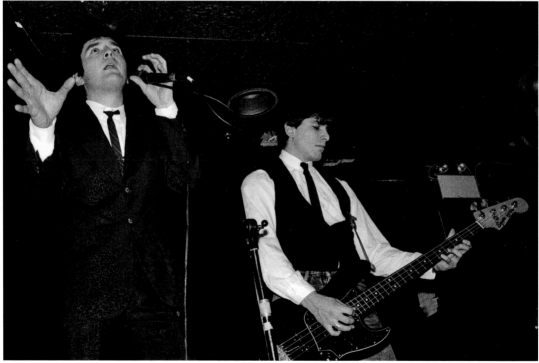

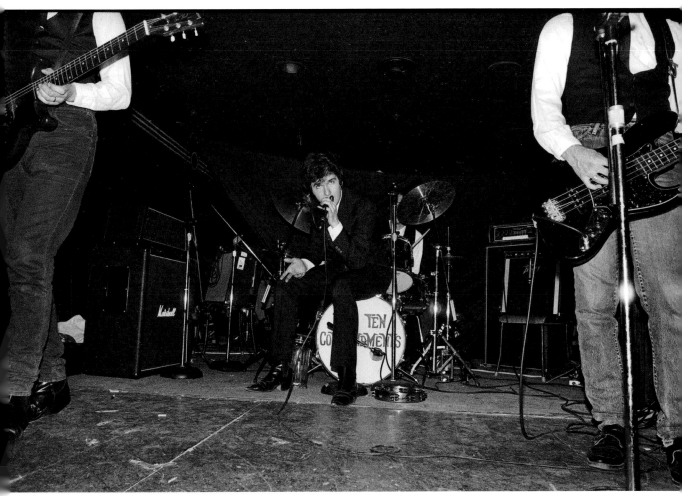

TEN COMMANDMENTS | FEBRUARY 19, 1988
Singer James Booth, currently music director at CBC Radio 3, was also a producer for The New Music on City TV. His early interviews with such bands as Smashing Pumpkins, Dinosaur Jr. and Nirvana remain historic.

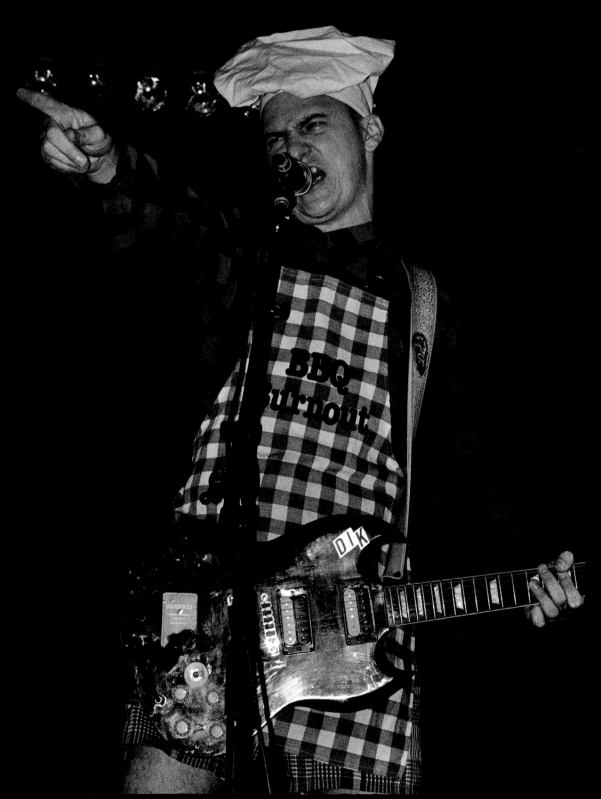

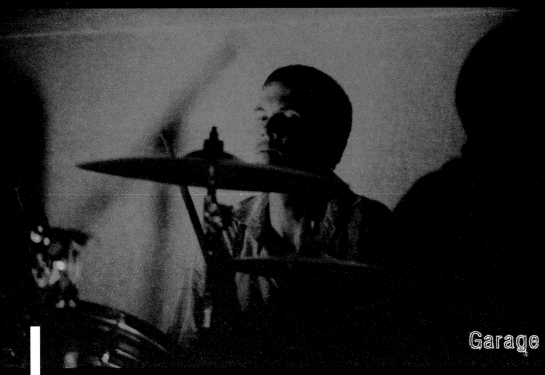

Garage

It's hard to pinpoint why garage music of the sixties made a comeback in the eighties. Some say it was a combination of accessibility, obscurity and the obsession of a few. Others say it was a natural progression of the UK meeting the U.S. and mass media providing the fuel before the days of the Internet. In this case, the media was the Xerox machine and the 90-minute cassette tape.

The champion of the scene was undoubtedly Og Music, a Montreal-based imprint that started with cassettes but quickly moved to vinyl, had the idea to start distributing demo tapes through a series called *It Came from Canada*. Among the groups that got onto these compilations were Shadowy Men, Ray Condo and His Hard Rock Goners, The Dik Van Dykes, Ten Commandments, The Gruesomes, The Dundrells, Supreme Bagg Team and Chris Houston among others, and, of course, Og's founders' own legendary duo, Deja Voodoo. Their song "Cheese and Crackers" is a classic from the period.

The emergence of this trend seemed to be part of a uniquely Toronto thing. Certainly Toronto and Montreal had nurtured and produced highly polished groups that were getting radio play, but by the time Seattle's Sub Pop records went seemingly overnight from being one of those cassette labels to becoming the biggest indie label in America, and by the time of the Northwest label's championing of such garage groups as Thee Headcoats and Mudhoney, the scene in Ontario and Quebec had started to fizzle. Of course, the demise of Og Music in 1990 was, in fact, a nail in the coffin of the garage-music renaissance of the eighties.

left: Mike "Dik" Johnson of THE DIK VAN DYKES | DECEMBER 3, 1987
above: Terry Kelly of THE DUNDRELLS | JULY 11, 1987

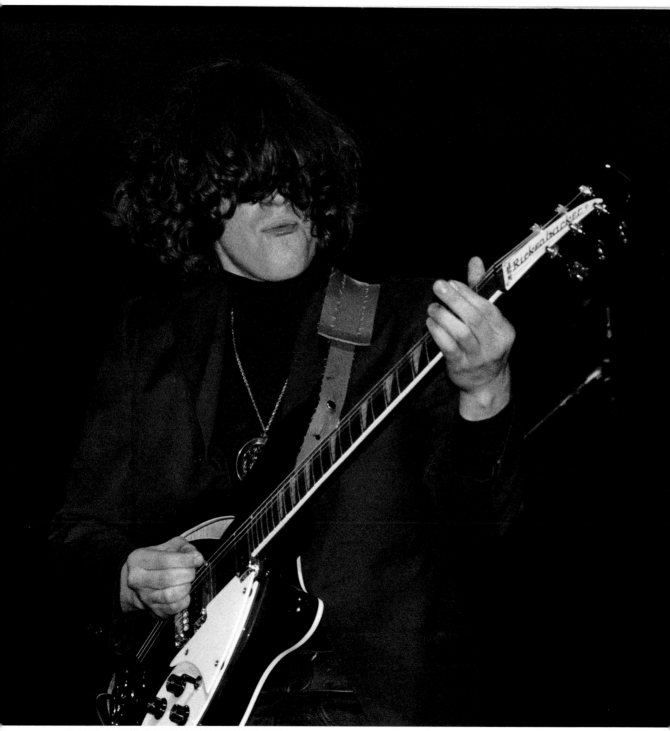

Bobby Beaton of THE GRUESOMES | DECEMBER 3, 1987

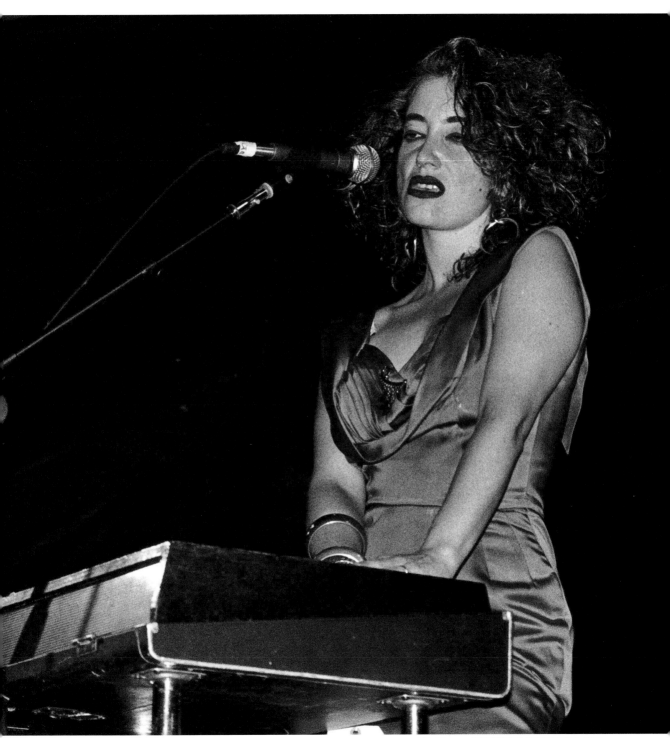

Julla Gllmore of CONDITION | DECEMBER 3, 1987

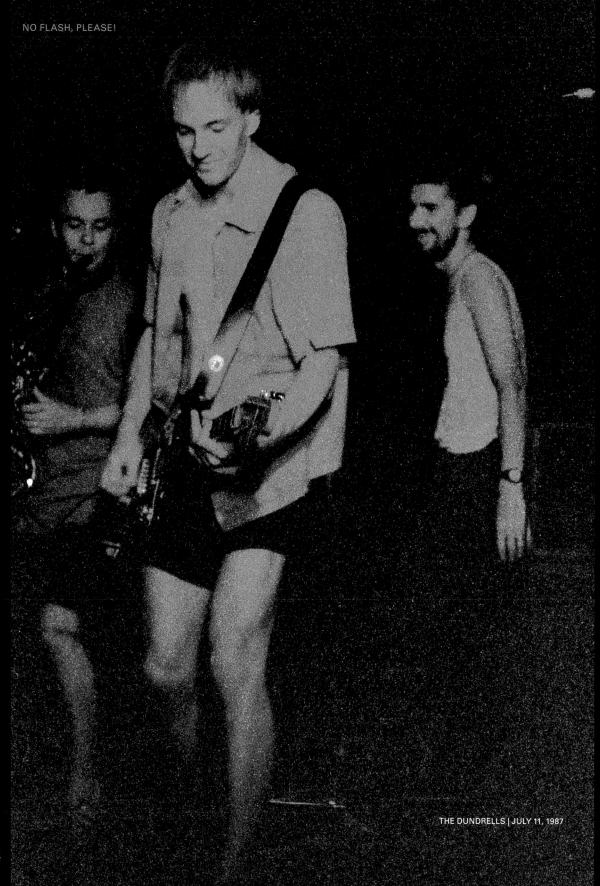

THE DUNDRELLS | JULY 11, 1987

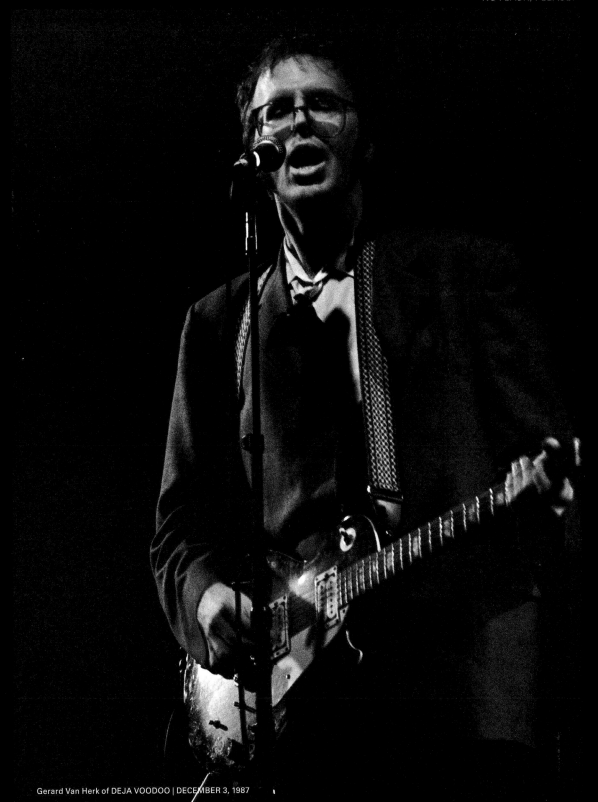

Gerard Van Herk of DEJA VOODOO | DECEMBER 3, 1987

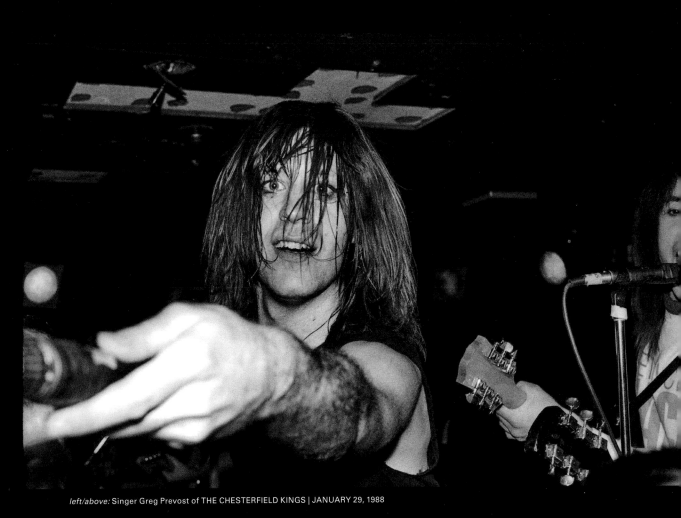

left/above: Singer Greg Prevost of THE CHESTERFIELD KINGS | JANUARY 29, 1988

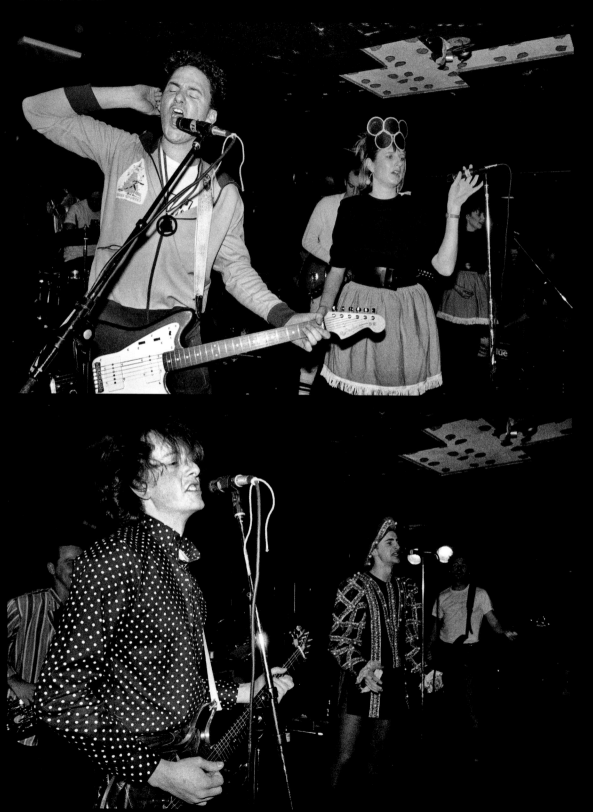

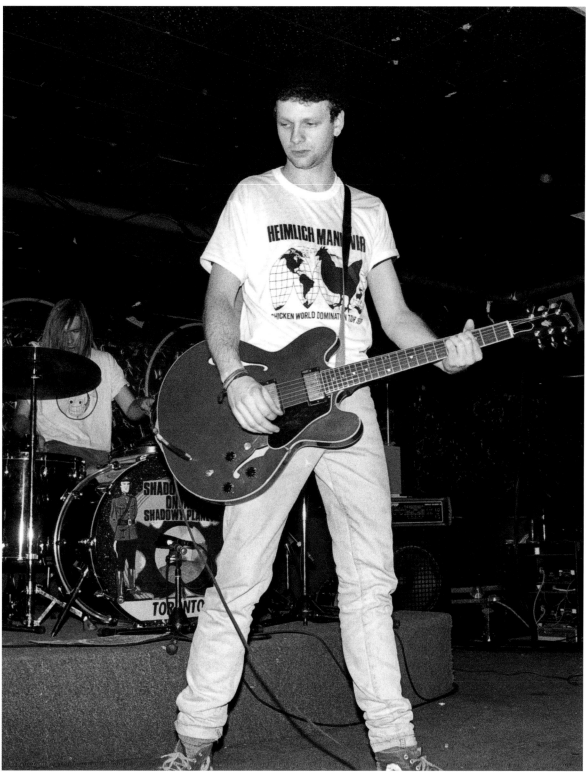

above: Drummer Iain Thompson & guitarist Kevan Byrne of HEIMLICH MANEUVER | FEBRUARY 20, 1988
left/top: THE DIK VAN DYKES | FEBRUARY 20, 1988
left/bottom: THE DUNDRELLS | FEBRUARY 20, 1988

"We mostly thought of ourselves as a punk band."

—Don Pyle (Shadowy Men on a Shadowy Planet)

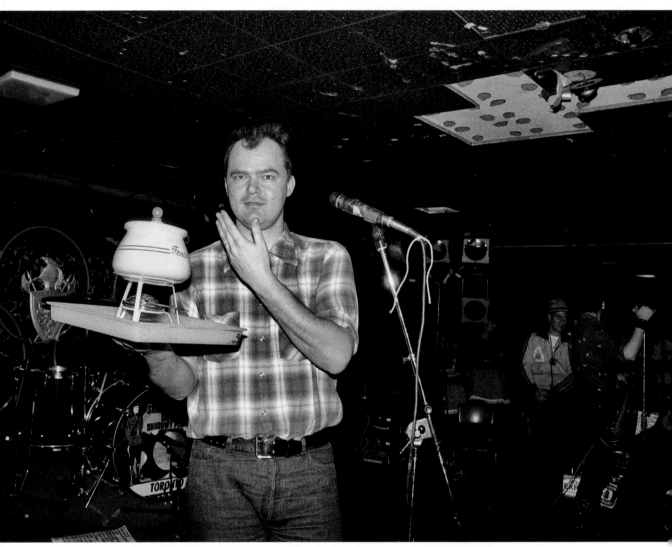

above: Don Pyle of SHADOWY MEN ON A SHADOWY PLANET serving fondue, live on stage | FEBRUARY 20, 1988
right: Brian Connelly of SHADOWY MEN ON A SHADOWY PLANET | MARCH 15, 1988

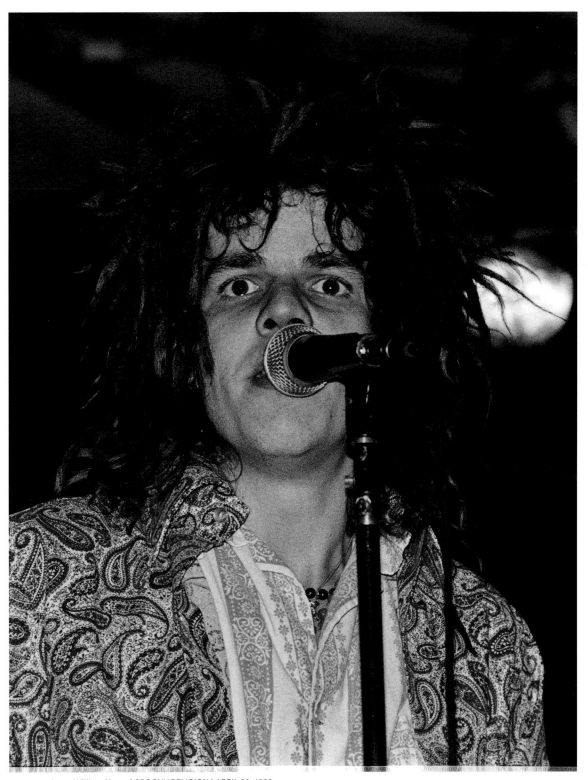

above: William New of GROOVY RELIGION | APRIL 26, 1988
left: HEIMLICH MANEUVER | MARCH 15, 1988

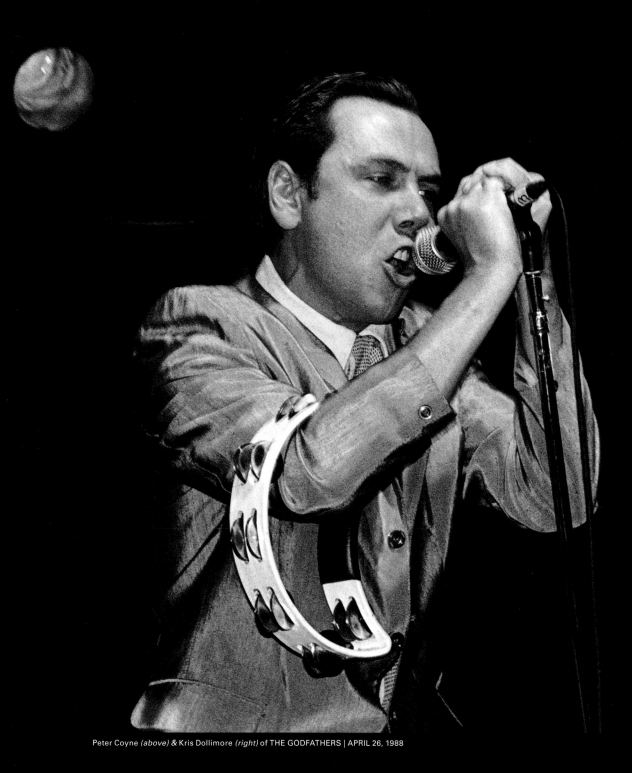

Peter Coyne *(above)* & Kris Dollimore *(right)* of THE GODFATHERS | APRIL 26, 1988

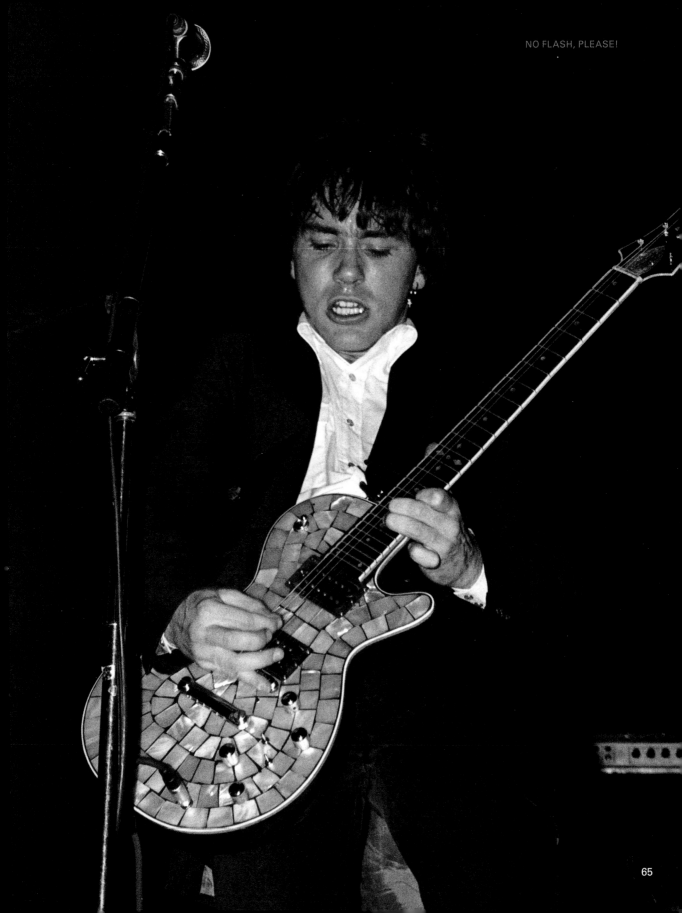

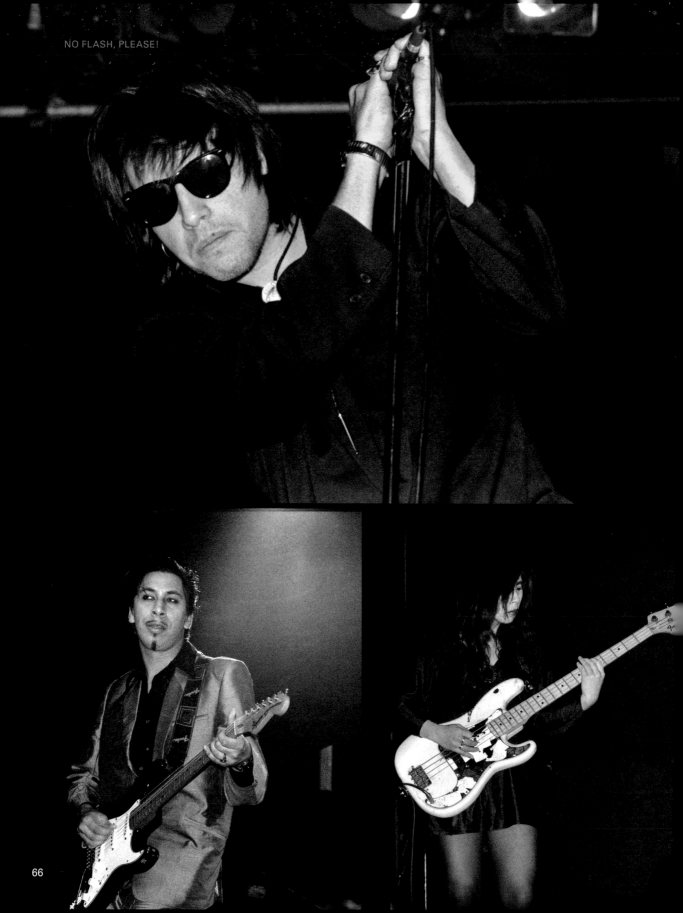

The Gun Club emerged from Los Angeles in 1979. They re-formed in the early nineties after Jeffrey Lee Pierce set aside his spoken-word performances and returned to music. Their album *Mother Juno* was critically acclaimed, but in retrospect, it is difficult to overestimate the impact of their debut, *Fire of Love*. A full frontal attack on American music in the same vein as Elvis, The Rolling Stones and Metallica, The Gun Club continues to be remembered as one of the first purveyors of punk rock and roll (sometimes called cow punk, associated with X, psychobilly, and with a whole host of musicians, most notably Tex and the Horseheads and Reverend Horton Heat) and dark, drug-induced gothic Americana (most celebrated by Nick Cave and his Bad Seeds, in which Gun Club's guitarist Kid Congo Powers became an important early creative force during The Gun Club hiatus). In the photo you see here, Pierce's creative muse and girlfriend Romi Mori is seen on bass. In fact, it is widely noted that the departure represented by their reunion album *Mother Juno* is largely attributed to Mori's influence on Pierce, whose drug- and alcohol-abuse struggles impacted heavily on his creative life. Drummer Nick Sanderson, who appeared in The Jesus and Mary Chain for a short stint, eventually married and had a child with Mori after Pierce's death in 1996. Sanderson himself died after a battle with lung cancer in 2008.

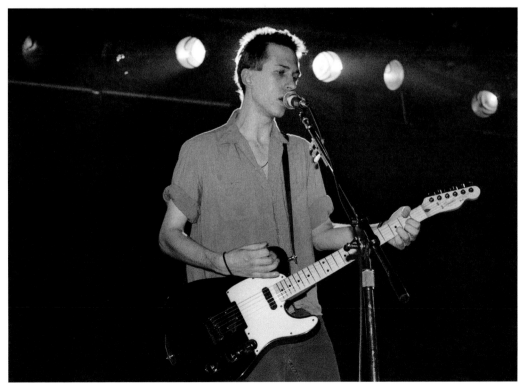

left: THE GUN CLUB | MARCH 31, 1988 | RPM *clockwise from top.* Jeffery Lee Pierce, Romi Mori, Kid Congo Powers
above: Glenn Mercer of THE FEELIES | MARCH 15, 1988

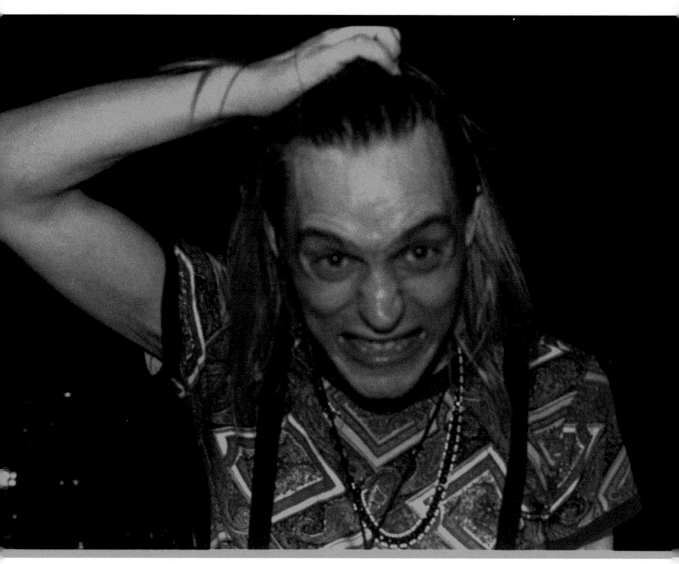

GAYE BYKERS ON ACID | APRIL 14, 1988
above: Ian Garfield Hoxley; *right/top:* Ian Garfield Hoxley & Ian Reynolds; *right/bottom:* Tony Horsfall

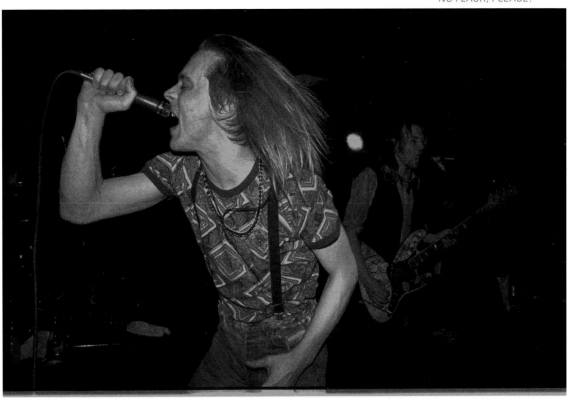

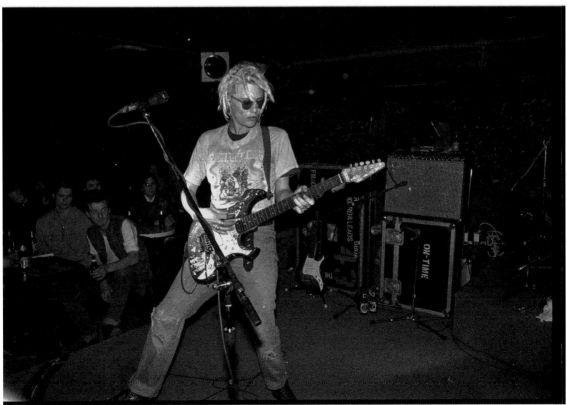

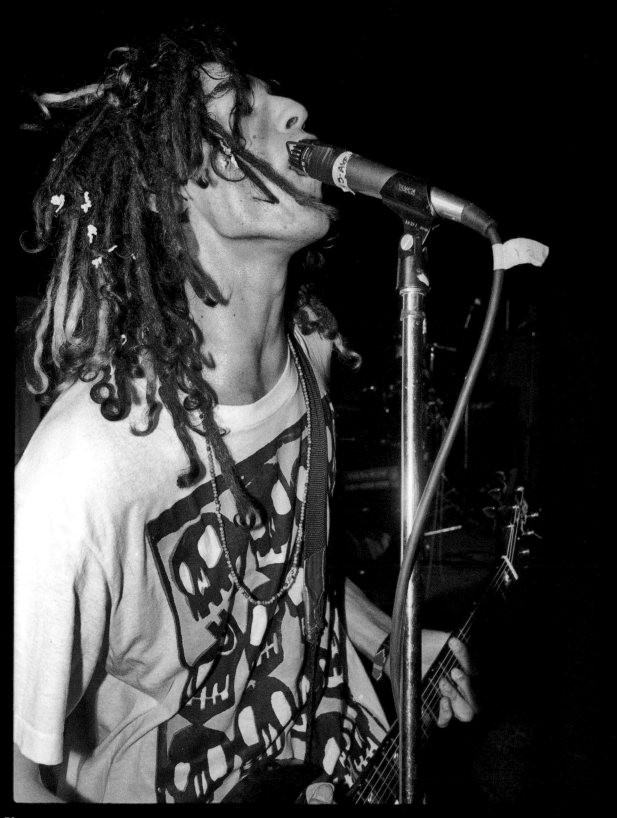

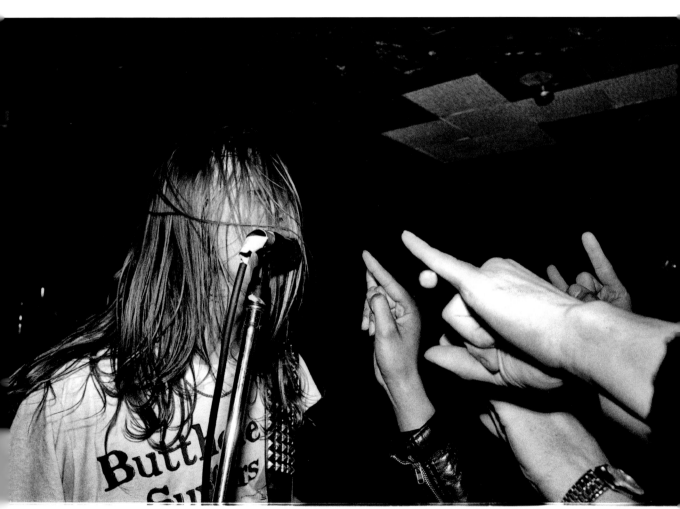

THE DOUGHBOYS | APRIL 21, 1988

In 1987 **Dag Nasty** played at Ildiko's, a crumby bar on Bloor Street known for booking great punk rock shows in the late eighties. Dag Nasty was promoting its debut LP on Dischord Records, produced by then-former Minor Threat vocalist Ian MacKaye (Fugazi) and included legendary Minor Threat guitarist Brian Baker (who joined LA hard-core punk icons Bad Religion in 1996). On *Can I Say*, you can hear what emerged as pop punk, made commercially viable by such bands as Blink-182 and Green Day. But during this period, it was Dave Smalley's vocals, later heard in the California band All started by Descendents drummer Bill Stevenson and guitarist Stephen Egerton, that really crystalized the merger of power pop of the mid- to late seventies with the post-punk emo-core of the nineties. Of course, the impact of the Descendents in this genealogy is undeniable, but Smalley's tuneful vocal style is an important starting point for this unique and commercially successful subgenre of punk in America. If one genre could be said to have survived the corporatization of alternative music in the nineties, it was this one, and Smalley is a key figure in that history. Bands such as The Mr. T Experience, The Doughboys, Big Drill Car, and The Nils are all part of this legacy.

Dave Smalley of ALL | APRIL 21, 1988

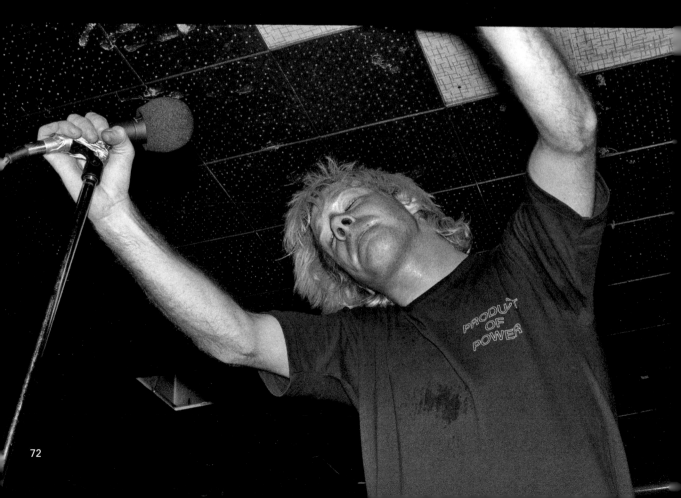

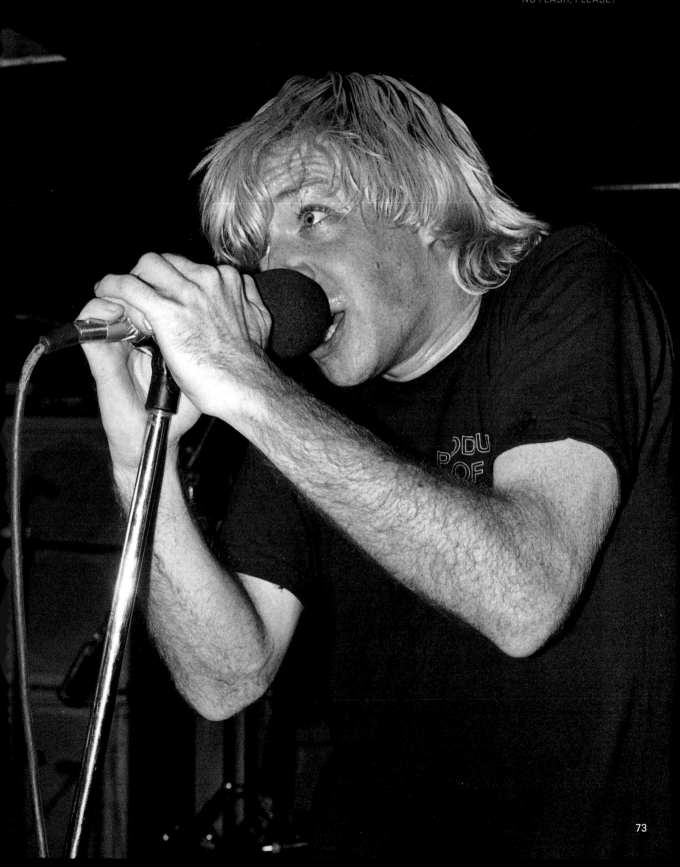

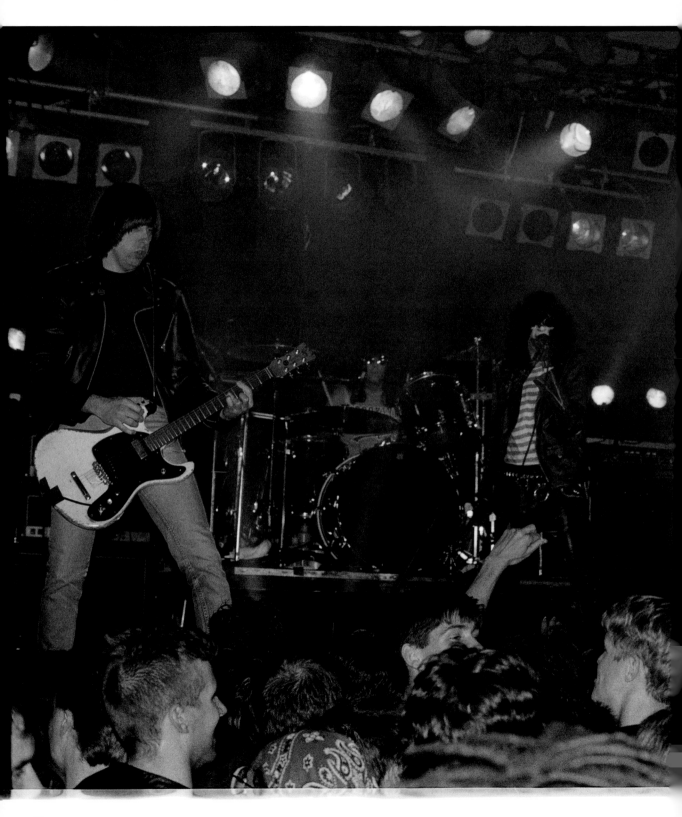

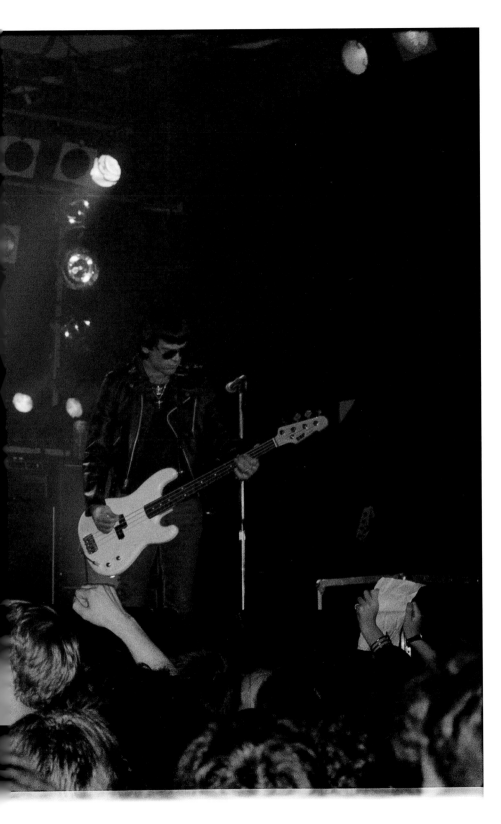

RAMONES | MAY 5, 1988

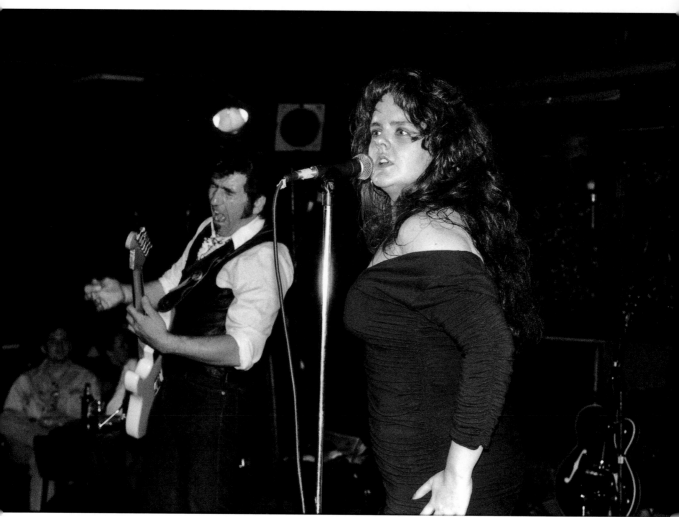

KRISTI ROSE & THE MIDNIGHT WALKERS | MAY 7, 1988

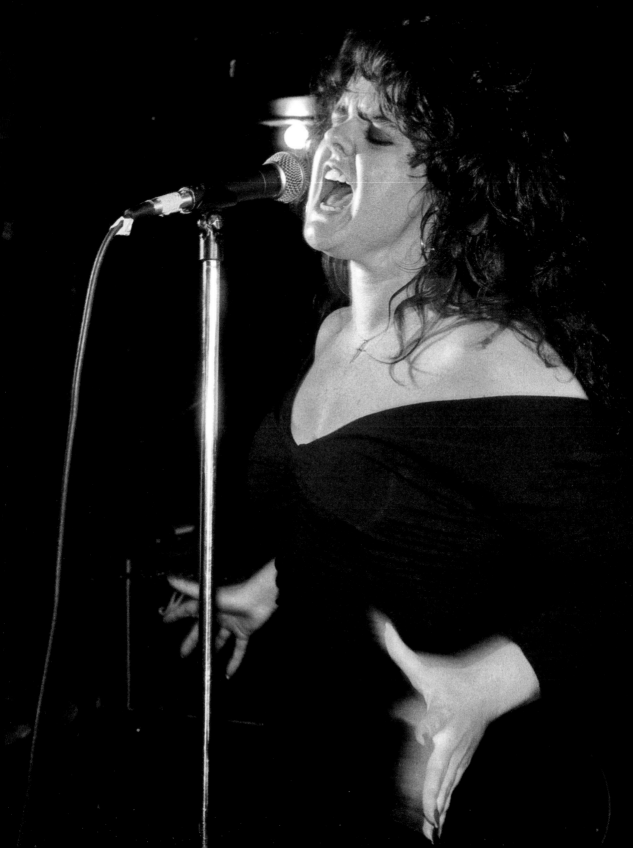

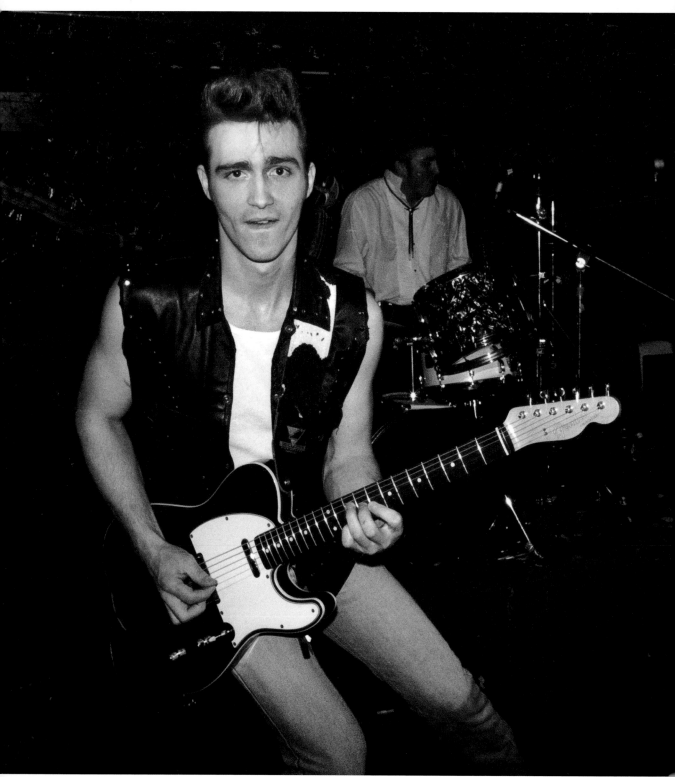

Guitarist Danny Bartley of SHOTGUN SHACK | MAY 7, 1988

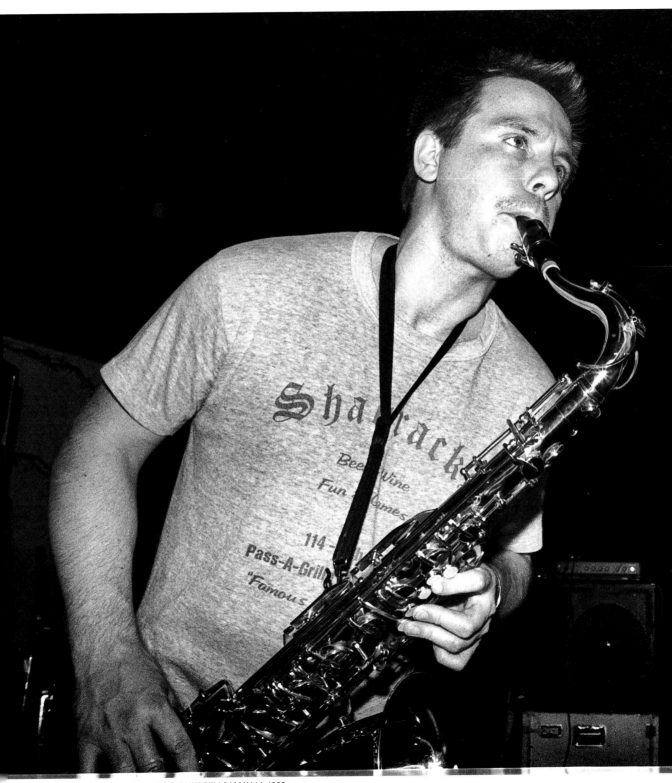

Andy Thorndyke of THE DUNDRELLS | MAY 14, 1988

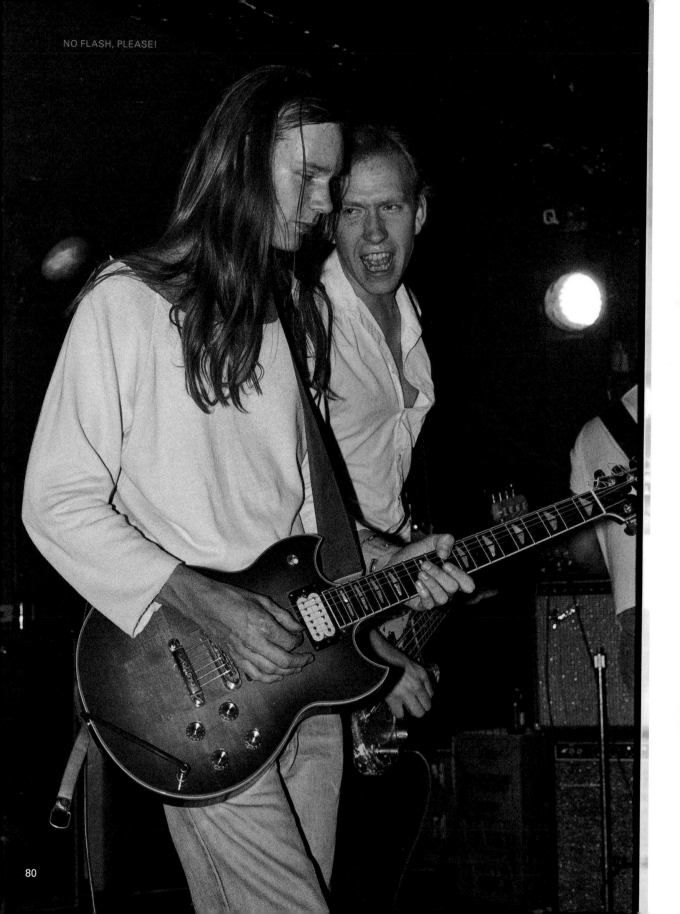

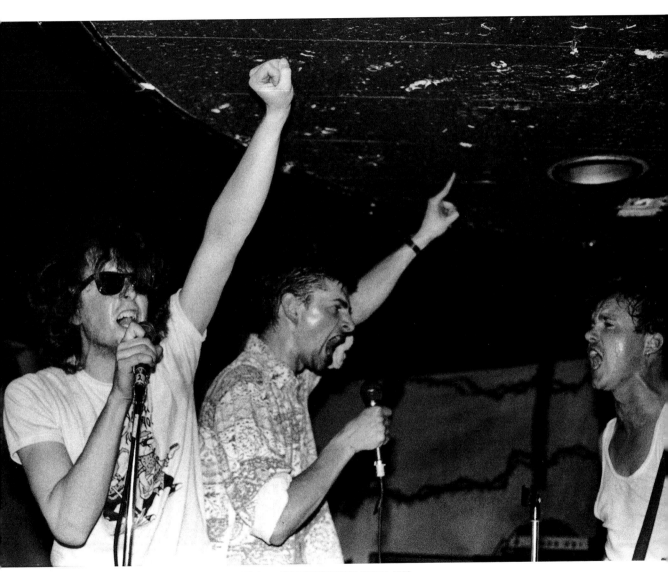

above: Peter Hudson, Garry Welsh & Richard Higham of THE DUNDRELLS | MAY 14, 1988
left: Scott Kendall & Dave Schellenberg of JELLYFISHBABIES | JUNE 11, 1988

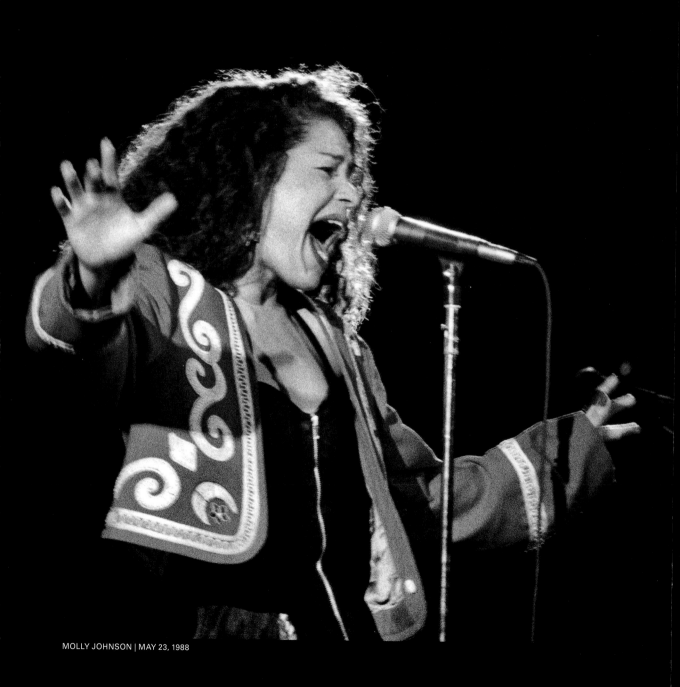

MOLLY JOHNSON | MAY 23, 1988

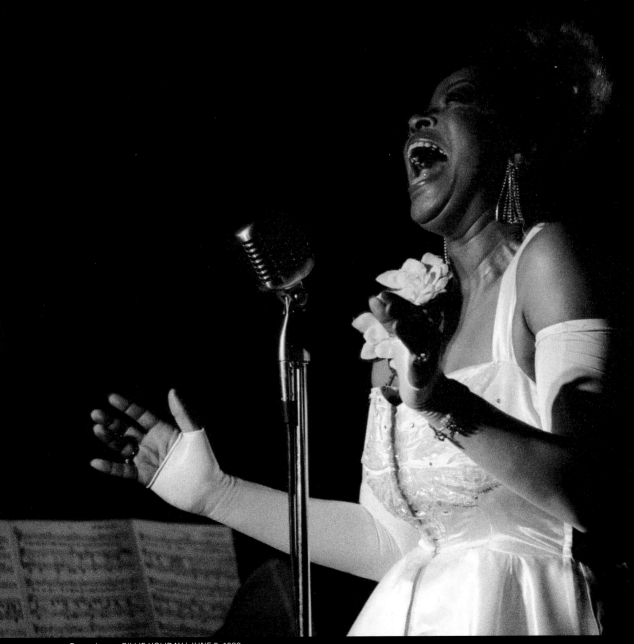

Ranee Lee as BILLIE HOLIDAY | JUNE 3, 1988

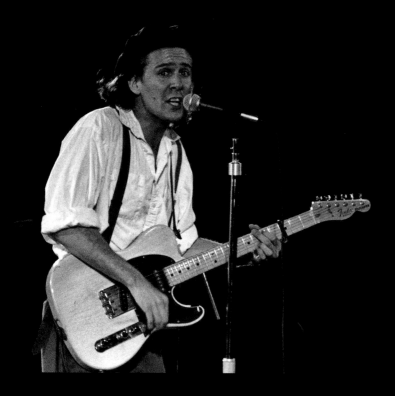

ANDREW CASH | JUNE 16, 1988

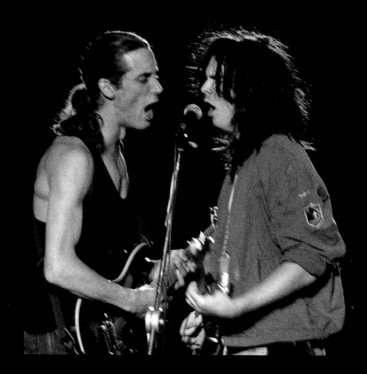

54-40 | JUNE 16, 1988

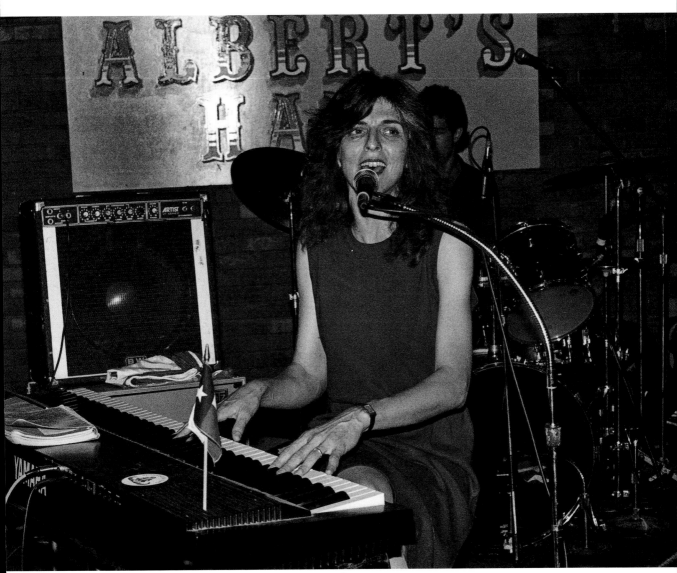

MARCIA BALL | JUNE 6, 1988

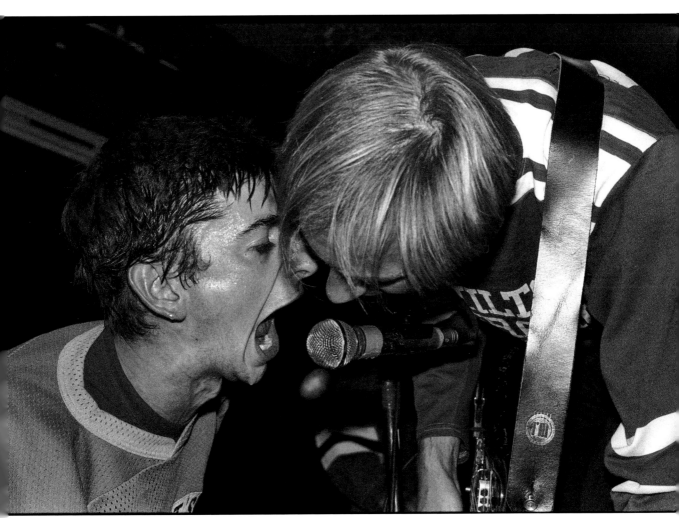

left/above: The last performance of THE DUNDRELLS | JUNE 11, 1988

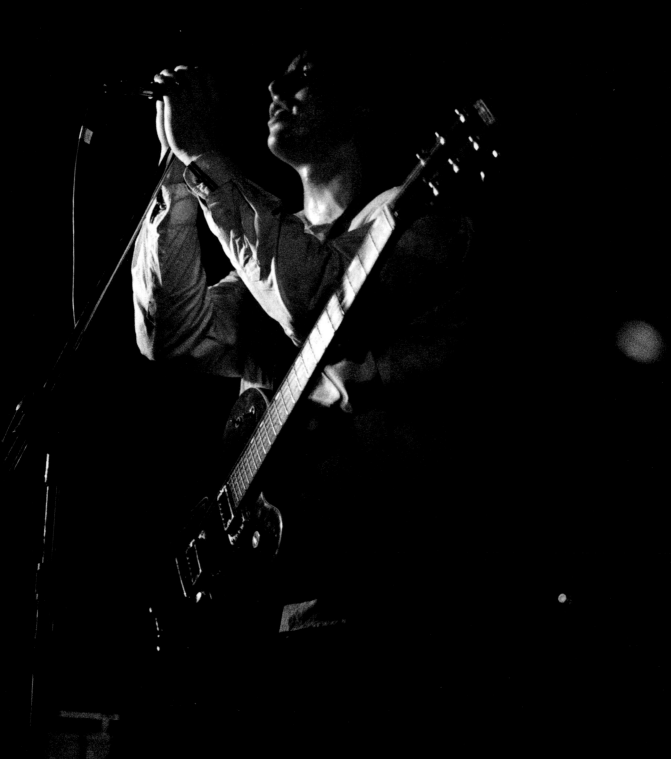

above: John Critchley of 13 ENGINES | JANUARY 21, 1989
right: 13 ENGINES | MAY 13, 1988

Originally named the Ikons, North Bay natives **13 Engines** were among the most career-oriented of the groups to emerge from the Queen Street West scene in the mid- to late eighties. They formed while attending York University and arose at around the same time as the now-legendary Rheostatics. Originally signed to a small Detroit-based label, Nocturnal Records, 13 Engines released *Before Our Time* and *Byram Lake Blues* before getting picked up by SBK Records in the U.S. and EMI Records in Canada. Their next and probably most popular release, *Perpetual Motion Machine*, got them not only significant radio play but also earned them a spot on The Tragically Hip's annual summer tour, Another Roadside Attraction. T-Hip singer Gord Downie made a point of exposing Tragically Hip's audiences to lesser-known bands, including the Rheostatics, Change of Heart and Kingston's Inbreds, despite their marginal popularity at the time. 13 Engines was dropped by SBK, and subsequent releases on EMI and Atlantic Records in the U.S. emerged but never materialized into increased popularity, despite being among the most critically acclaimed work that singer guitarist John Critchley, guitarist Mike Robbins, bassist Jim Hughes and drummer Grant Ethier ever did. A cross between The Only Ones, The Feelies and Neil Young, with a dash of Australia's The Saints for good measure, 13 Engines is among the most respected and cherished bands from the late eighties' and early nineties' scene, and its releases are well worth seeking out, if for no other reason but to realize one of the best in breed of the period.

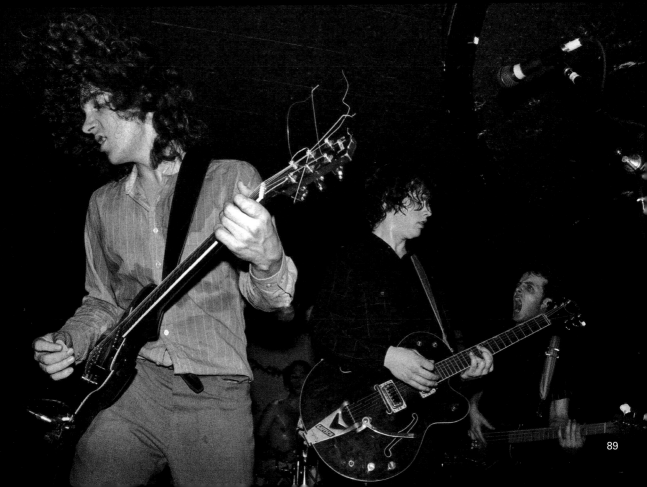

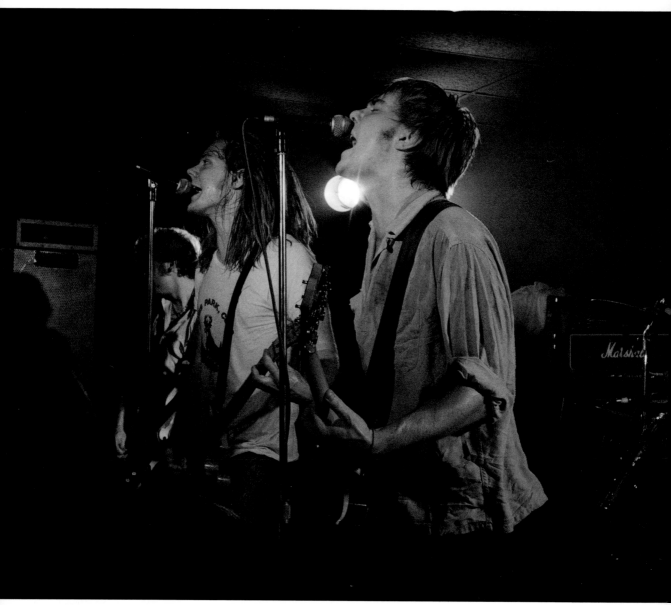

SOUL ASYLUM | JULY 22, 1988

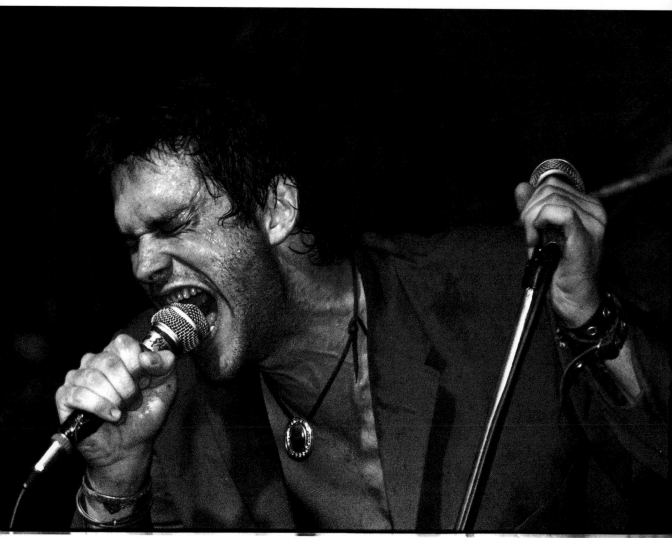

above: Jerome Godboo of THE PHANTOMS | JUNE 26, 1988
right: TAV FALCO'S PANTHER BURNS | JULY 29, 1988

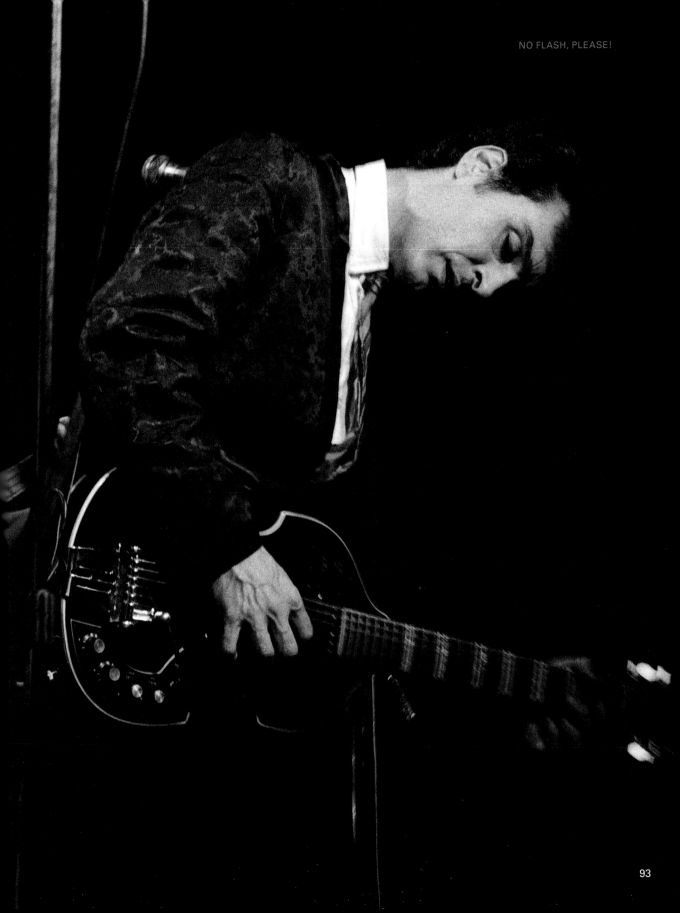

THE HELLCATS | JULY 29, 1988
above: Diane Green, *right:* Lorette Velvette

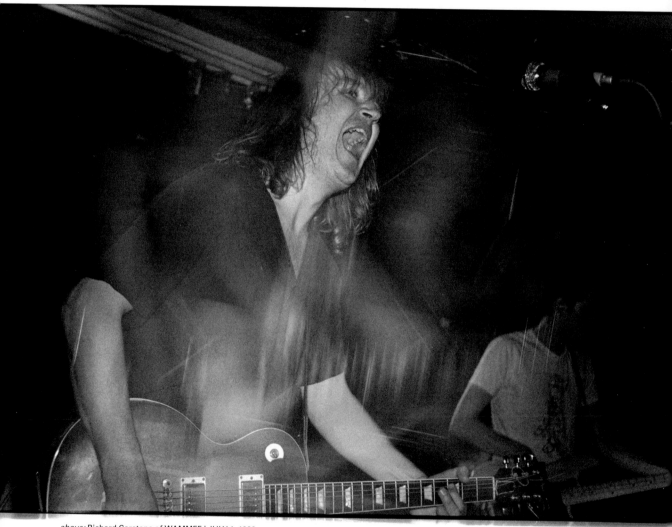

above: Richard Carstens of WAMMEE | JULY 1, 1988
right: Peter Hudson & Corinne Culbertson of VARIS TOMBLEY | AUGUST 22, 1988

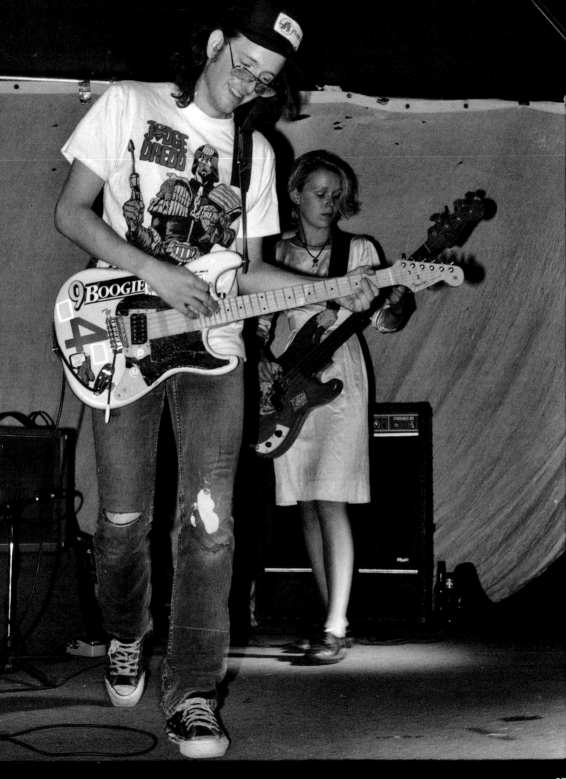

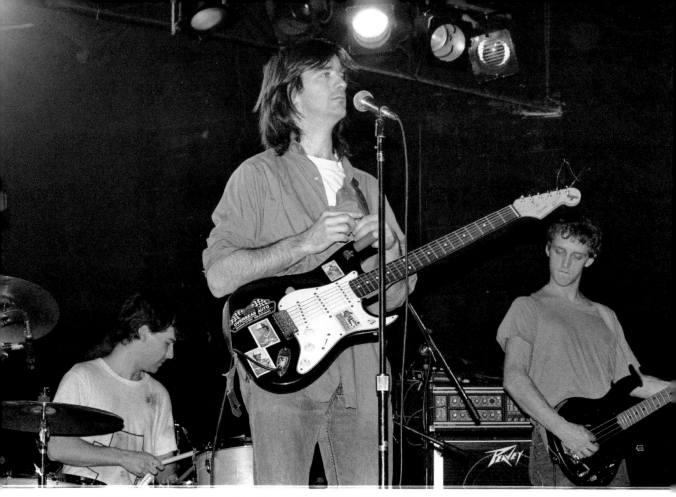

above: (L-R) Mike Duggan, Gord Cumming, Richard Gregory of THE LAWN | MARCH 31, 1988
right: Louise Kiner of JOHN DRAKE ESCAPES | JULY 1, 1988

"I remember, coming to Toronto from Nashville and being embraced by the music community in Toronto. Caroline Azar (Fifth Column) and Charlie Salmon (Plasterscene Replicas) became dear friends to me. I saw and loved The Woods are Full of Cuckoos, so when former member Gord Cumming (founder of The Lawn) started the Lawn, I played bass, and was so happy when Richard (Gregory) came along, because he was really meant to be the bassist in that band. I'm still surprised that those bands didn't become bigger. If you listen to those records today, they hold up to anything that came out from that period anywhere in the world,"

—Peter Hudson

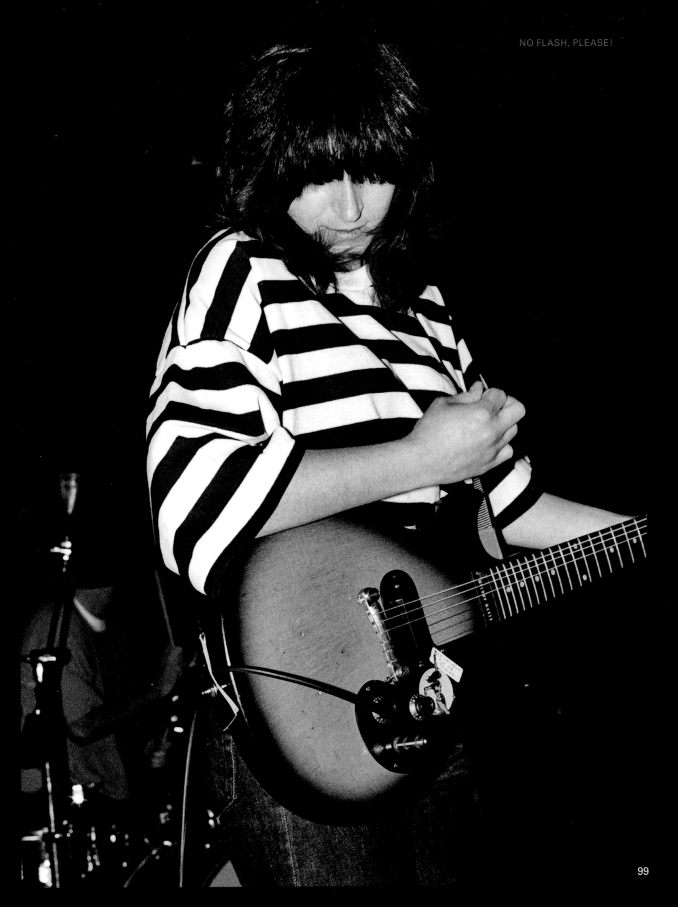

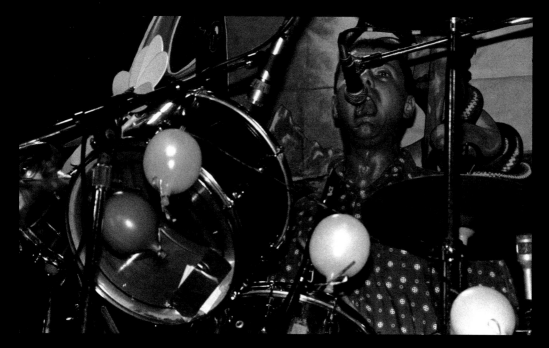

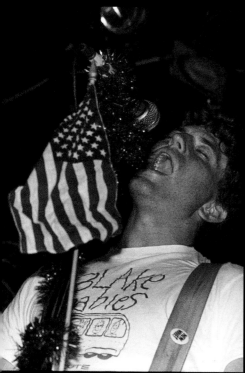

Volcano Suns is among the least recognized guitar-oriented post-punk bands to emerge from America's Midwest. Drawing on ground planted by iconic bands like New Jersey's The Feelies, the Suns produced a form of music that is ethereal, song-focused, melodic and harmonically complex. But lacking hooky commercial songs that bands like R.E.M. and the DBs would popularize in the eighties and nineties, they remained unpopular. A significant aspect of the Volcano Suns was the membership of drummer Peter Prescott, who played alongside Roger Miller in Mission of Burma, considered a pioneering group in the post-punk era. It is important to note that Volcano Suns bassist Bob Weston would be part of Mission of Burma's resurgence in 2002. It is also worth noting that Weston plays in nerd-rock outfit Shellac with paradigmatic producer Steve Albini. Although never fully realized for their contributions to Midwestern indie rock, the Volcano Suns, and Bob Weston in particular, are important reference points for what would become alternative rock in the nineties and early 2000s.

top: Peter Prescott, *left:* Bob Weston of VOLCANO SUNS | AUGUST 5, 1988
opposite page:
Rob Taylor (left) & Ian Blurton of CHANGE OF HEART | SEPTEMBER 2, 1988

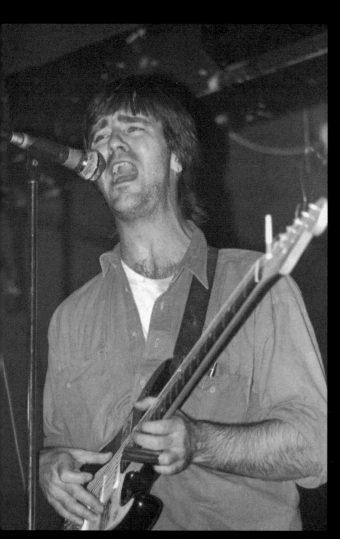 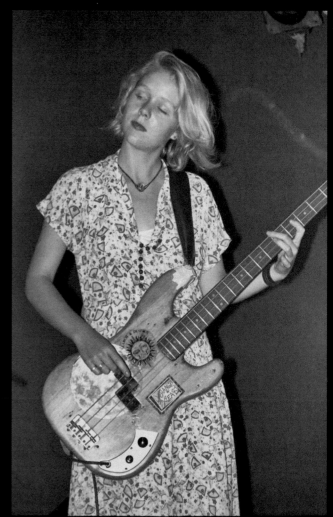

Gord Cumming & Corinne Culbertson of VARIS TOMBLEY | AUGUST 27, 1988

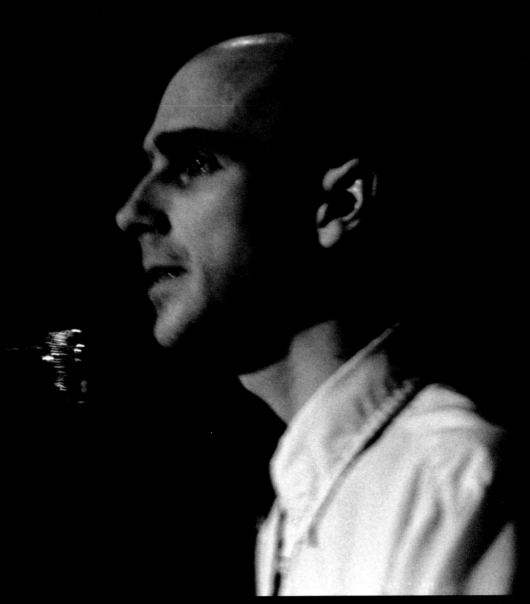

NEAL ARBIC | AUGUST 27, 1988

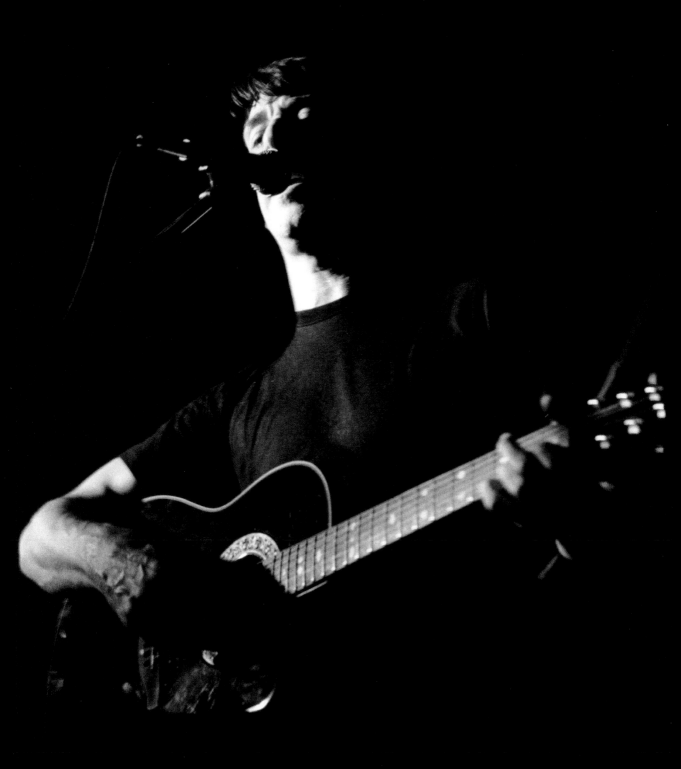

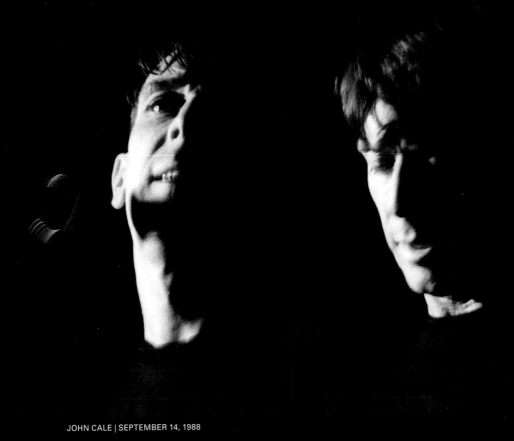

JOHN CALE | SEPTEMBER 14, 1988

Grandparents:

John Cale, Maureen Tucker, Iggy Pop, Dave Thomas and Jack Bruce

When The Velvet Underground rose up from Andy Warhol's Factory in the early sixties, it was featured in *Life* magazine, as was Warhol's *Exploding Plastic Inevitable.* When The Stooges rose up from the Midwestern hippie scene fuelled by the University of Michigan's White Panther Party and symbolized by the Motor City Five (aka MC5), it was the first time that white middle-class America had connected itself to an increasingly militant Black Power movement. Pere Ubu was another example of an unexpected cultural export—this time out of Cleveland, Ohio—where Cheetah Chrome had also emerged in Dave Thomas's on-again off-again Rocket from the Tombs.

So what do all these groups have in common, aside from the fortuitousness of being the subject of Derek von Essen's camera?

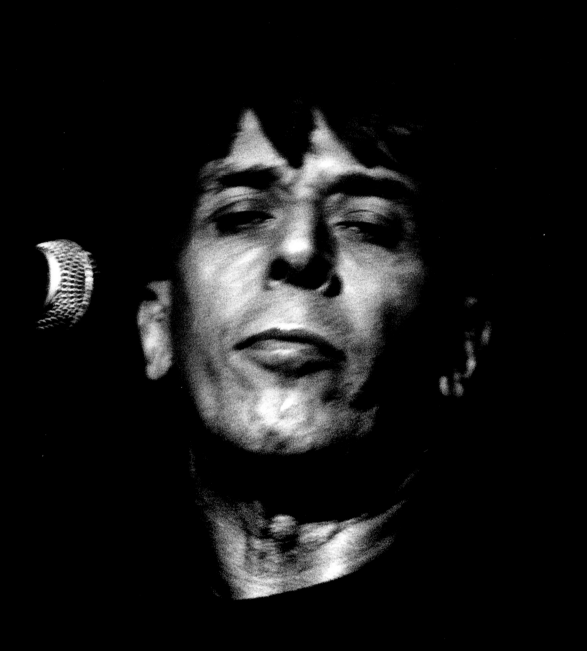

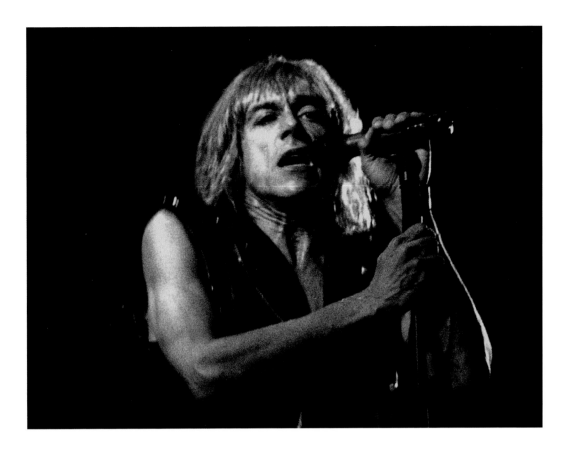

Let's start with The Stooges. Considered a commercial failure, The Stooges are never-theless often cited as the primary impetus for punk rock in the seventies. The musical con-tribution of The Stooges, along with Iggy Pop's unique stage presence and snarky approach, remains unrivalled in modern music. Even punk-rock gladiator Henry Rollins has prostrated himself before Mr. Pop (whose first name refers to his place in the Midwestern garage legends The Iguanas).

Supergroup Cream tenuously rose up from the blues and psychedelic scene in England, featuring bassist and vocalist Jack Bruce, who had to be goaded by Eric Clapton into joining the group after a number of very public physical confrontations with drummer Ginger Baker, who'd warned Clapton of his dislike for the talented Bruce. Nevertheless, during a short two-year period, the influence of Cream on the movement of modern music is undeni-able, particularly as it relates to progressive rock, psychedelic and blues rock.

The Velvet Underground literally changed music, but was also largely seen as a marginal success, owing its notoriety more to the solo career of Lou Reed and its connection to Andy Warhol. Its album *White Light/White Heat* is widely considered the most important record to

left: JOHN CALE | SEPTEMBER 14, 1988 *above:* IGGY POP | AUGUST 16, 1988

come out of New York in the sixties, and the band's style and demeanour are still referenced today in such bands as The Dead Weather, The Black Keys and a little further back, The Strokes. The fact that The Velvet Underground's songs are being covered by contemporary bands remains a kind of rite of passage and speaks volumes about how important the band is in terms of modern music.

Finally, and certainly not least, Dave Thomas's Pere Ubu emerged in the early seventies with two milestone releases: its self-titled album, which included the song "Final Solution" as well as the prescient "Non-Alignment Pact"; and *Dub Housing*, which, as a whole, remains one of the most important progressive rock/punk records to come out of the Midwestern U.S. since *Raw Power* by Iggy and the Stooges. Thomas's ability to deliver timely yet timeless lyrics, while conducting a wide-open tonal approach that brinks on Dadaist and Situationist aesthetics, is still unequalled. As such, Thomas and Pere Ubu, whose members included subsequent members of The Feelies and The Golden Palominos, are unique in their importance during the arrival of so-called alternative music in the nineties.

below: PERE UBU | SEPTEMBER 14, 1988 *right:* MOE TUCKER | MAY 2, 1989

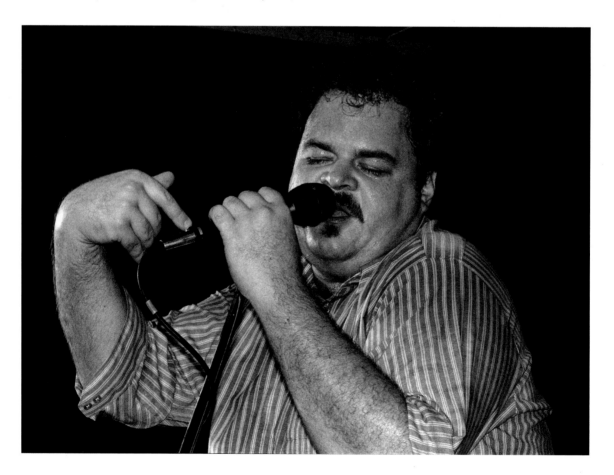

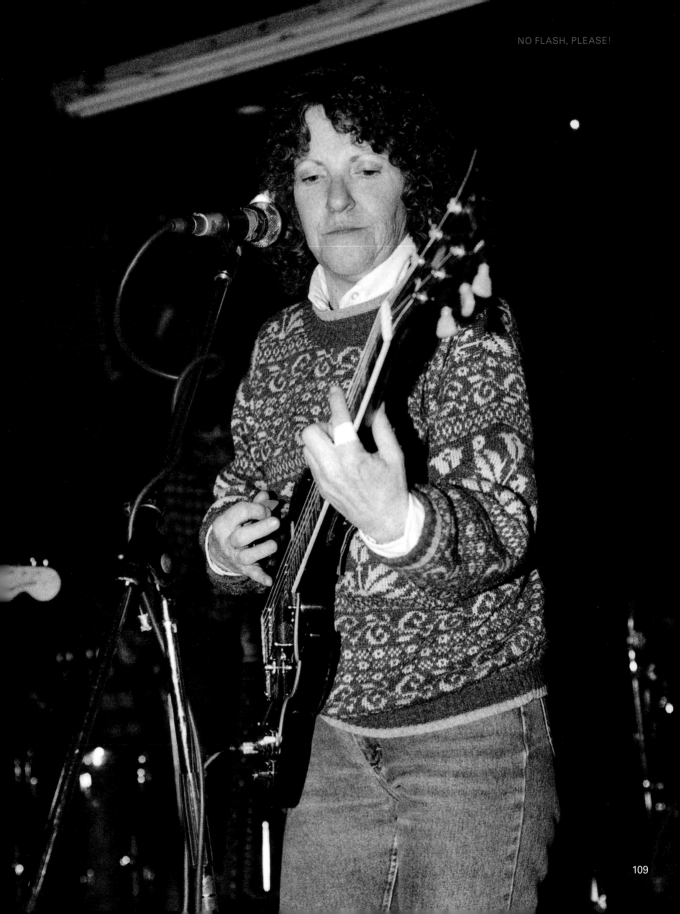

There are many theories about the emergence of punk rock in America. Pop music scholars enjoy debating the question of what was and wasn't punk. The strident figure of James Osterberg (aka **Iggy Pop**) casts a long shadow over this debate. When you listen to The Stooges and recognize what he and his Ann Arbor, Michigan mates did was so completely out of synch with what was happening in music at the time, and then reflect on rediscovered bands like Detroit's Death, or listen to some of Funkadelic's early recordings; and then explore the music that emerged from a similar pool in Toledo, Ohio's Necros, Die Kreuzen, Negative Approach and the Laughing Hyenas, you start to form a map of punk that is very different from the one that was drawn by New York and London, England. A favourite story about Iggy Pop comes by way of one of his least prolific periods, during a promotional tour for the album *Brick by Brick*. He turned up at the backroom of Queen Street West's Rivoli on a promotional tour, where he would speak to the media about his new album and potentially play a song on an acoustic guitar if the mood struck him. The story went like this: the band playing that night was Washington DC's Scream. They were about to call it quits, and their drummer, Dave Grohl, would soon be asked to join Nirvana. As Iggy waited for his moment to meet the press, he heard the band sound checking for their show that evening. He apparently asked the boys if they knew any of his former band's songs. Grohl and bassist Skeeter Thompson laughed and said something like, are you kidding? Of course. That night, Iggy took his classic form, backed up by Dave and Skeeter of Scream. Little did Iggy (or Dave) know that this meeting would later create a legendary connection between his Stooges (re-formed in the early 2000s with Minutemen/fIREHOSE bassist Mike Watt) and Nirvana, and later Foo Fighters, as ensconced members of punk rock lore. What is important to note about the photograph included here is that Derek was required to sign a release form prior to taking any pictures of Iggy. For whatever reason, there were limits put on his image and limits to how he should be portrayed. These days, of course, that would never fly, since taking cellphone shots—and sometimes even videos—at shows has become commonplace; but in those times, Mr. Pop's people possibly feared his image would be used in an unflattering manner.

IGGY POP | AUGUST 16, 1988

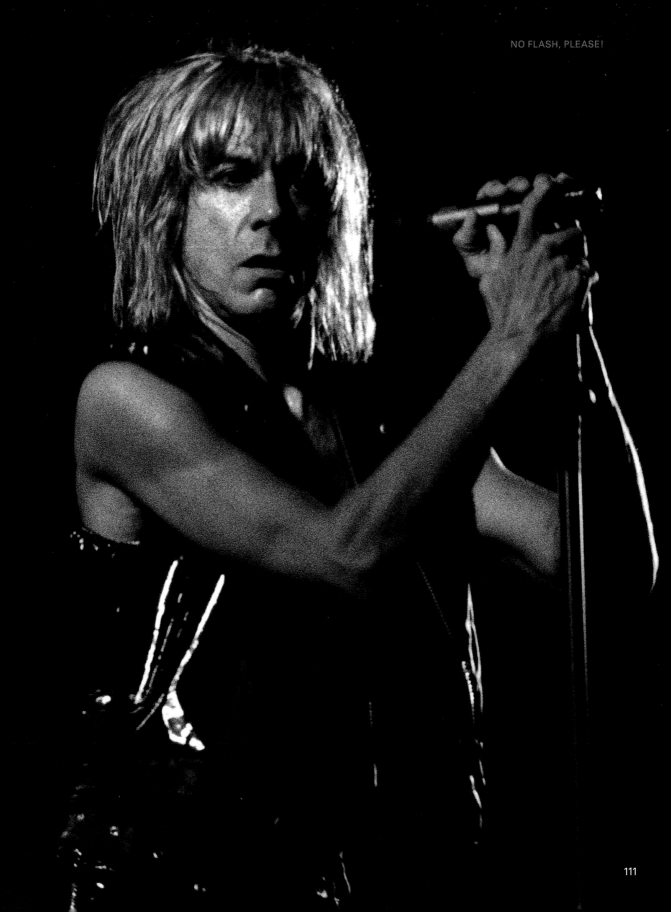

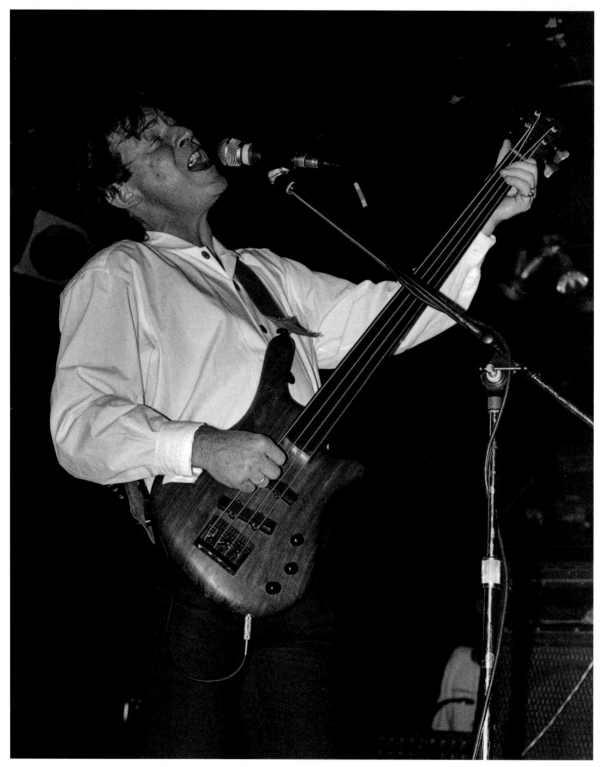

JACK BRUCE | OCTOBER 5, 1988

BUCKWHEAT ZYDECO | DECEMBER 5, 1988

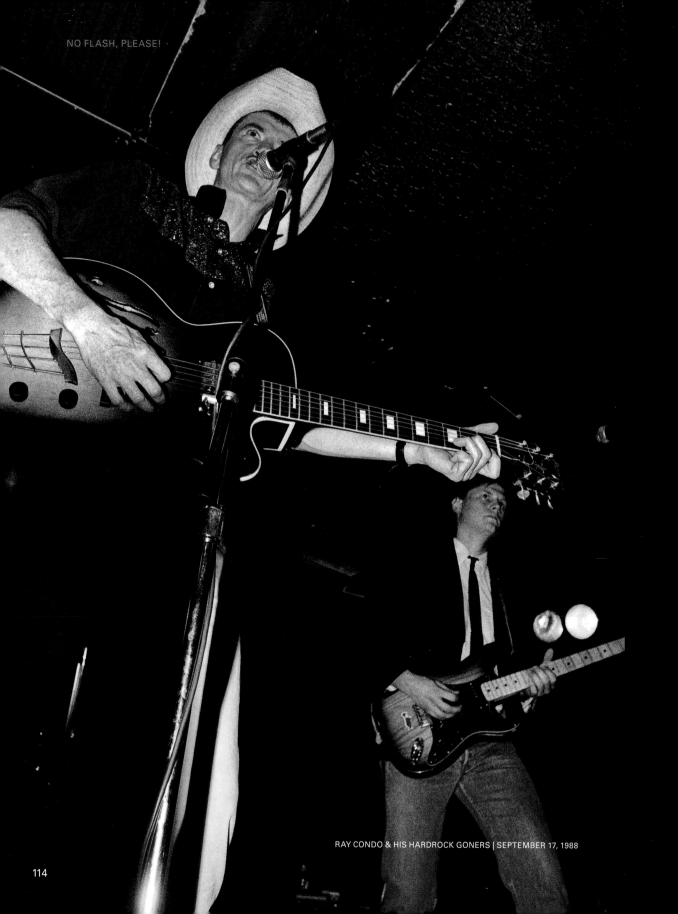

RAY CONDO & HIS HARDROCK GONERS | SEPTEMBER 17, 1988

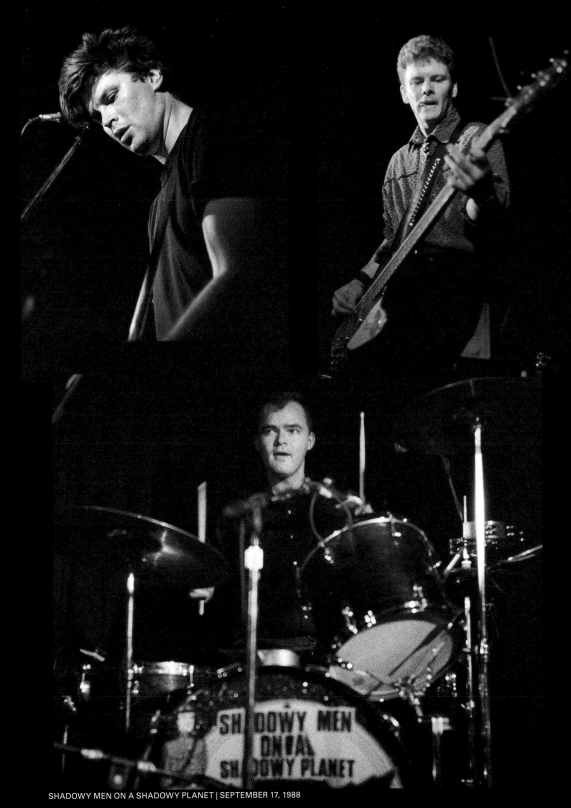

SHADOWY MEN ON A SHADOWY PLANET | SEPTEMBER 17, 1988

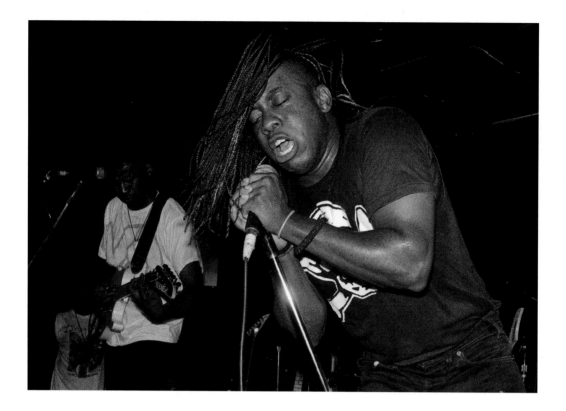

Vernon Reid, a well-regarded jazz rock guitarist who played with such luminaries as Ronald Shannon Jackson and Lester Bowie's son Joe's group, Defunkt, established **Living Colour** to prove a point: that an all-black band could play in what had been previously the domain of the white, blonde (dyed or not) boys. As did such bands as The Runaways, and Bad Brains before them, Living Colour re-presented something that could be broadly and commercially successful, or so the theory went, apart from inherent marginalizing by corporate interests. Academic and experimentalist writer and culture critic Greg Tate (*The Village Voice, Downbeat*) and Reid branded their philosophy the ostentatious Black Rock Coalition, doing regular gigs at CBGB's and Irving Plaza, with a mix of black artists across genres.

Invited to play with The Rolling Stones, and later at Jane's Addiction's debut Lollapalooza Festival, Living Colour seemed to be doing it right. Their blend of R&B and hard (daresay metal) rock style, mostly drowned out by vocalist Corey Glover's soul acrobatics, never really allowed them to escape the marginal presence of the groups they were emulating through their failed subcultural revolution. But Reid's experiment continues to get referenced in the same breath as De La Soul, A Tribe Called Quest, The Beatnigs, The Disposable Heroes of Hiphoprisy, Spearhead, Body Count, Fishbone and others who tried to reclaim rock culture through the African American experience. It is no accident that a whole spectrum of new music emerged, recasting the narrow confines of the genre-exclusive ideas of accessible music produced and delivered by so-called black artists soon afterwards. In this way, Living Colour were pioneers.

above: LIVING COLOUR | SEPTEMBER 21, 1988 *right:* ROCKTOPUS | SEPTEMBER 22, 1988

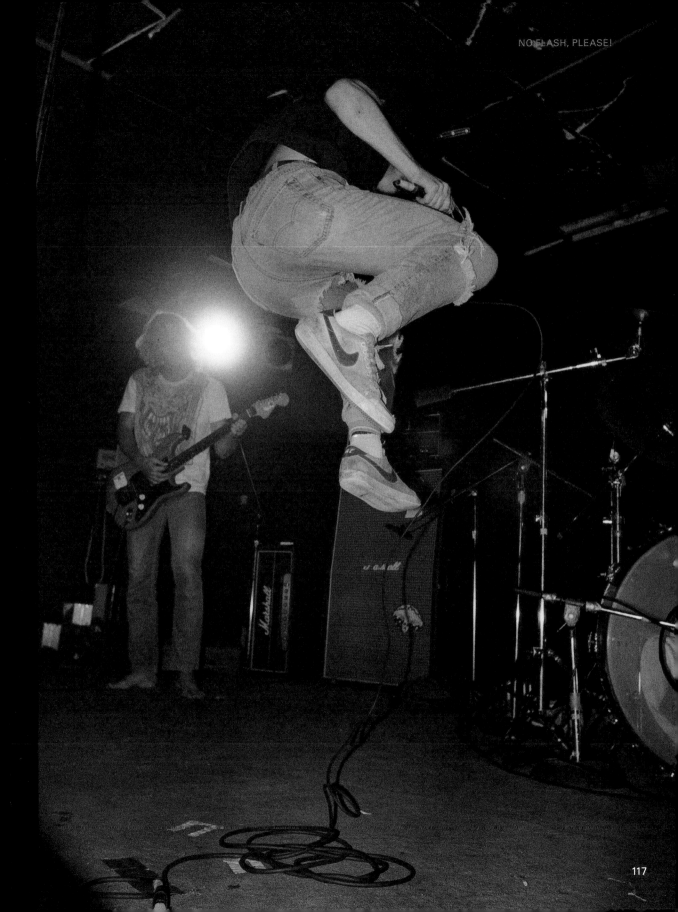

NOMIND | SEPTEMBER 22, 1988 Dave Walsh, guitar; Alisdair Jones, bass; Scott Tremaine, vocals; Paul Newman, drums

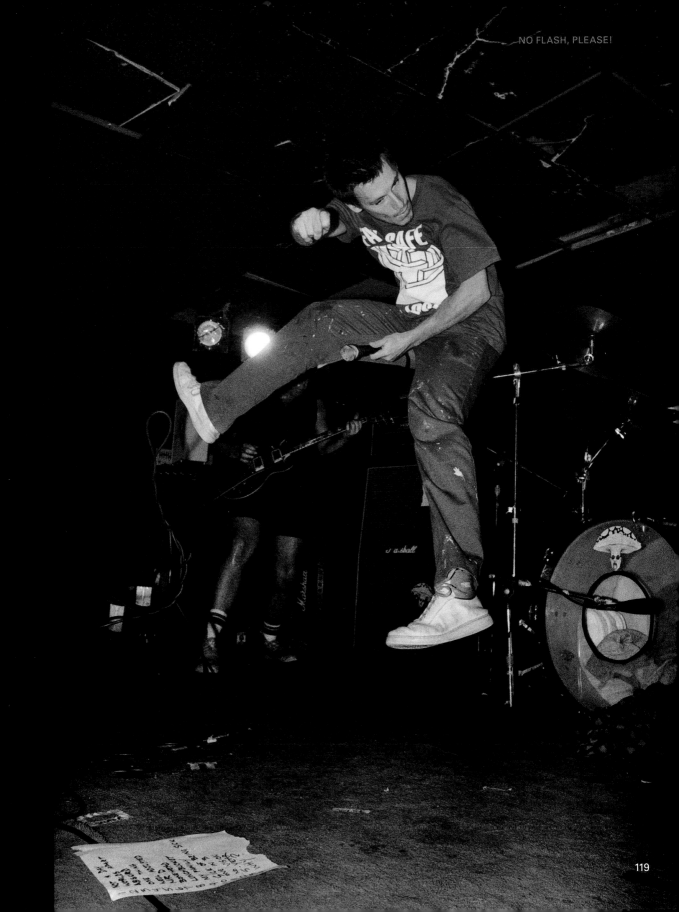

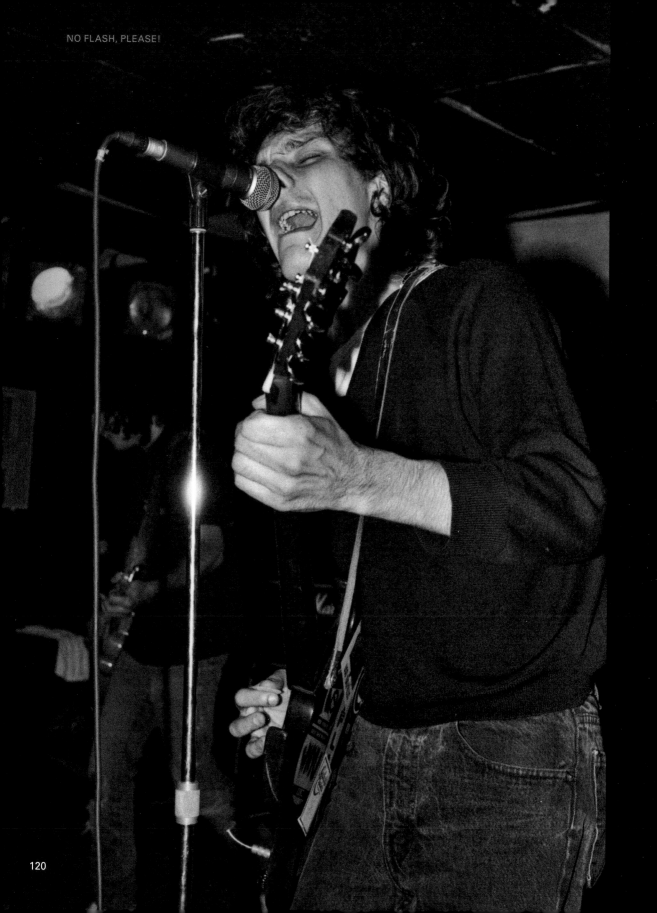

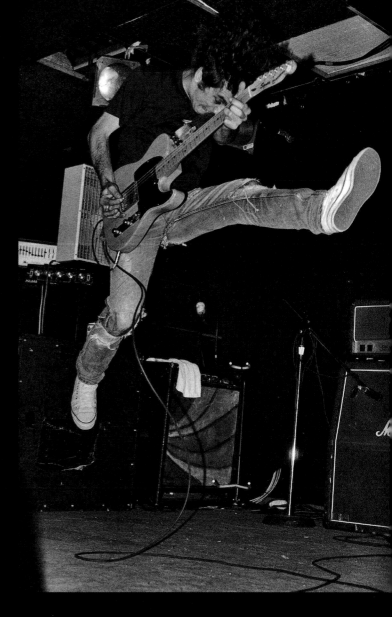

Punk becomes pop

It has been widely acknowledged that what is often called punk in the UK lasted about one hundred days. Once a trend was identified and, in particular, money was made, it all changed. Nonetheless, the idea that nothing was happening in punk rock until 1976 is not only naïve but also unhealthily historicist. Punk rock was more about attitude than music, though certainly the music often fuelled the rebellion. The fact remains that audiences drove the music, and the musicians making it recognized the power of a good song. So it was inevitable that in the early eighties, certain sounds began to emerge that were, for lack of another descriptor, poppy. By the mideighties, a long line of so-called post-punk bands, inspired by groups like The Real Kids, The Only Ones, Television, Stiff Little Fingers, Elvis Costello, the Ruts and, of course, The Clash emerged. The most striking contribution came by way of Montreal's The Nils, a band that to this day is seen as among the most important to encourage a more tuneful approach to punk. Reissues and reunited versions of the band continue, but it was its first release, *The Nils*, that remains a perfect merging of punk and pop that inspired such successors as All, the Doughboys, Big Drill Car, Mr. T Experience, Rocktopus and a whole host of bands that were soon being called emo-core, referencing their punk hard-core roots with emotional song writing.

Alex Soria *(left)* & Carlos Soria *(above)* of THE NILS | SEPTEMBER 29, 1988

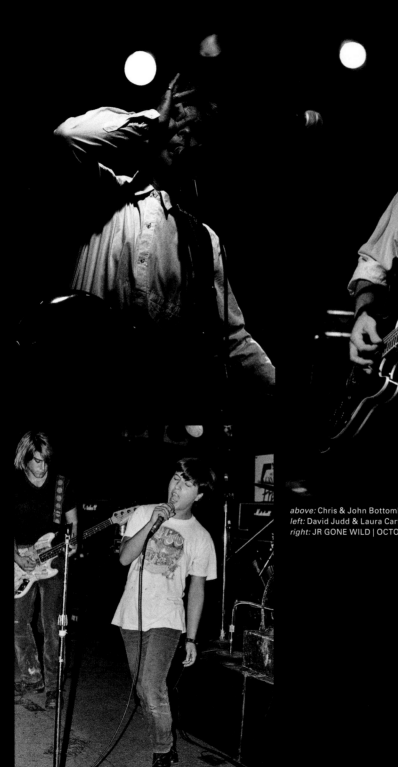
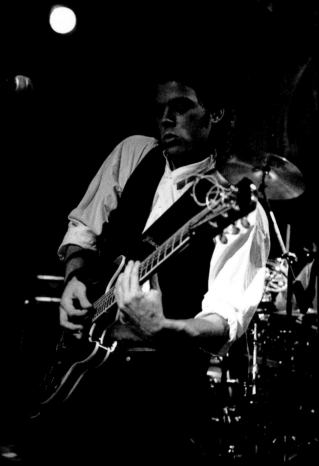

above: Chris & John Bottomley of TULPA | SEPTEMBER 28, 1988
left: David Judd & Laura Carter of the BAR-B-Q KILLERS | SEPTEMBER 28, 1988
right: JR GONE WILD | OCTOBER 1, 1988

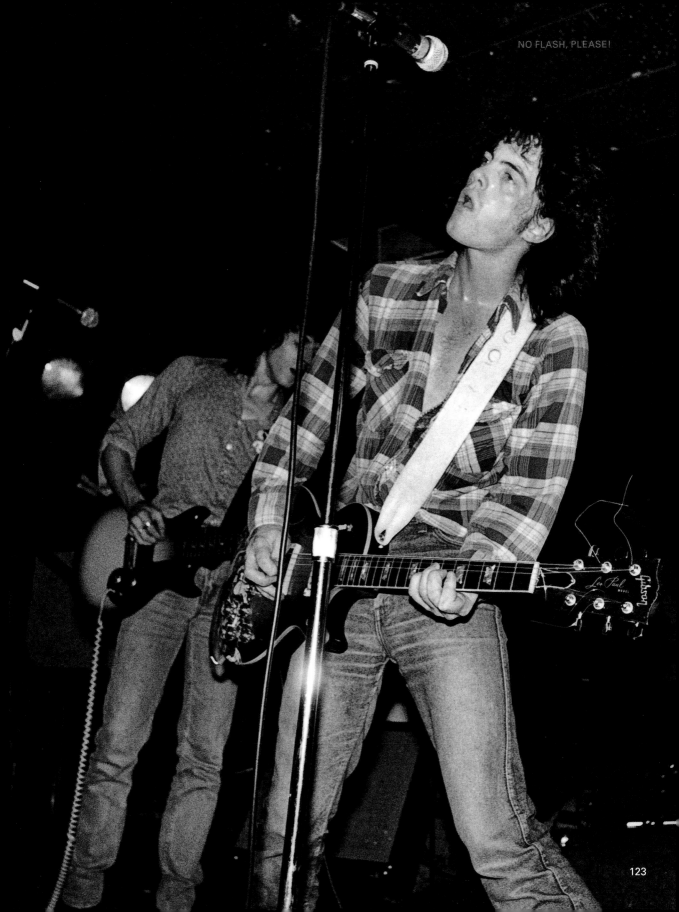

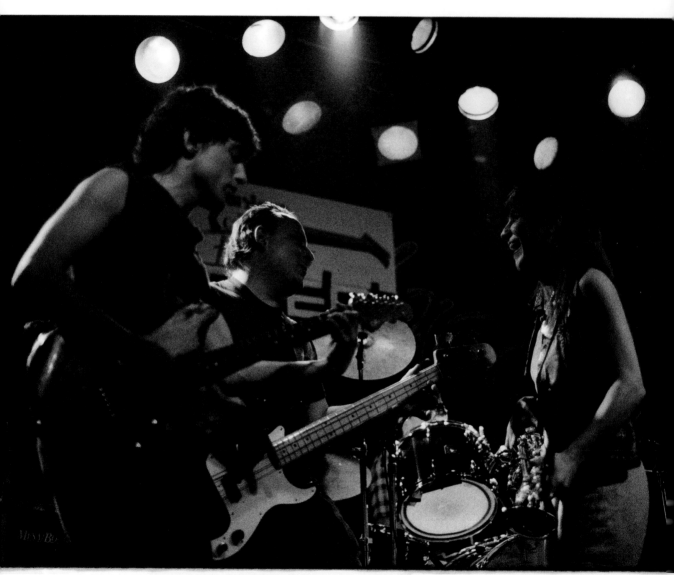

above & right: SUFFER MACHINE | SEPTEMBER 29, 1988

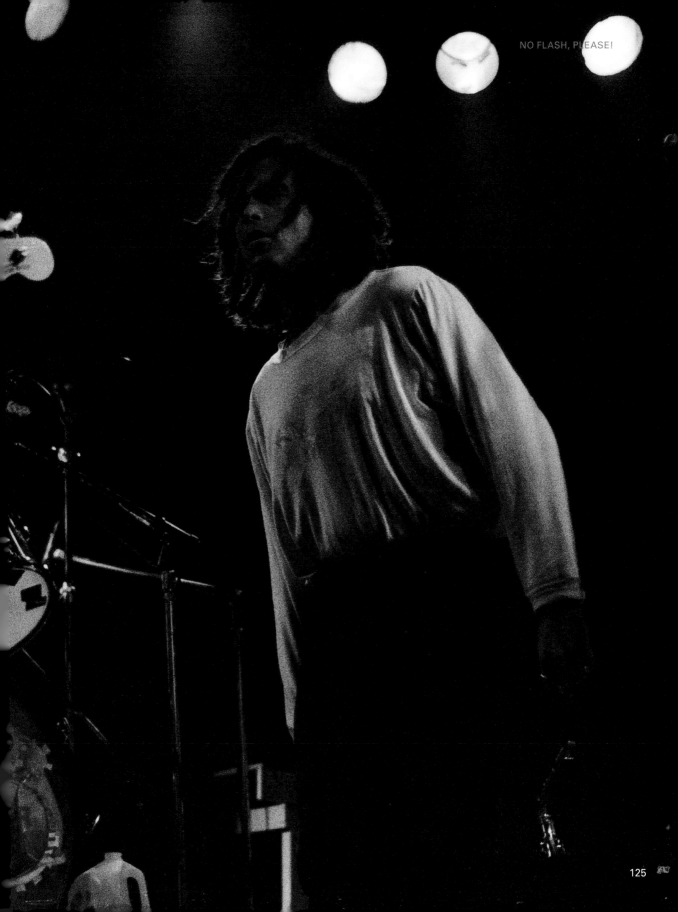

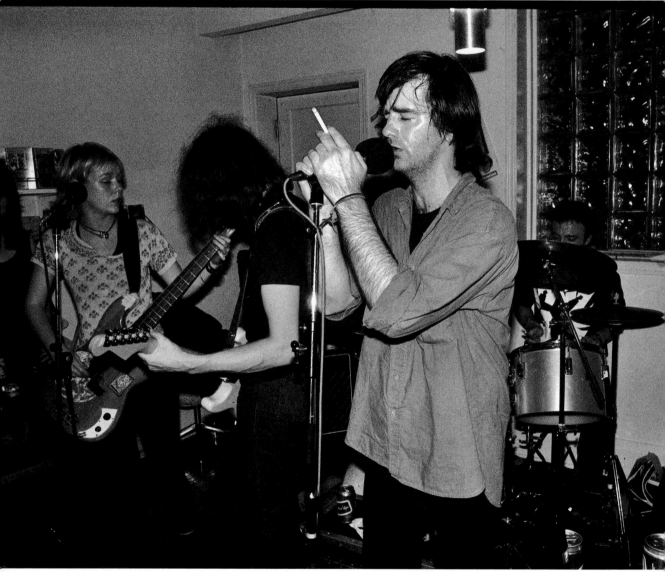

above: VARIS TOMBLEY | OCTOBER 1, 1988
right: Kevan Byrne of HEIMLICH MANEUVER | SEPTEMBER 20, 1988

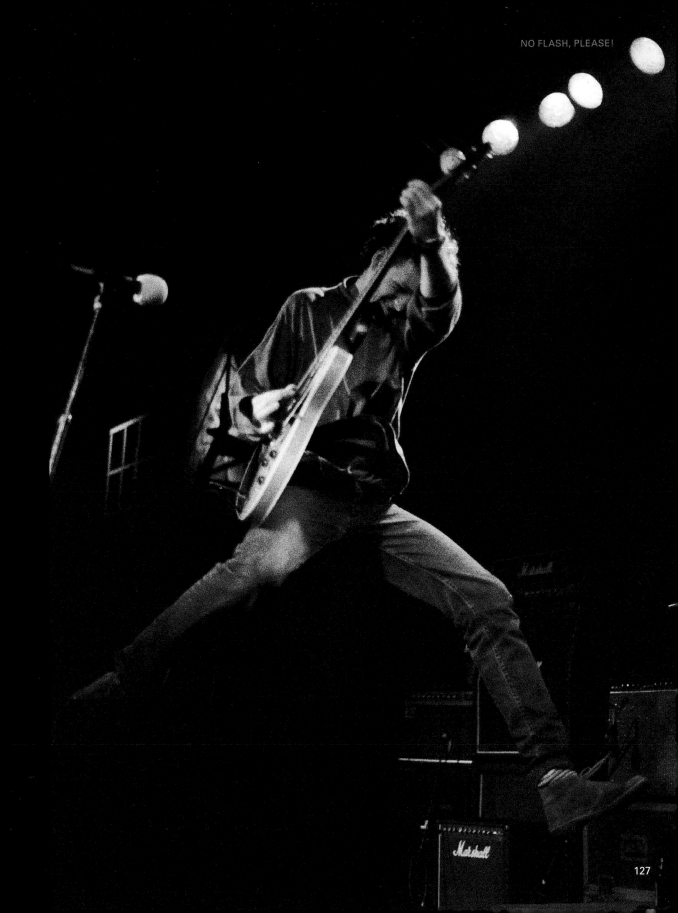

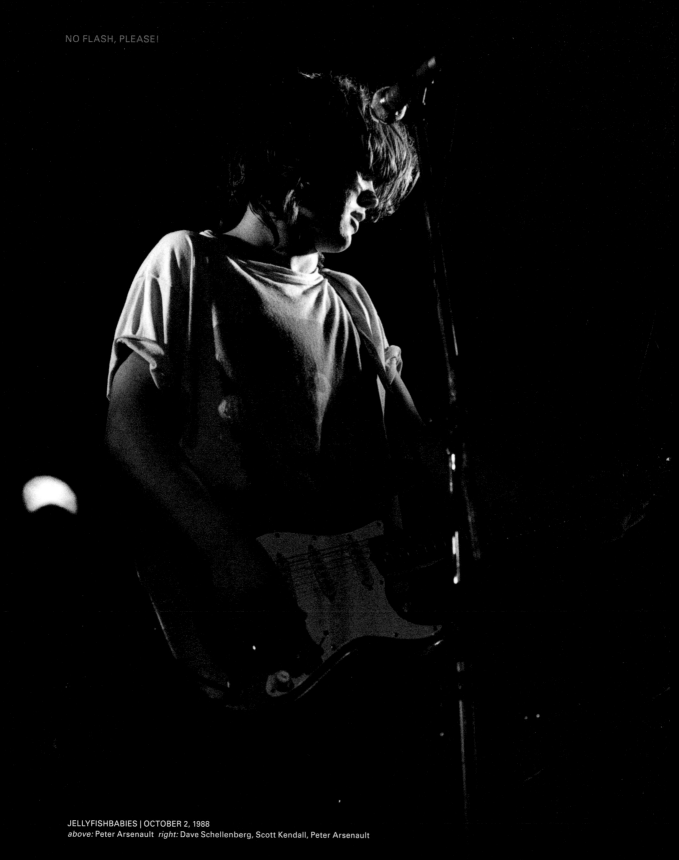

JELLYFISHBABIES | OCTOBER 2, 1988
above: Peter Arsenault *right:* Dave Schellenberg, Scott Kendall, Peter Arsenault

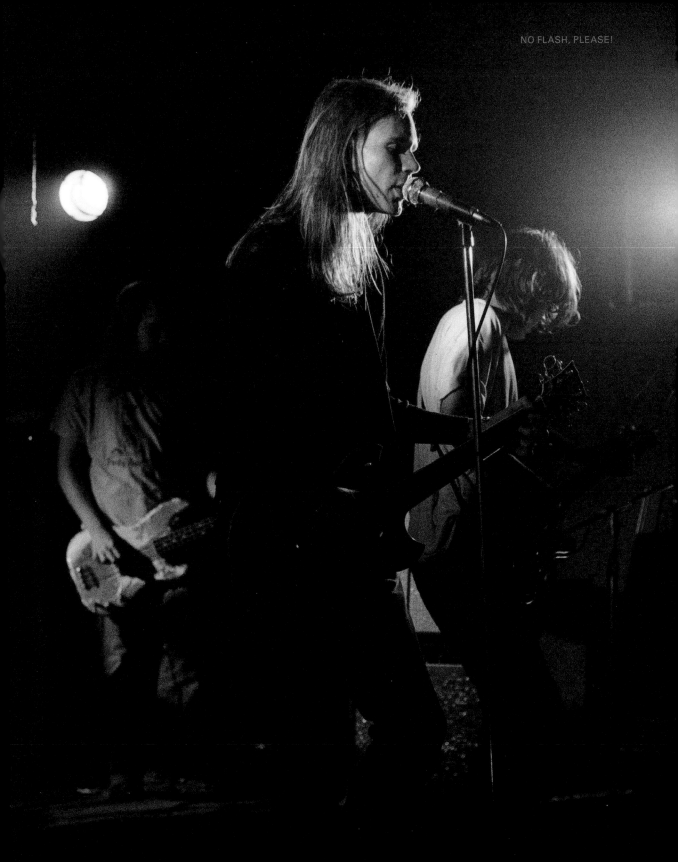

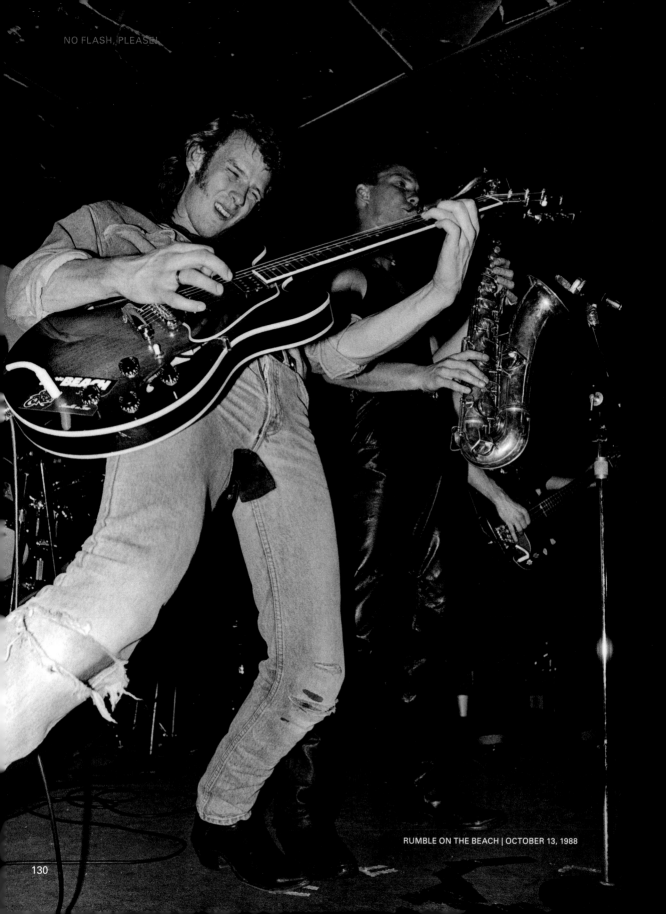

RUMBLE ON THE BEACH | OCTOBER 13, 1988

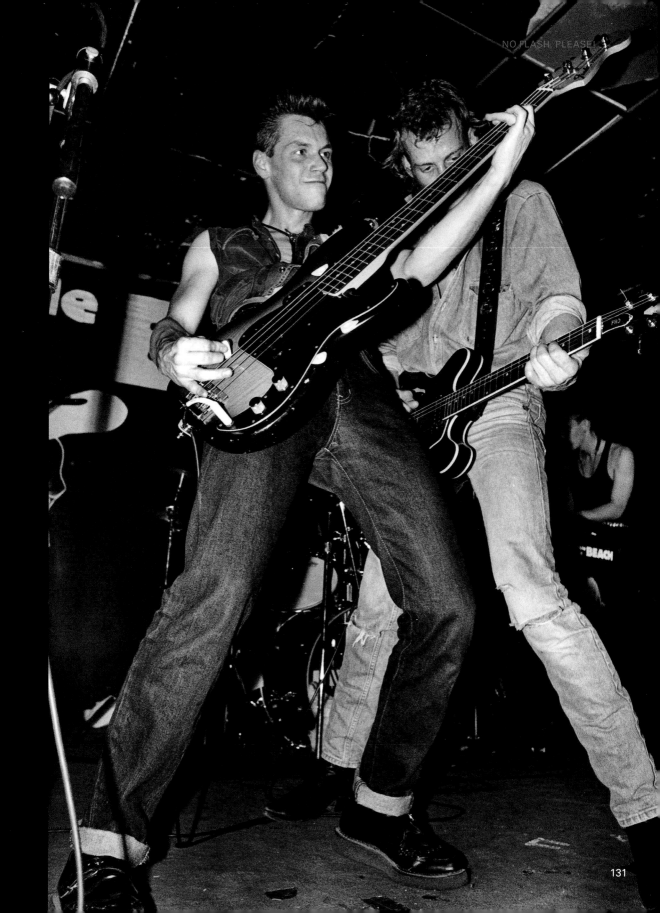

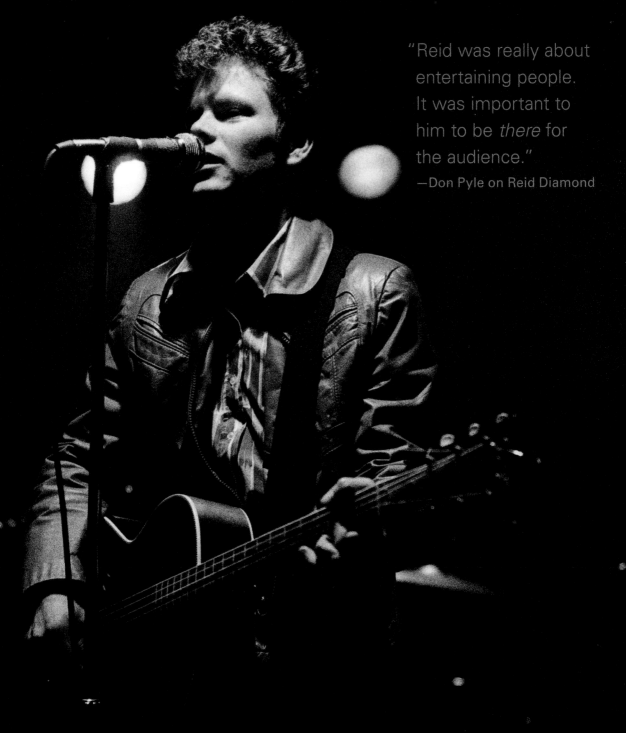

"Reid was really about
entertaining people.
It was important to
him to be *there* for
the audience."

—Don Pyle on Reid Diamond

REID DOES NEIL | OCTOBER 14, 1988
Reid Diamond, bassist in Shadowy Men on a Shadowy Planet in his Neil Diamond persona.

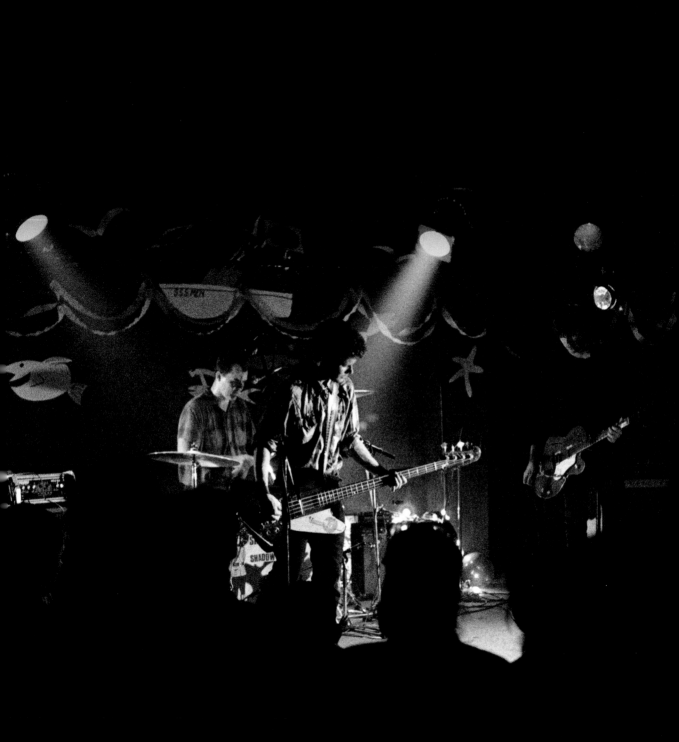

SHADOWY MEN ON A SHADOWY PLANET | OCTOBER 14, 1988

Sprouting from earth plowed by The Velvet Underground, **Sonic Youth** is among the most iconic and seminal groups to come out of the New York Underground in the mideighties. With a unique creative blend of post-industrial, postmodern, art and film, founders Thurston Moore and Kim Gordon forged an approach to music that was epic, punk, atonal and orchestral, all at the same time. Their early releases were a blend of experimentation and angst-driven punk songwriting. But instead of embracing the primal three-chord structures, guitarist Lee Ranaldo's love of the psychedelic music of the sixties and seventies coupled with Moore's love of atonality and penchant for "hot rodding" instruments to get truly unique sounds for each and every song, they carved out a completely different road, drawing on the work of modern composers and orchestral artists like Glenn Branca, Rhys Chatham, John Cage and Pauline Oliveros. What emerged was a completely unique blend of punk aesthetic with innovative chord structures and a music that went from large, sweeping feedback symphonies to brooding feminist chants, to bubblegum, to Ramones-like anthems.

Somewhat misunderstood in America, Sonic Youth found its largest and most engaged audiences in Europe. In fact, when Sonic Youth toured Europe in 1991, taking Nirvana with them, it was argued that Sonic Youth's sanctification of Nirvana played a big part in intro-

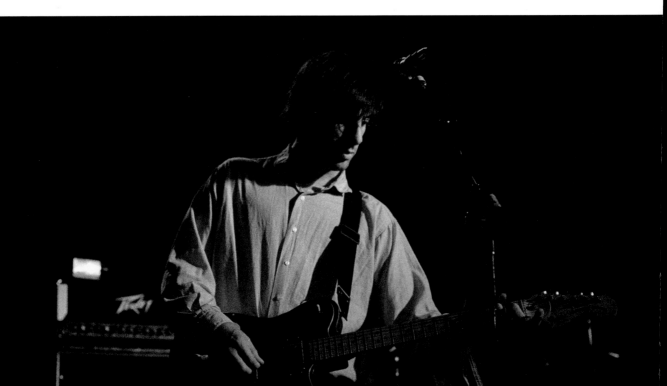

ducing them to international audiences. It was rumoured at the time that Thurston Moore was a de-facto A&R man for David Geffen Company Records (DGC). DGC had signed Sonic Youth in the late eighties, and Moore was reputed to have been the catalyst for the subsequent signing of not only Nirvana, but also Urge Overkill and Teenage Fanclub. He was even said to have created a buzz around Canada's Sloan when he saw them perform the first time in New York, thereby earning them DGC attention.

When listening to Sonic Youth perform, you experience a sense of chaos and discord married to naïve melodies, but when you get closer to the music, you start to realize that every song is actually deliberately and meticulously structured and composed. Sonic Youth's approach to music is akin to the great jazz bands of the fifties and sixties. Despite allowance for improvisation, the forms that they create are polished and refined. What you hear when you listen to Sonic Youth is controlled, sublime bliss turned into middle-class angst: a perfect soundtrack for the end of the world, or in the case of the 1990s, the end of the century.

SONIC YOUTH | NOVEMBER 3, 1988 | DIAMOND CLUB
L-R: Lee Ranaldo, Kim Gordon, Thurston Moore

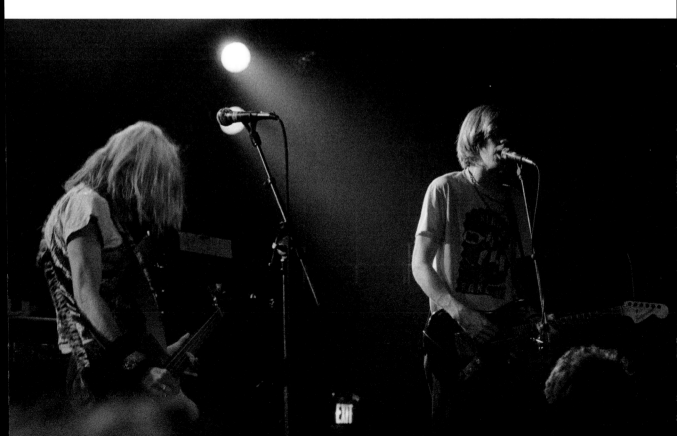

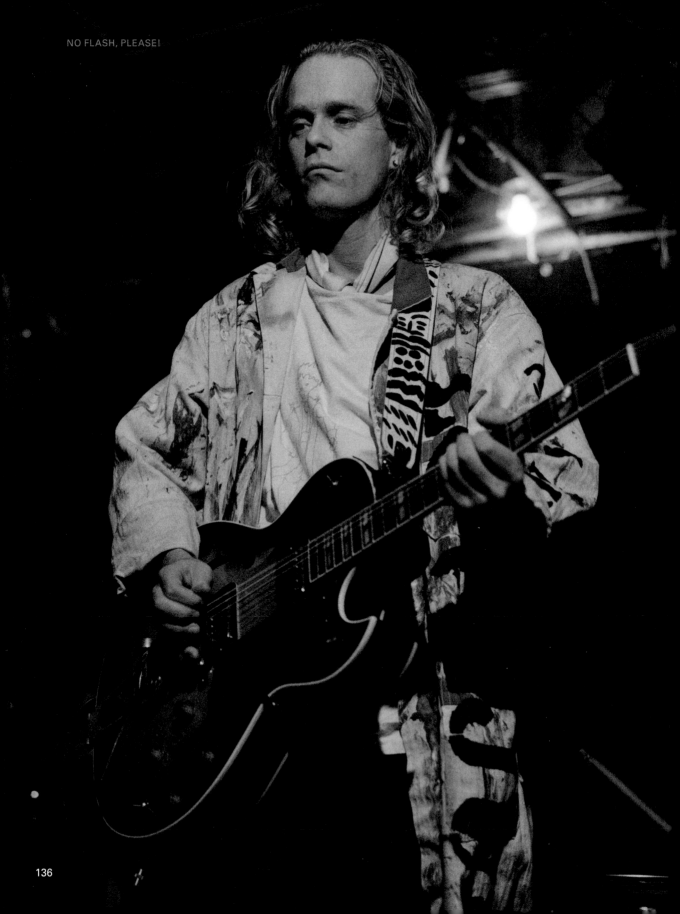

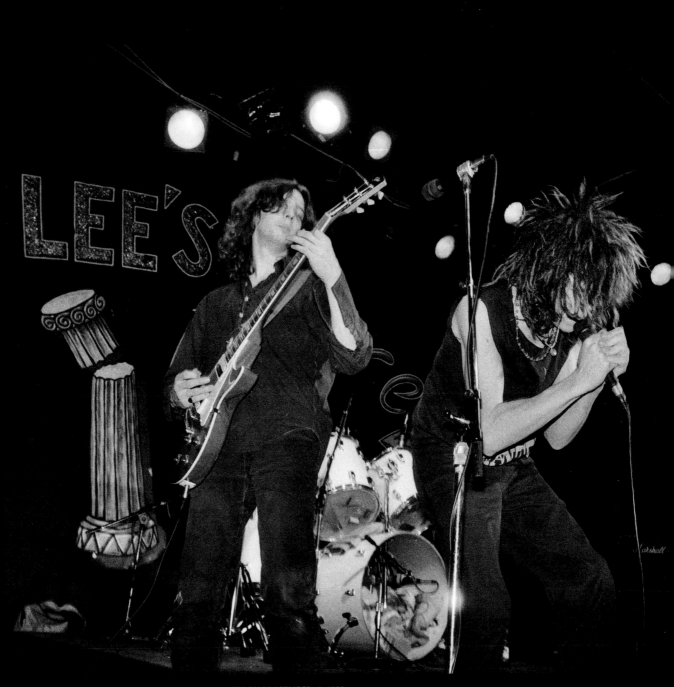

left: James Newton of SONS OF FREEDOM | DECEMBER 13, 1988
above: William New of THE GROUND | NOVEMBER 28, 1988

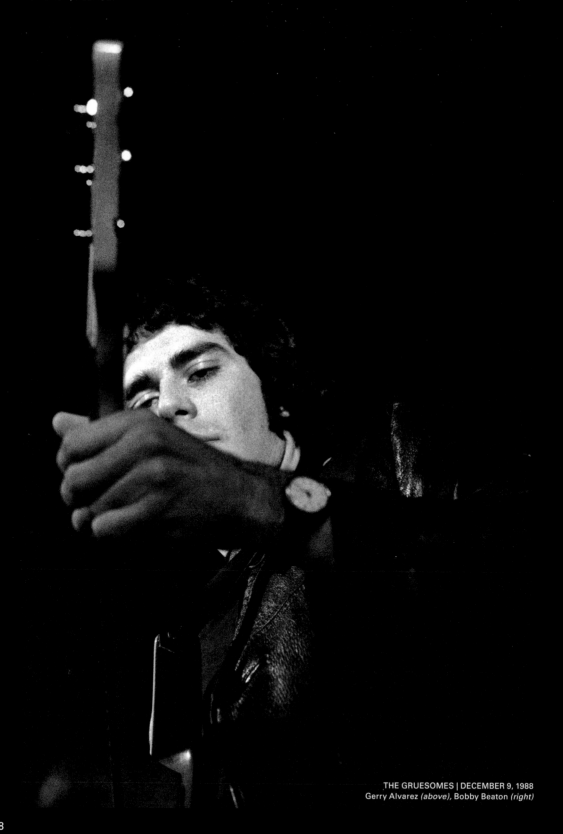

THE GRUESOMES | DECEMBER 9, 1988
Gerry Alvarez *(above)*, Bobby Beaton *(right)*

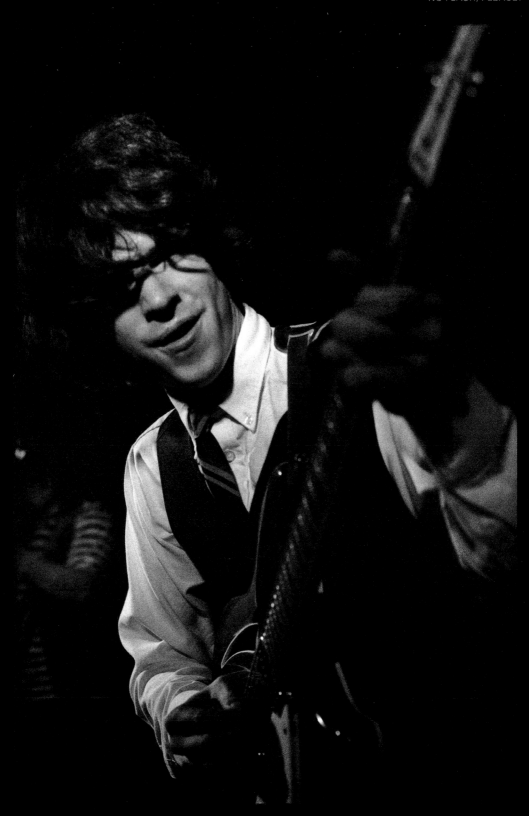

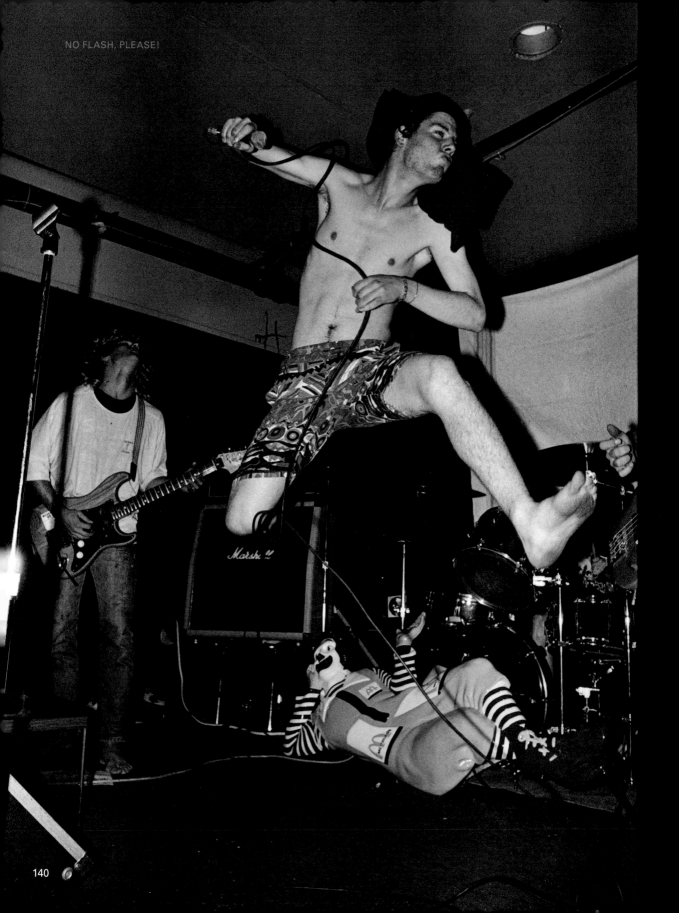

ROCKTOPUS | OCTOBER 22, 1988
On stage performance and backstage shenanigans.

A clique of young, flamboyant musicians began to emerge in the late eighties inspired not just by punk, but also excessive hard rock associated with groups like KISS, Cheap Trick and Mötley Crüe. One of the most talked about bands of the time, Circus Lupus, founded by guitarist and singer Jonathan Cummins who would go on to join Montreal's Doughboys around 1987, left singer Simon Nixon, bassist Bruce Gordon, drummer Cam and his brother guitarist Brad Maclean, to form **Rocktopus**.

Seemingly uninterested in much more than playing live with relentless self-deprecating humour, they developed a mixture of seventies glam with the pop-punk sound that was reflecting a larger trend of the time. Other similarly nurtured bands that emerged during this period include Sons of Ishmael, Triggerhappy, Beyond, Punchbuggy (Ottawa), Guilt Parade, Sing Along with Tonto, No Mind, Nothing in Particular, Rise (Montreal) and Hype.

Soon after releasing their EP *Sleestak Attack* on indie promoter/producer/manager Jill Heath's Lone Wolf Records, the band broke up, leaving bassist Gordon to be recruited by up and coming corporate rockers I Mother Earth.

But Rocktopus were unique both in their explosive talent and their humorous, almost campy demeanour. Cam Maclean's hippy sensibility, drawn from a love of psychedelic rock bands of the late sixties and early seventies, Bruce Gordon's jazz leanings and funk technique, Simon Nixon's *aw shucks* clumsiness and Brad Maclean's quiet almost studious approach made them a local favourite with a solid group of fans and followers.

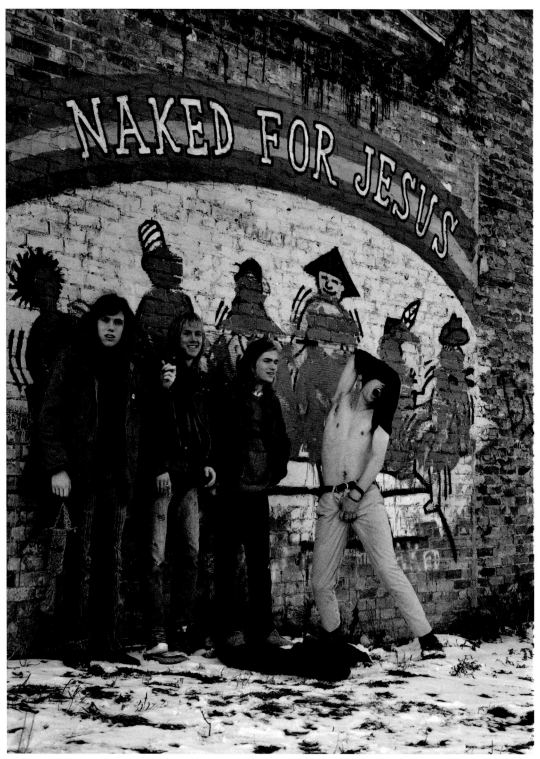

ROCKTOPUS | DECEMBER 9, 1988 (L-R) Cam MacLean, Brad MacLean, Bruce Gordon & Simon Nixon

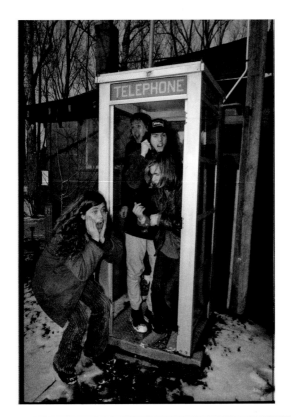

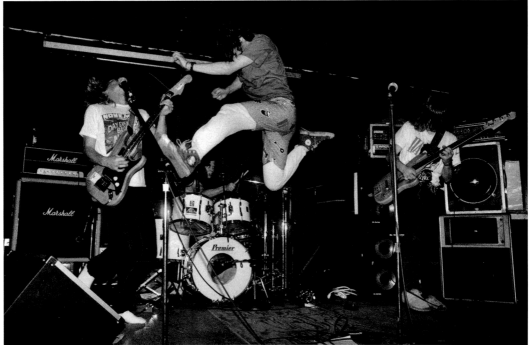

ROCKTOPUS | JANUARY 6, 1989

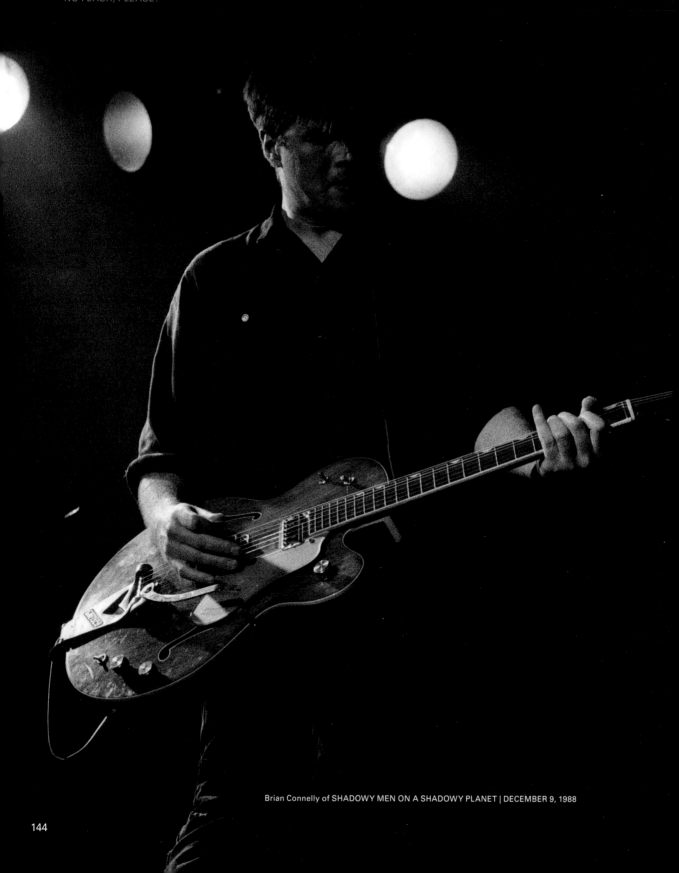

Brian Connelly of SHADOWY MEN ON A SHADOWY PLANET | DECEMBER 9, 1988

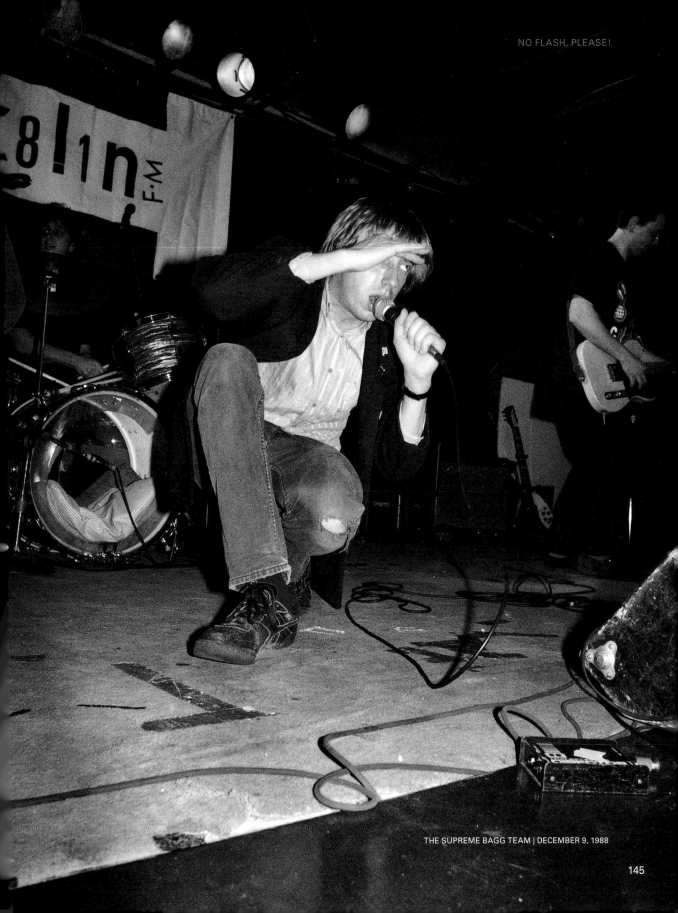

THE SUPREME BAGG TEAM | DECEMBER 9, 1988

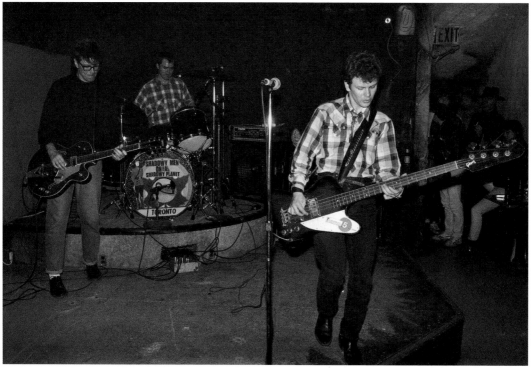

SHADOWY MEN ON A SHADOWY PLANET | JANUARY 14, 1989

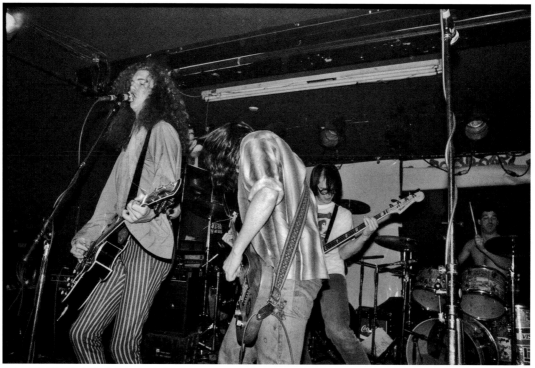

BIG DADDY CUMBUCKETS | FEBRUARY 10, 1989

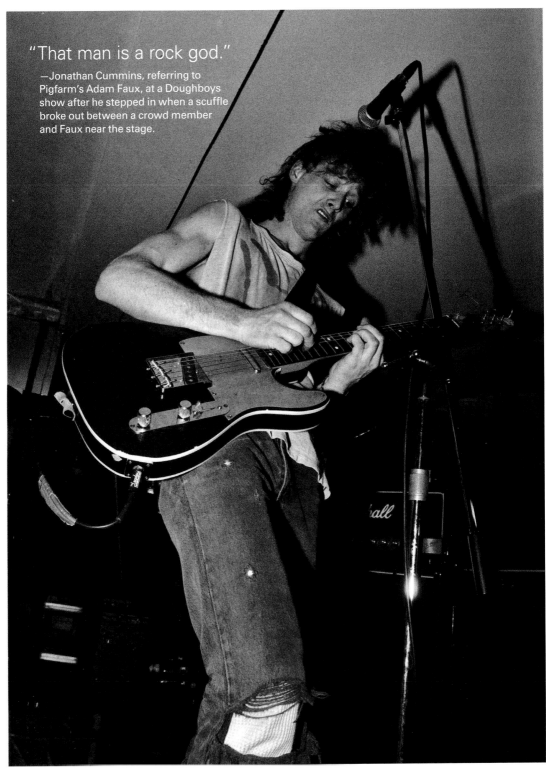

"That man is a rock god."

—Jonathan Cummins, referring to
Pigfarm's Adam Faux, at a Doughboys
show after he stepped in when a scuffle
broke out between a crowd member
and Faux near the stage.

Adam Faux of PIGFARM | MARCH 18, 1989

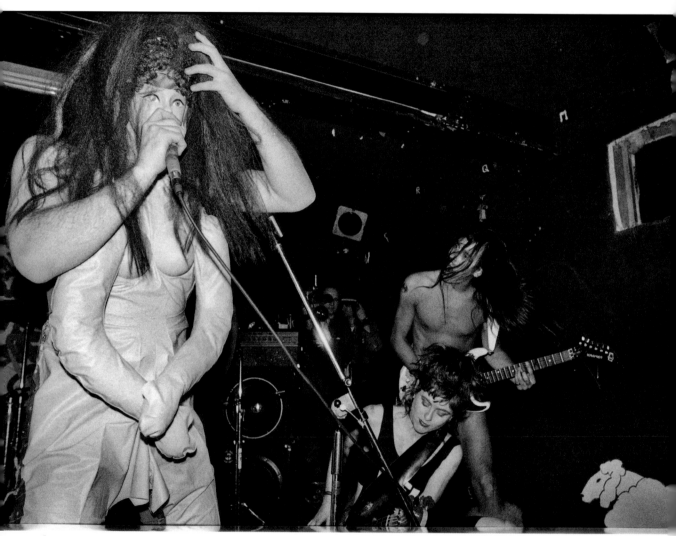

MY DOG POPPER | FEBRUARY 10, 1989

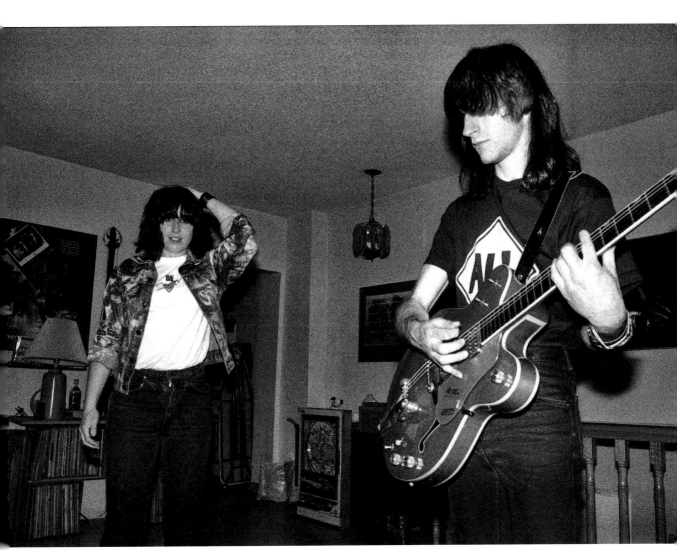

LOUISE & DAVE KINER | MAY 23, 1988

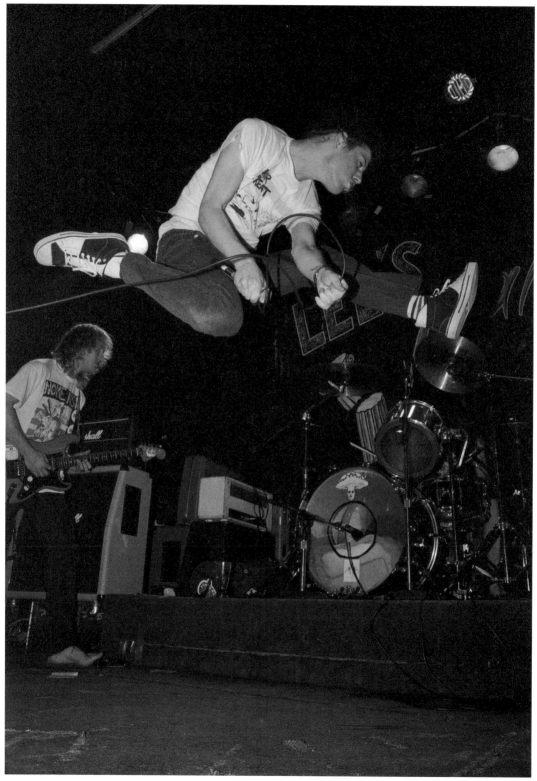

ROCKTOPUS | MARCH 3, 1989 *above:* Brad MacLean & Simon Nixon; *right:* Bruce Gordon

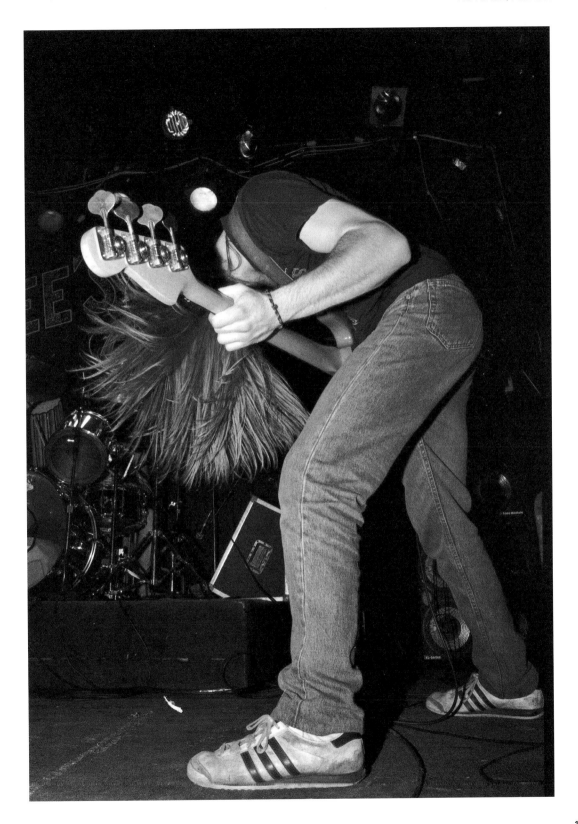

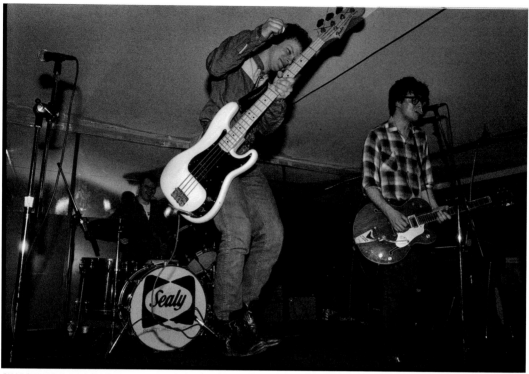

SHADOWY MEN ON A SHADOWY PLANET | MARCH 18, 1989

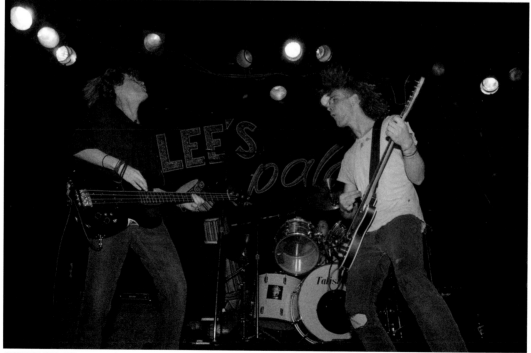

PIGFARM | MARCH 25, 1989 (L-R) John Deslaurier, Leslie Becker & Adam Faux

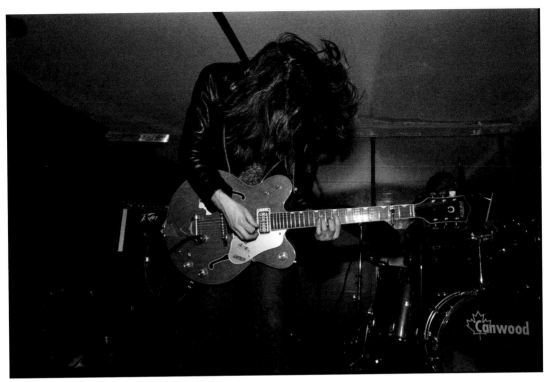

Dave Kiner of JOHN DRAKE ESCAPES | APRIL 4, 1989

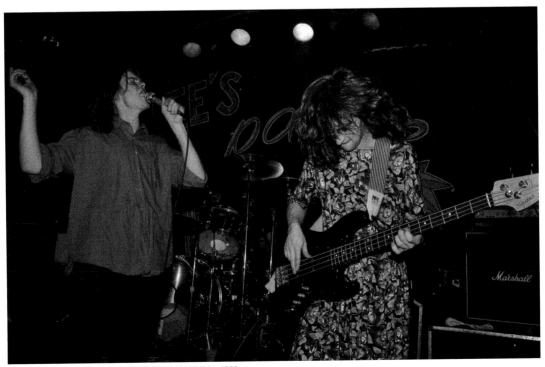

Ian Blurton & Alisdair Jones in SUPERFLY | MARCH 31, 1989

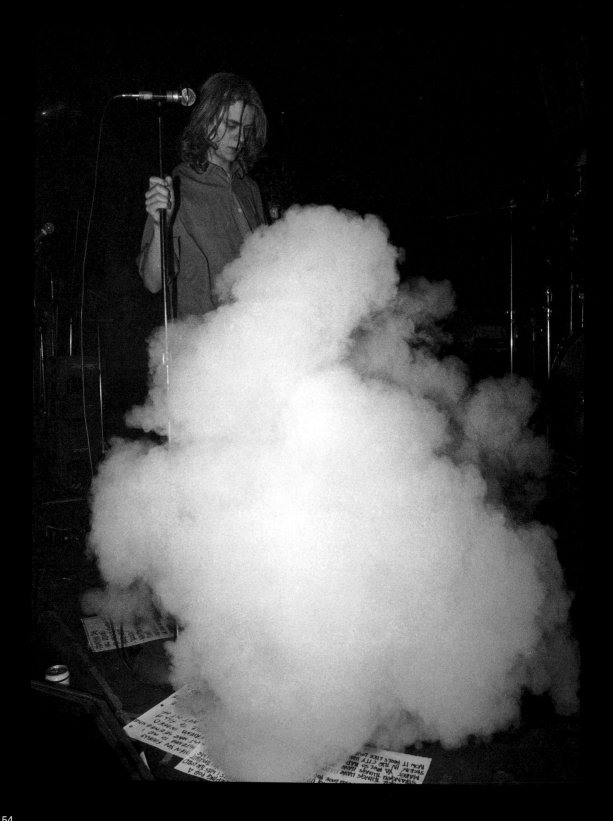

"King of Rock" is how the cover of Toronto's entertainment weekly *Eye* trumpeted the ascension of **Ian Blurton** to the throne of Queen Street West in 1999, when he dissolved his band Change of Heart and released a solo project entitled *Adventures in The Kingdom of Blurtonia*. But Blurton's trajectory was far from regal. Born in Champaign, Illinois, he arrived on the Toronto scene as a teenager and in 1982 fronted a band called Change of Heart at the Beverley Tavern, after having spent time as drummer in A Neon Rome. The journey for Blurton and his bandmates would go on for fifteen years before enshrining him as one of the most formidable musicians to come along in Toronto's burgeoning scene. Today you will find Blurton fronting Public Animal, after having led a band called C'mon for several years. But a recently remixed and reissued compilation of songs by Change of Heart (including those from two striking releases on Virgin Records in 1994 and 1997 during the heyday of alternative music) uncovers an array of complex songwriting and often progressive and forthrightly unfashionable music that holds up as some of the best of the era. Transitioning from introspective songs to full-throttle punk-rock anthems, Change of Heart's songs and Blurton's guitar playing remain the most significant of this period. Blurton didn't limit his talents to just one band, playing lead guitar in a local supergroup called Scott B. Sympathy (which also featured Groovy Religion's Scott Bradshaw and The Lawn's Gordon Cumming) and goofing with bands like Big Daddy Cumbuckets, Thumpasaurus and other short-lived ensembles. Thus it was rare that you didn't see him on any given night, either viewing a show or playing one.

> "I absorbed anything I could during that time," Blurton recalls. "It wasn't enough to hear the records and play the music, but I had to experience it live, and my appetite was insatiable."
>
> —Ian Blurton

Blurton was incapable of pandering, and his work is like a lexicon of sounds emerging from a wide variety of places. Punk and post-punk bands such as The Minutemen, Gang of Four and The Clash were early inspirations, but you can barely smell those influences in Change of Heart, until its debut on Virgin Records in 1994, which clearly cites sonic references ranging from The Who, Rush and The Jesus Lizard in its sonic assault. Although remixed versions of earlier material reveals a complexity and maturity unmatched during this age of the musicians, *Steelteeth* and its predecessor *Tummysuckle* remain the strongest releases put out by any Toronto band from this period. As such, Change of Heart and Blurton himself are a paradigm for understanding the diversity and strength of a relatively unfettered musical community during one of its most fertile and interesting periods.

Furthermore, Blurton's production work was an important contribution to the history of indie rock, not least of which are three releases by The Weakerthans. Today Blurton's ears are frequently sought in production and sound engineering. Largely self-taught, Blurton's appetite for sound has become his most valued contribution to new music in the twenty-first century. Having turned fifty at the end of 2015, Blurton remains a must-see performer whose innovation and skill continue to be unmatched and treasured by fans and musicians alike.

Ian Blurton in SUPERFLY | MARCH 31, 1989

Dinosaur Jr. is probably the most interesting success story of the indie rock of the late eighties and early nineties. Although they recorded and released an album on Homestead Records and were essentially canonized by (Matador Records founder) Gerard Cosloy and his minions (college radio stations on the U.S. east coast), it was their release *You're Living All over Me*, via SST, their LA-based label, that really made people sit up and take notice. It was like taking Led Zeppelin, Black Sabbath and Neil Young and recording their music on a four-track recorder, then mastering it through a transistor radio and releasing it on CD. There was something absolutely pure about what J. Mascis, Murph and Lou Barlow were up to.

Dinosaur Jr. first opened for Plan 9 from Outer Space at the Cameron House in Toronto, played for a larger crowd than the headliner (about 100 people) and were paid 100 bucks and a pizza. Their return engagement a year later at Lee's Palace as a headliner would no doubt be wildly successful. Dinosaur was, and continues to be, a force of nature and an anomaly in their unexplainable popularity. At the show pictured here, promoter Lefko oversold the show. It was estimated that Lee's Palace could hold around 500 to 600 people, but there were at least 750 tickets sold, and Lefko could be seen giving people their money back at the front door, having let too many people in while also selling the venue capacity in advanced tickets. This would not be the only time Lefko would be forced to do this. That same year, that same thing happened for Sonic Youth and the Pixies. This was symbolic of a time when the UK press, which dominated the Canadian music scene thanks to its higher-than-normal reliance on British imports, made these indie American bands their media darlings. So as magazines such as *Melody Maker, Sounds* and the venerable *New Musical Express* made their way to Toronto through the Record Peddler and Records on Wheels, the buzz became palpable and infectious. By August of 1991, Lou Barlow had left the band, and his equally legendary group Sebadoh became his main focus. Dinosaur Jr. played at Reading—the infamous bank-holiday event that was often a jumping-off point for many new bands, with venerable BBC

deejay John Peel playing records from the stage—on a bill that included Babes in Toyland, Nirvana, Sonic Youth and Iggy Pop. After a morning of typical soggy British weather, J. launched into a signature solo with his anthem, "Freak Scene." As the crowd sang along, an unexpected beam of light broke through the clouds and reflected off his Gibson guitar's gold glitter, sending a beam of light across the audience. It played like a sign from the heavens that something special was about to happen. Little did they know that Nirvana were about to hit the stage and effectively change the course of indie rock forever.

DINOSAUR JR | MARCH 31, 1989
below: The uncommon sight of a stagefront media scrim.

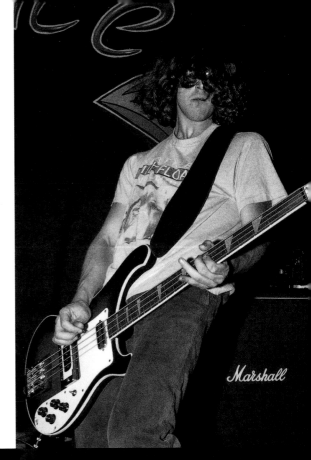

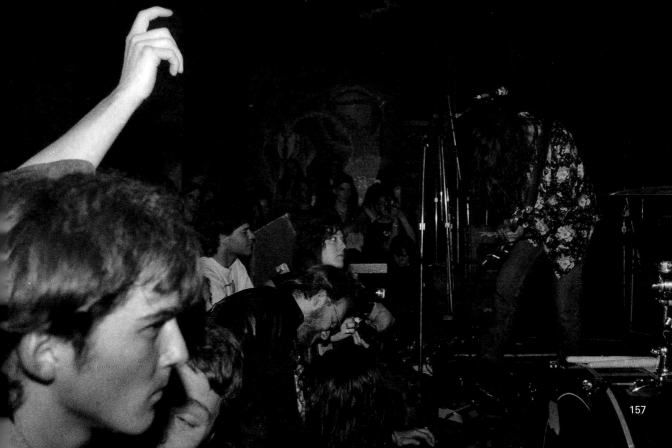

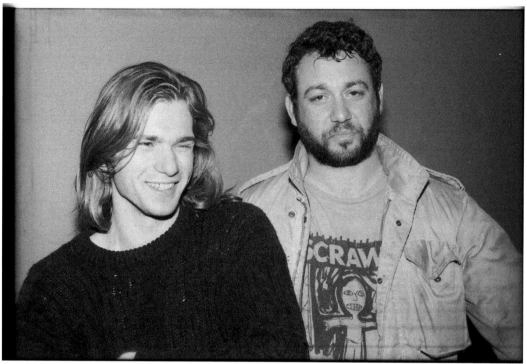

Bruce Gordon (ROCKTOPUS) & Mike Watt (fIREHOSE) | APRIL 25, 1989

SCRAWL | APRIL 25, 1989

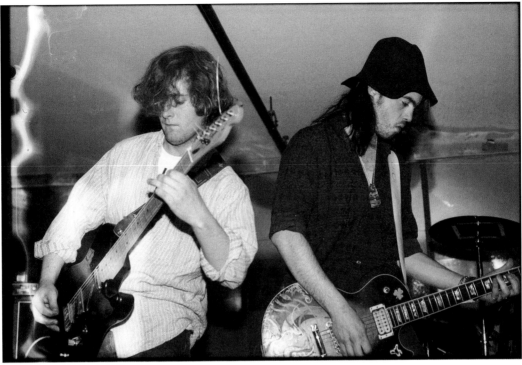

JR GONE WILD | APRIL 28, 1989

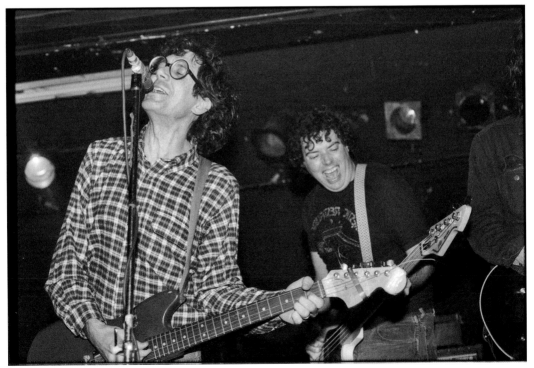

Jad Fair & John Sluggett of HALF JAPANESE | MAY 2, 1989

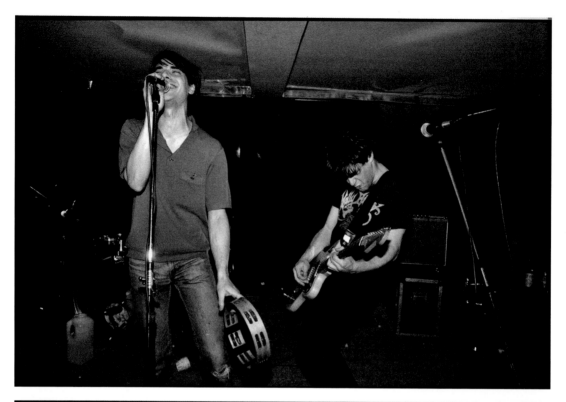

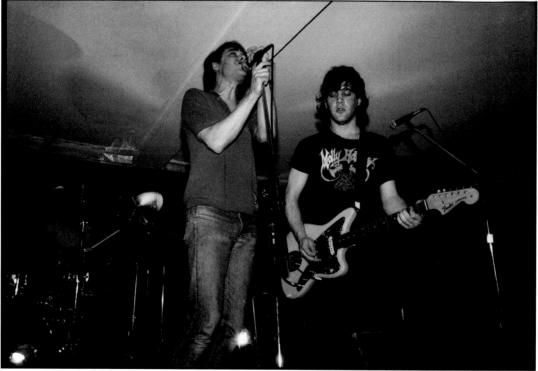

Mike Chandler & Mike Mariconda of THE RAUNCH HANDS | MAY 12, 1989

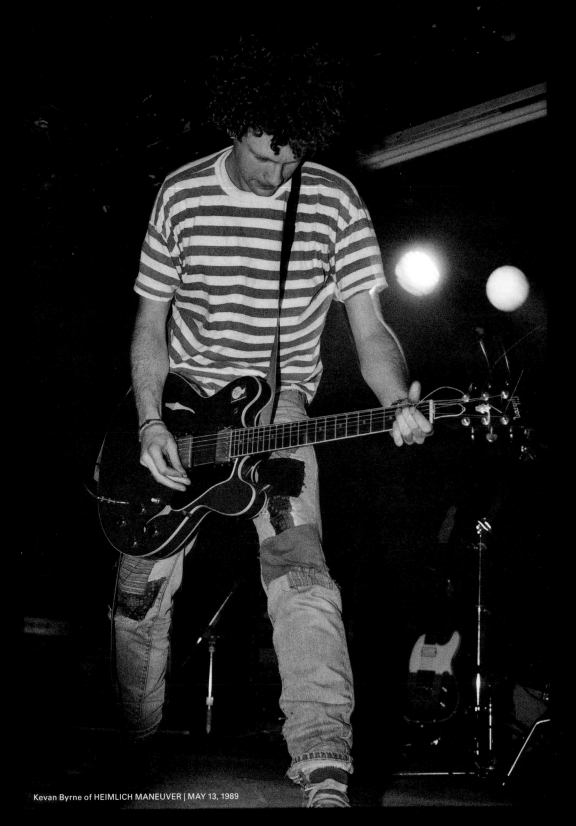

Kevan Byrne of HEIMLICH MANEUVER | MAY 13, 1989

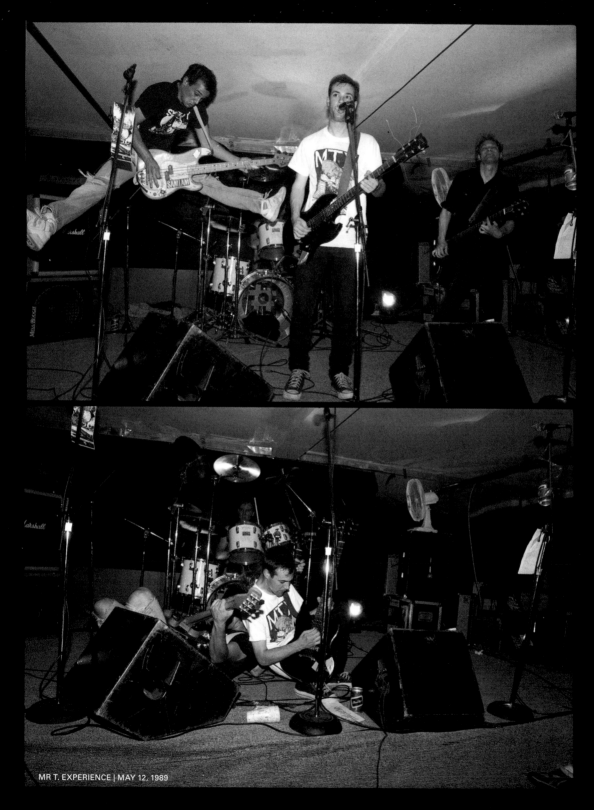

MR T. EXPERIENCE | MAY 12, 1989

Friends and live music aficionados Debra Lary (top, 1989) and Leslie Lane (above, 1990)

The presence of **Redd Kross** on the indie rock scene of the late eighties through the midnineties was in some respects peculiar. Was indie and punk rock a rejection of all the exploits and pomp of seventies' excess? Who were these guys in the androgynous polyester jumpsuits with long hair, prancing around while playing some bizarre mixture of power pop and punk? The fact remains that the McDonald brothers were among the most crucial cogs in the indie rock of the mideighties. Of course, to ensure credibility—something these boys never really needed—Steve also played in the spoof skate-punk band called Anarchy 6 and, more recently, bass in the punk granddaddies OFF! In retrospect, Redd Kross was, without a doubt, among the most important of the bands to emerge from California's schizophrenic punk scene. The style and songwriting they contributed is significant and lasting. The funny thing is, they were popular but they didn't sell as many records as perhaps their corporate masters would have liked, and thereby retained a kind of cult status. If you see them today, decades on, forthright, fierce and undeniably skilled musicians, it is hard to deny how Redd Kross profoundly impacted a generation called X. It quickly reminds you of the importance of the skillfully crafted songwriting that remains a staple of their sound and is arguably unmatched by bands that emerged from LA in the eighties. Furthermore, its style only sweetens the band's impact. As beacons for the latchkey generation weaned on *The Brady Bunch, The Partridge Family* and *Match Game,* who could resist the band members' honesty about their origins? Redd Kross was one of the most fun live bands to play in Toronto during this period, and the healthy crowds that came to see it were proof of the band's irresistible charisma.

REDD KROSS | MAY 19, 1989 *above:* Robert Hecker, *right:* Steve McDonald

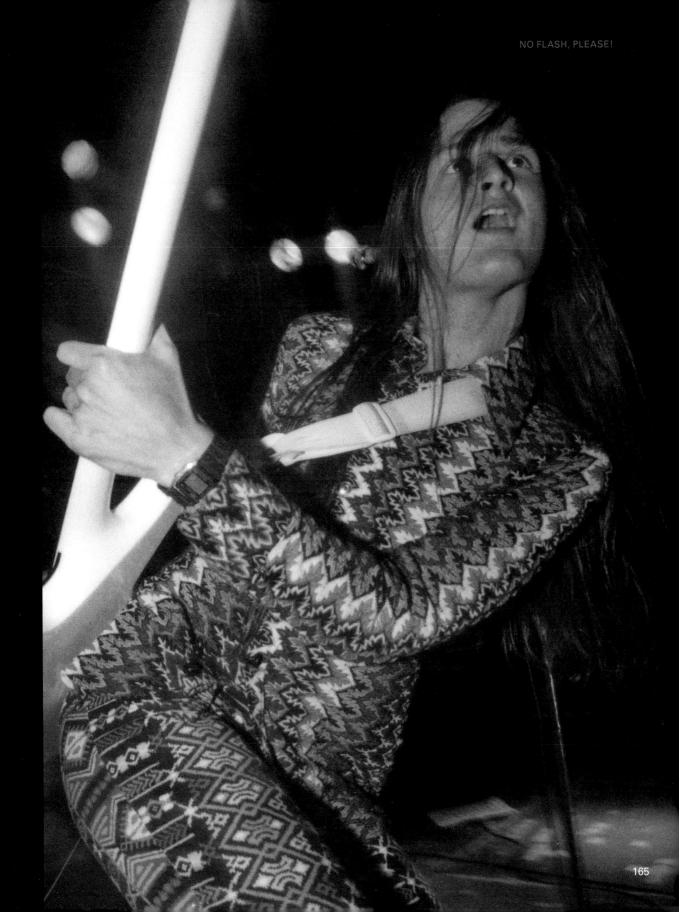

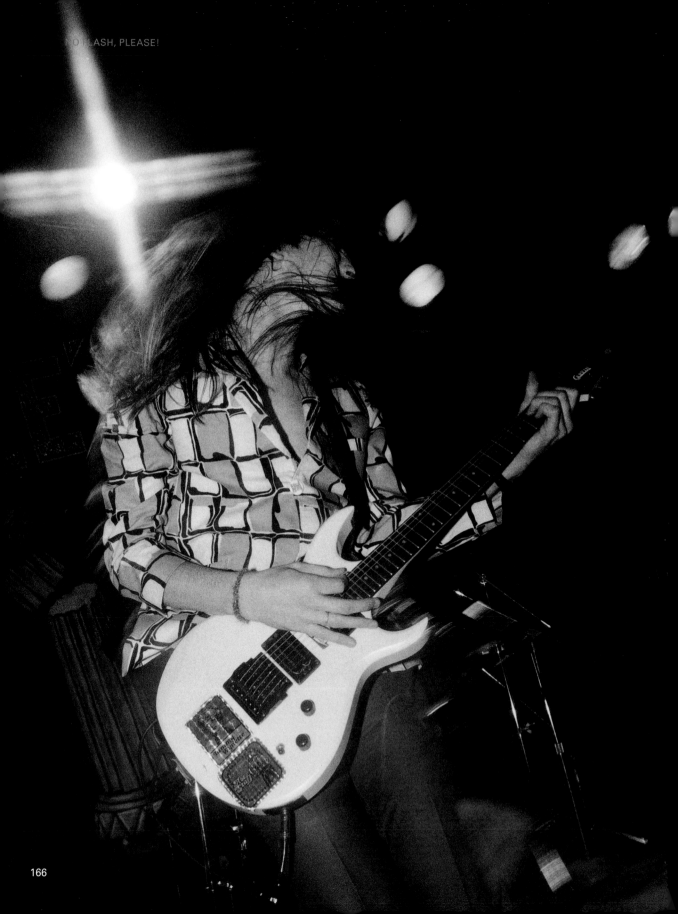

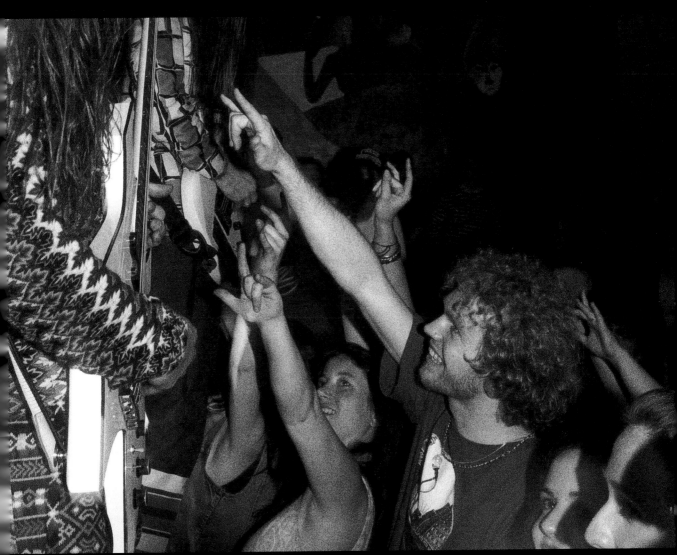

REDD KROSS | MAY 19, 1989
left: Jeff McDonald

Kevin Thomson of NICE STRONG ARM | MAY 20, 1989

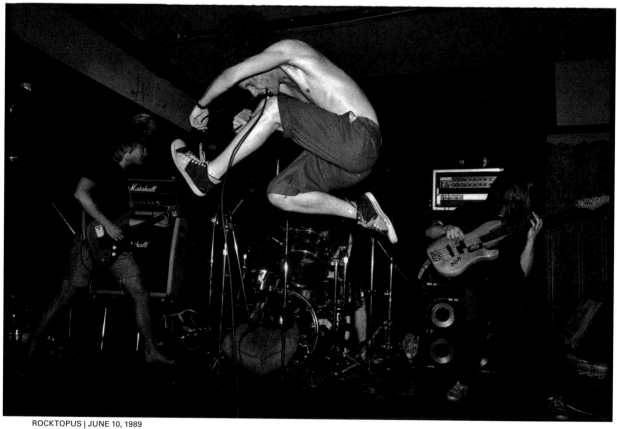

ROCKTOPUS | JUNE 10, 1989

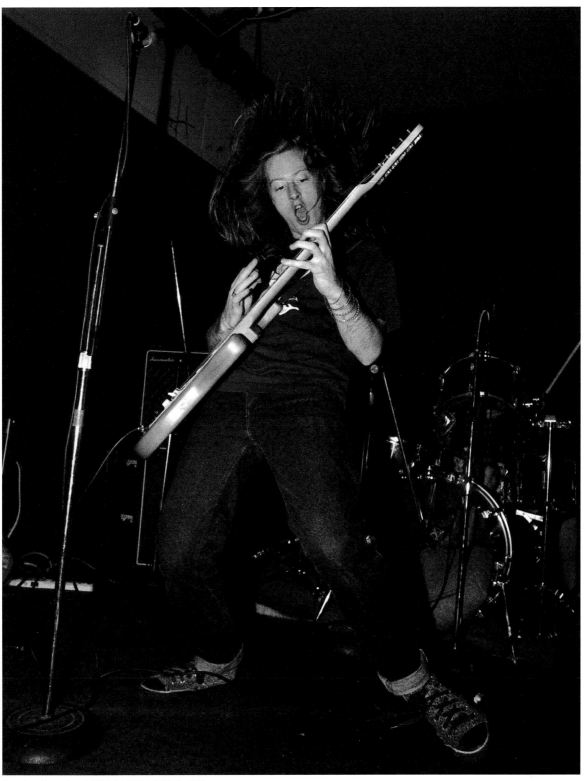

Jonathan Cummins of CIRCUS LUPIS | JUNE 12, 1989

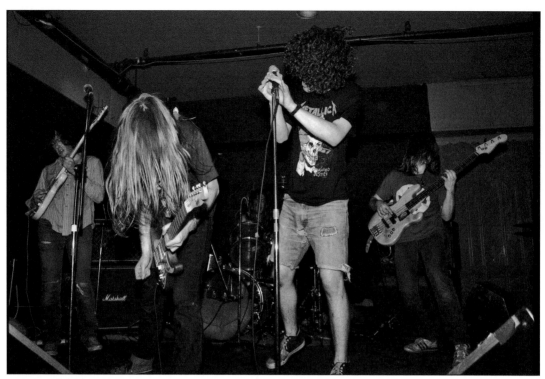

CIRCUS LUPUS | JUNE 12, 1989

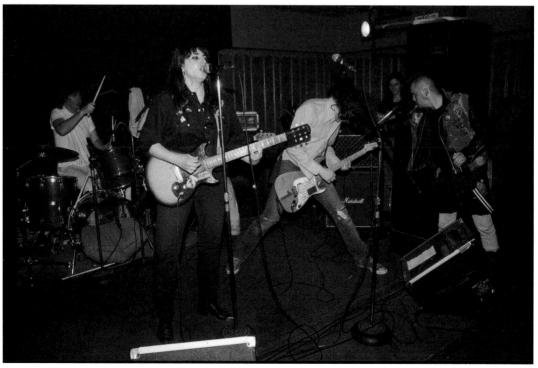

GRINCH | JUNE 12, 1989

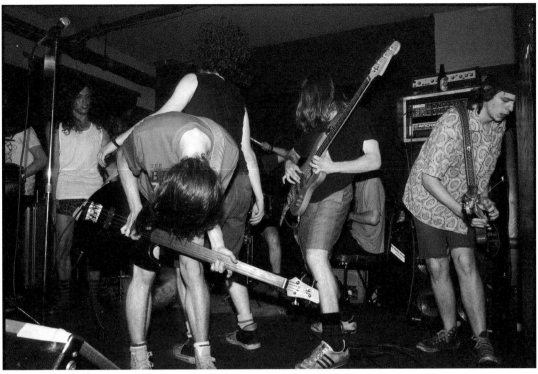

JAM BAND (members of Snowdogs, Rocktopus, Nomind & Change of Heart) | JUNE 26, 1989

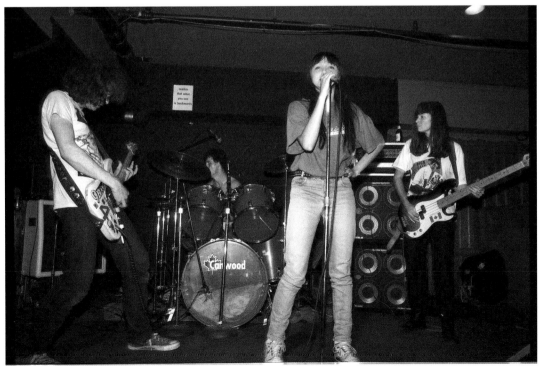

SNOWDOGS | JUNE 26, 1989

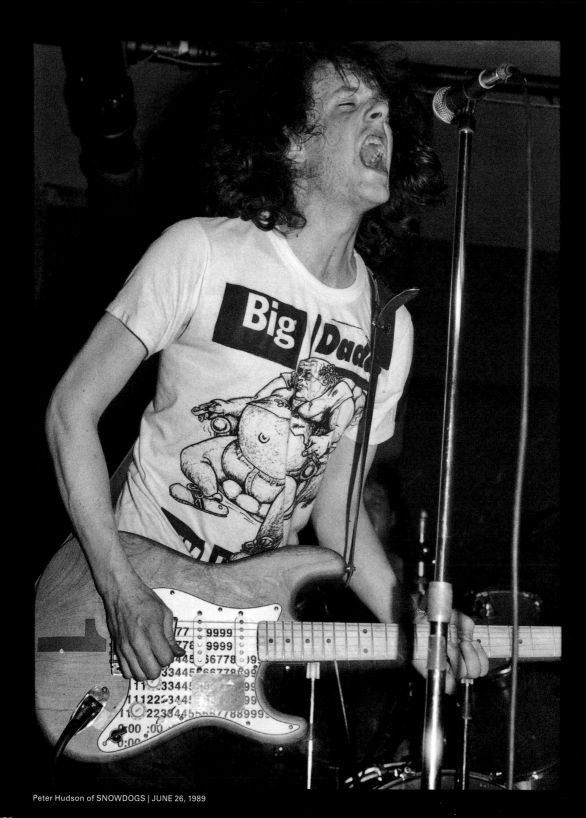

Peter Hudson of SNOWDOGS | JUNE 26, 1989

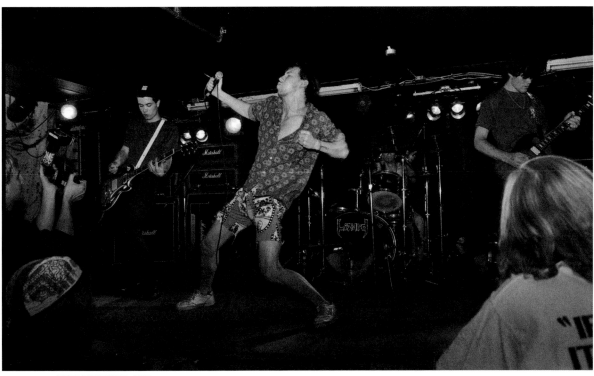

RISE | AUGUST 26, 1989

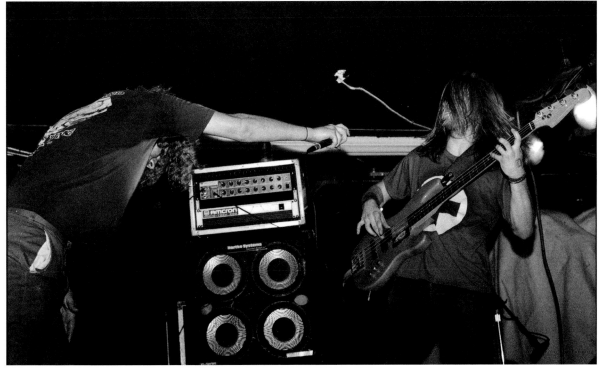

ROCKTOPUS | AUGUST 26, 1989

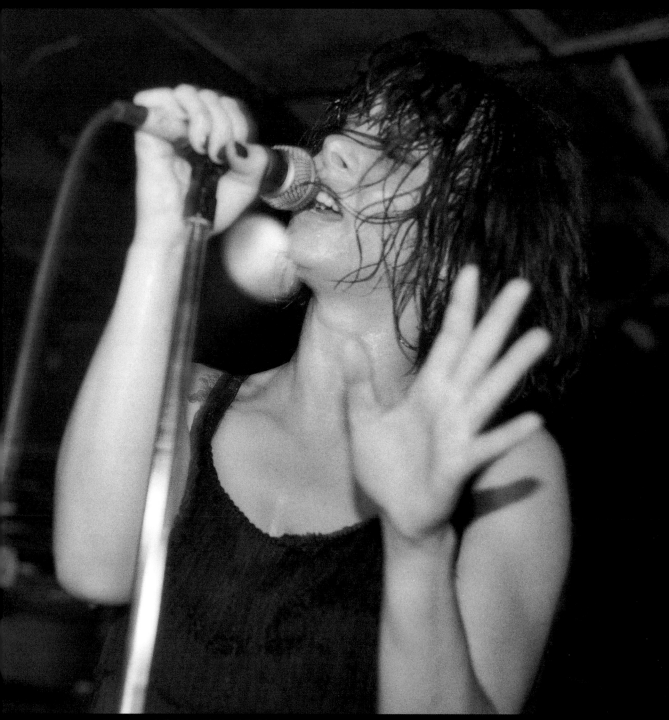

Johnette Napolitano of CONCRETE BLONDE | JULY 18, 1989

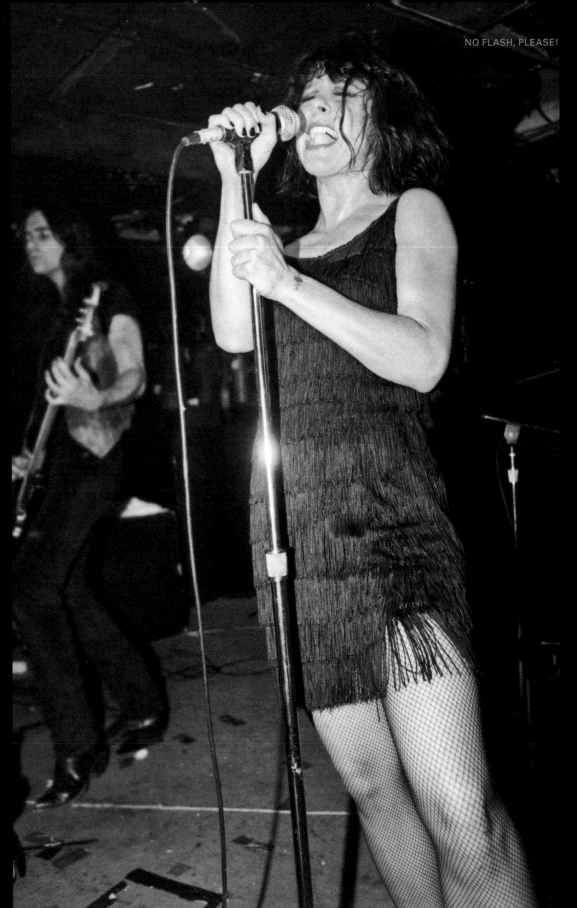

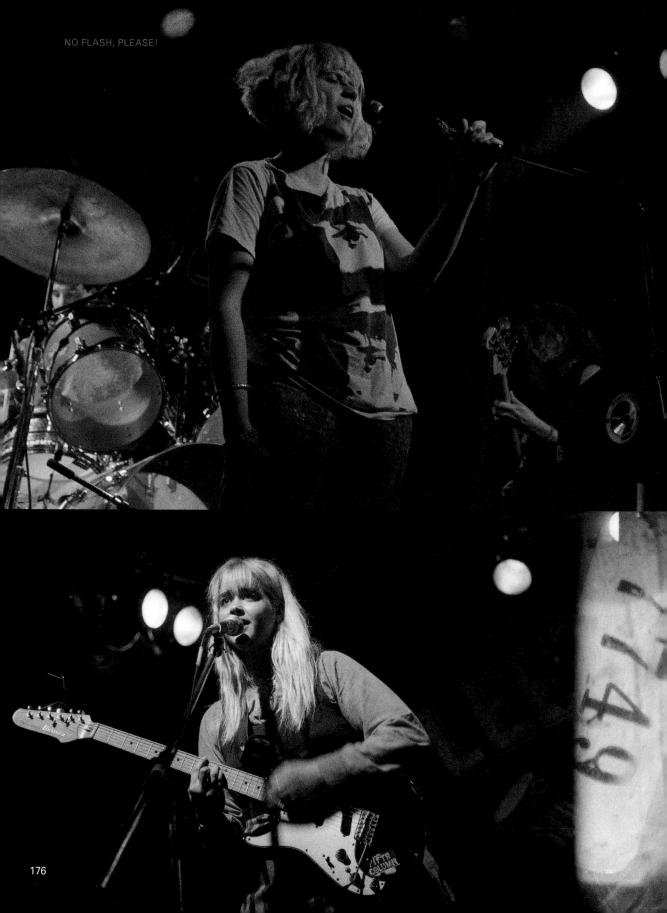

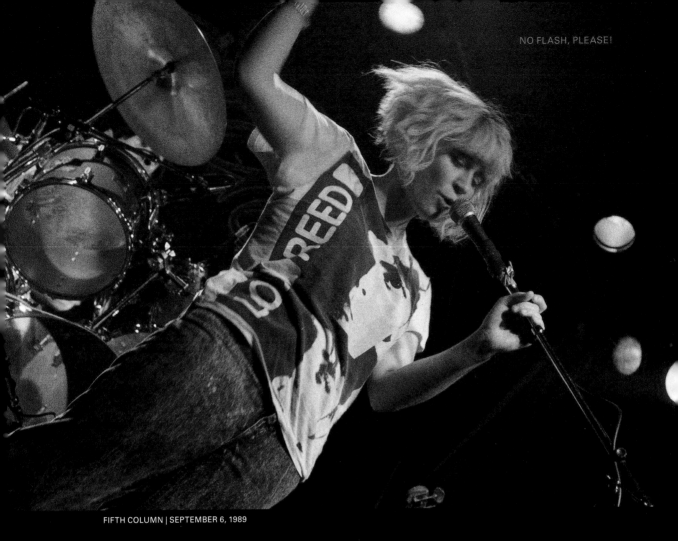

FIFTH COLUMN | SEPTEMBER 6, 1989

Inspired by bands such as Britain's The Slits and The Raincoats, **Fifth Column** emerged around 1981 as an organic expression of a small cadre of young women and men who had something to say, but didn't really connect with the traditional punk scene of the time. After founding drummer and film-maker G.B. Jones played a show with Janet Martin and Kathleen Robertson under the name Second Unit, she met Caroline Azar, who joined on vocals and keyboards, and they became Fifth Column. Among the variety of members of the band, bassists Donna Dresch (Dinosaur Jr., Screaming Trees, Some Velvet Sidewalk) and Beverly Breckenridge (Phono-Comb and The Spinanes) became central to the band's development and creative evolution. Fifth Column's approach to music, theatre, aesthetics and spectacle is unique in that they took responsibility for reflecting the zeitgeist of the time among a group of people who were marginalized in a backwater city that was about to become Canada's largest urban centre. In this way they gelled with the punk movement, but their goals were loftier, more intelligent and cosmopolitan than the city that spawned them.

Although acknowledging the influence of the all-female group The Raincoats, an inspiration also to Nirvana's Kurt Cobain and Sonic Youth's Kim Gordon, Fifth Column's mostly female personnel was incorrectly perceived to be a purposeful statement against men. Although the band was certainly feminist, the truth is that many men played a significant role in the music and art it produced: namely guitarist Charlie Salmon (Plasterscene Replicas), drummers Joel Wasson (Snowdogs and Big Daddy Cumbuckets) and Don Pyle (Shadowy Men), visual artist John Brown, film-maker Bruce La Bruce, producer Walter Sobczak and K Records founder Calvin Johnson. The band's sound was somewhat like the sixties' garage sound emanating from Toronto at the time, but with a more ethereal and ambient feel. But its most controversial song, the punk anthem "All Women Are Bitches," raised the ire of the Toronto-based twenty-four-hour music-video channel MuchMusic when Fifth Column was asked to play the annual AIDS benefit Kumbaya, broadcast live in a telethon format inviting donations from the audience. Despite being told that they couldn't perform their hit single, they did and were immediately vilified for it. Released by K Records, the single received airplay on campus radio across North America and was named single of the week in the UK's prestigious *Melody Maker* magazine after a glowing review by Everett True. Thus the group's reputation spread as a band with the ability to satirize and speak to old-school, outdated sexual politics in a critical and meaningful way. Fifth Column eventually became associated with the riot grrrl movement of the midnineties. Its last release, *36C*, was its most widely distributed and embraced, but its earlier work *To Sir with Hate* is still its most interesting musical contribution and reveals an originality and freshness not commonly found in the Toronto music scene of the early eighties.

> "They played music that was punk in idea, but not punk in genre, they played psychedelic rock music, sixties influenced…it made me realize that there could be all kinds of women in bands playing all kinds of music and it's not this one thing where everybody sounds like L7 or Hole."
>
> —Kathleen Hanna, Bikini Kill, Le Tigre
> (taken from the documentary She Said Boom)

LYDIA LUNCH | OCTOBER 21, 1989

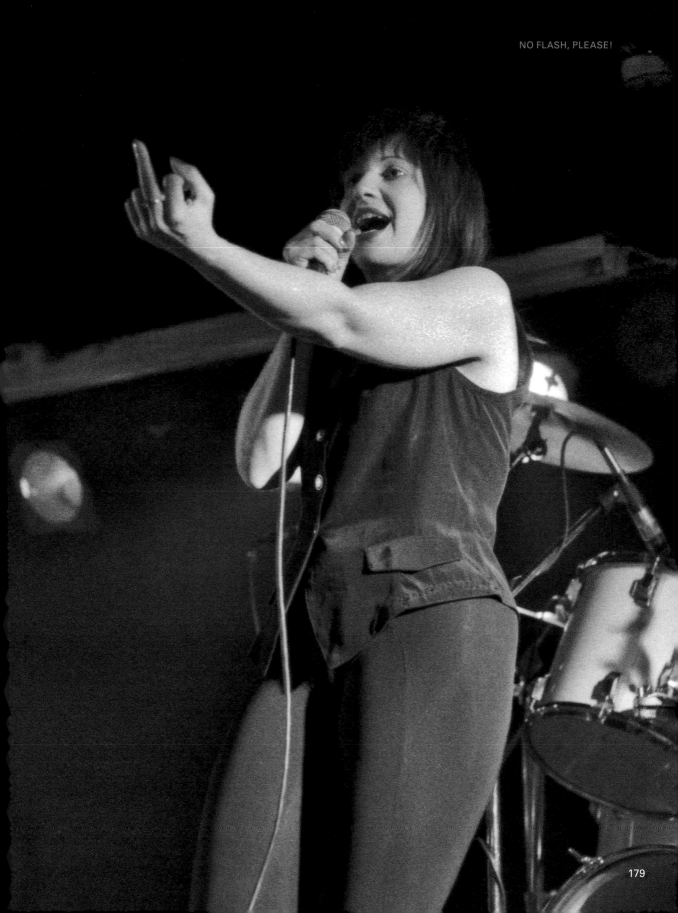

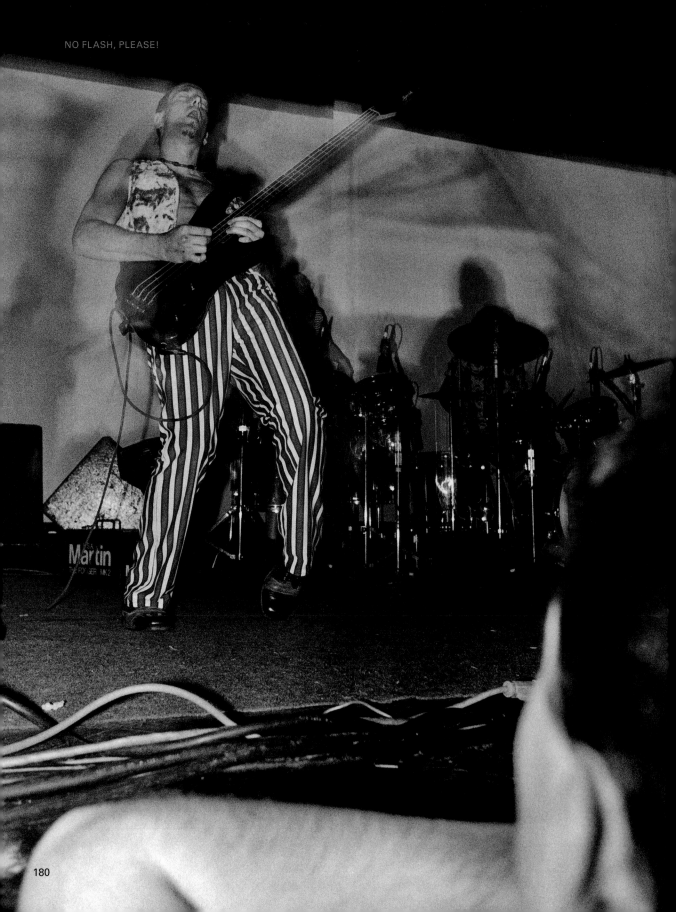

Butthole Surfers is probably the scariest and at the same time most absurdly funny band to emerge from what was already a massively prolific Texas punk scene in the eighties. Coming from the same fountain as Scratch Acid (later The Jesus Lizard), Daniel Johnston, D.R.I. and Steve Fisk, the Butthole Surfers embraced insane stage shows with wildly psychedelic punk. One twenty-year-old seeking controversy became instantly infatuated with them, mostly because they allowed him an entry point to a less mainstream sound: their new fans, many having grown up listening to KISS, Black Sabbath, Led Zeppelin and other similar rock bands, suddenly had something to hang on to, in this case their showstopper version of Black Sabbath's iconic "Sweet Leaf," retitled "Sweat Loaf" by the eccentric Texans. The Butthole Surfers' bizarre approach to this music, coupled with a seemingly clinically insane musical style that was unmatched at the time, plus their uncanny ability to create a mythology that preceded them, made them instant stars among alternative music fans. As an

left/top: THE BUTTHOLE SURFERS | NOVEMBER 10, 1988
above: THE BUTTHOLE SURFERS | DECEMBER 0, 1907 Dancer Kathleen Lynch

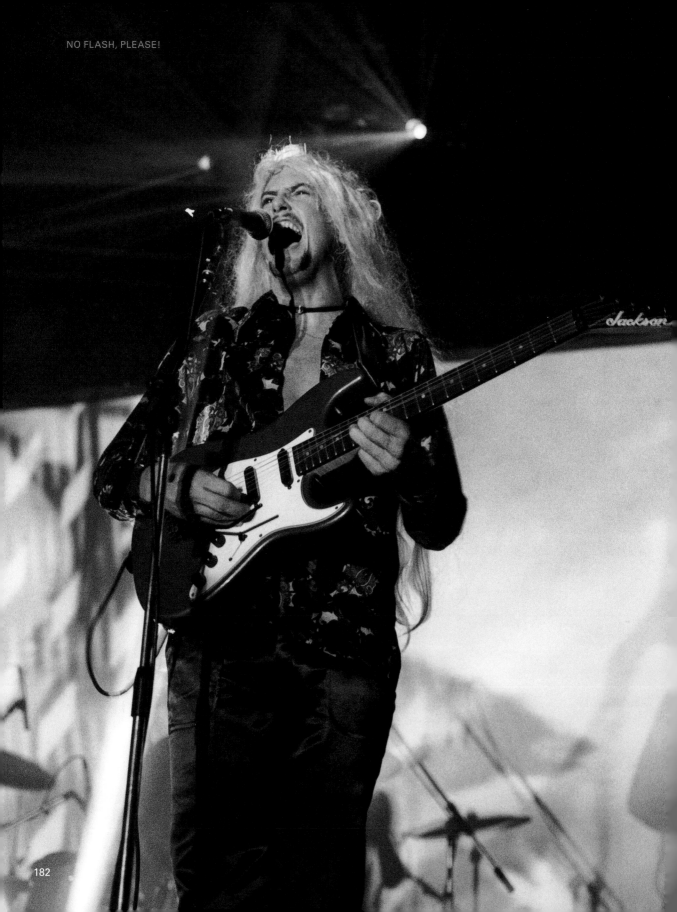

apparently satirical snub to the rising tide of alternative music, they told Spin magazine that they moved to Athens, Georgia, "to be closer to R.E.M. …" and before returning home to Texas some months later, also told Spin that they were going to park a dilapidated van in front of R.E.M. singer Michael Stipe's home with the statement "Michael Stipe / Despite the hype / I still wanna suck / Your big long pipe" spray painted on the side. When the Butthole Surfers performed at RPM, it was not too surprising to hear them perform "The One I Love," a popular radio hit by R.E.M. that was getting a lot of radio and MTV video play at the time. The satanic undertones of the song were not lost on the Butthole Surfers, whose persistence in bizarre humour was relentless. It should also be noted that Windsor, Ontario, resident Trevor Malcolm, the original bassist, soon became known as "the most hated man in America" when he suddenly quit the band. Malcolm continued with the equally ironically entitled band Luxury Christ and became a staple of the Southern Ontario punk alternative scene throughout the nineties.

left/below: THE BUTTHOLE SURFERS | OCTOBER 17, 1989

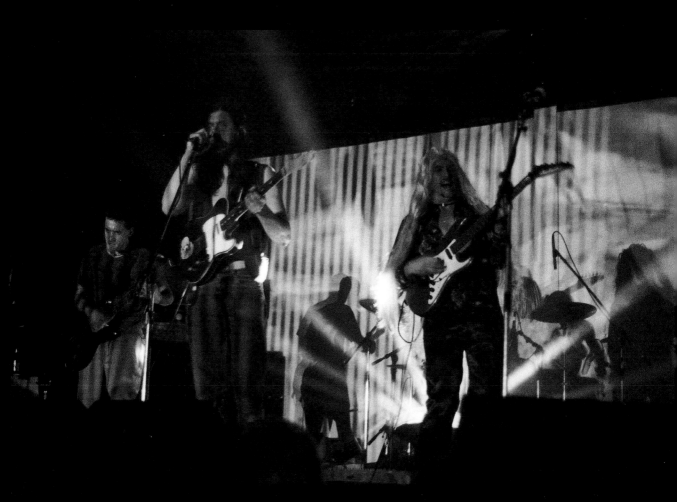

HEIMLICH MANUEVER | OCTOBER 30, 1989

Kevan Byrne's of HEIMLICH MANUEVER | OCTOBER 30, 1989

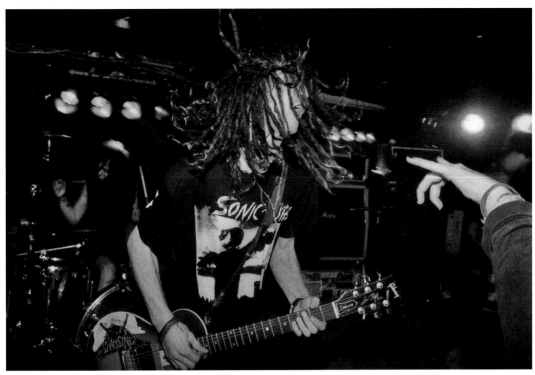

Paul Newman & John Kastner of THE DOUGHBOYS | NOVEMBER 10, 1989

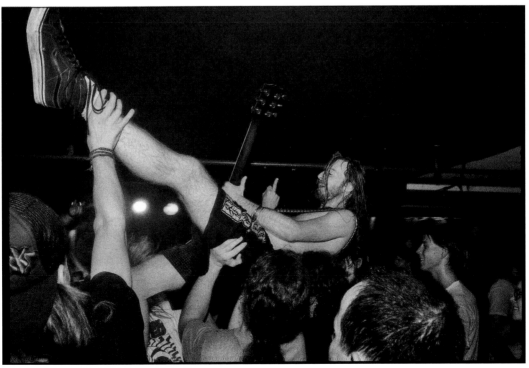

Jonathan Cummins of THE DOUGHBOYS | NOVEMBER 10, 1989

Red Hot Chili Peppers was the first of the punk-funk bands to come out of an established Los Angeles punk scene in the eighties. Their first several records were released on EMI-Manhattan, a remarkably corporate imprint for a band of misfits, and as we later learned, addicts and/or recovering addicts. The spiritual centre of the group was the incomparable talent Flea (born Michael Peter Balzary), while vocalist Anthony Kiedis became the stylist and unique voice that merged rap and song. The two were best friends, having allegedly met in a driving-school class. Hillel Slovak joined them on guitar as a mutual friend, forming the trio of misfits who would become the Red Hot Chili Peppers, version one. Jack Irons, who had played in Slovak's band Anthym, soon joined what would become the Chili Peppers when Flea replaced Anthym's bassist upon the urging of Slovak. The Chili Peppers famously appeared at Lee's Palace for the first time jumping on stage wearing only sweat socks, placed on their auto-erect penises. To say they were the talk of the town is an understatement. I'm not sure this version of the group ever returned to Toronto. The next time Toronto saw the Chili Peppers was in support of *Mother's Milk*, the first release with then-new guitarist John Frusciante and newly minted Michigan-raised drummer Chad Smith. This photo is from the Diamond Club show they played in support of *Mother's Milk*. Frusciante told one reporter that his entire life had led him to play guitar in the Red Hot Chili Peppers. Smith, who has since surpassed all the former members for having the longest career with the group, at the time seemed as interested in going to see the Detroit Red Wings play the Toronto Maple Leafs that night as he did in playing the gig. Nevertheless, the second version of the Chili Peppers was among the most musically gifted and important groups to

emerge from the California punk-funk scene. Only Fishbone came close to them in terms of musicianship, but the Peppers' ability to write hits, manage their challenging personal lives and continue to create some of the most accessible music of this period made them the reigning champs of Los Angeles punk funk. Flea remains one of the great bassists in alternative rock, surpassed only by Mike Watt, whom Flea acknowledges as a major influence. Even on-again, off-again guitarist John Frusciante, himself struggling with addiction and personal problems, was temporarily replaced by Dave Navarro (Jane's Addiction); but it was Frusciante's work that really carried the band to greater heights after the overdose death of Slovak. It must be said, however, that Slovak successfully merged the band's love of Parliament Funkadelic with the energy of punk, fused with the purple haze of Jimi Hendrix. Even Frusciante recognized the importance of maintaining this signature sound, a sound that lasts to this day: distinct, bold and infectious.

RED HOT CHILI PEPPERS | OCTOBER 18, 1989

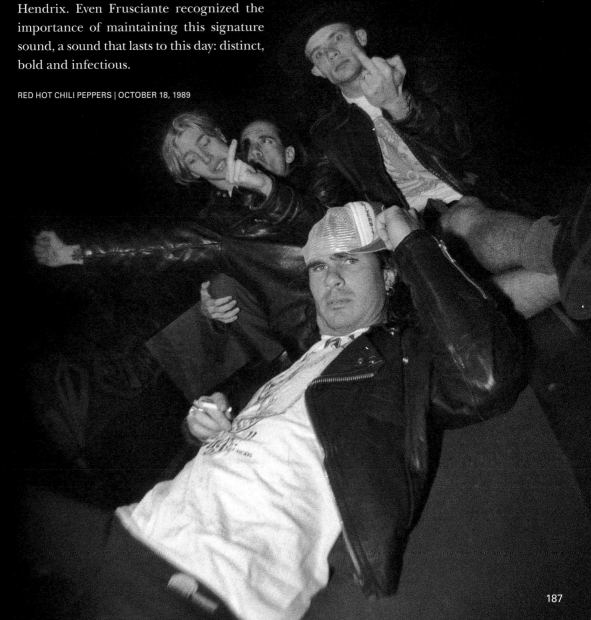

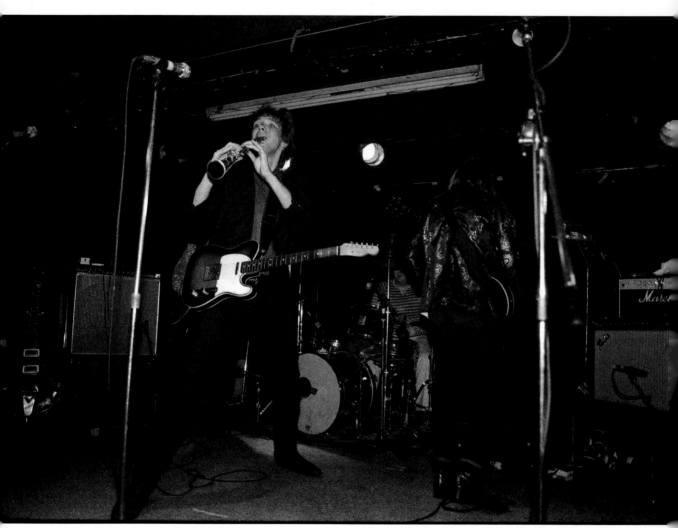

DEATH OF SAMANTHA | SEPTEMBER 8, 1989

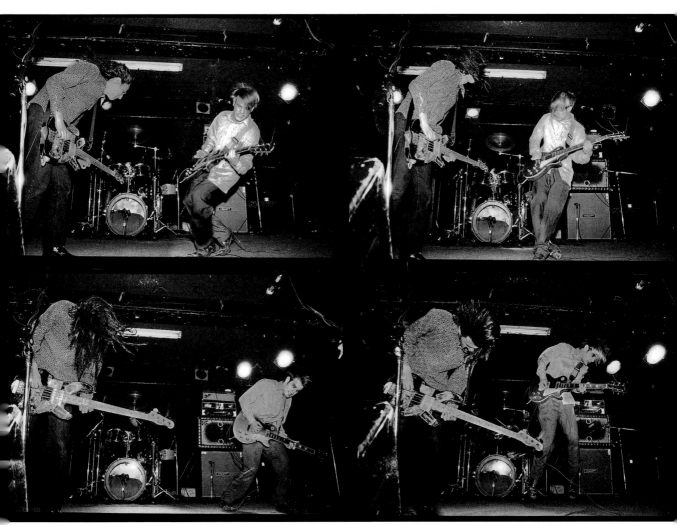

NICE STRONG ARM | JANUARY 13, 1990

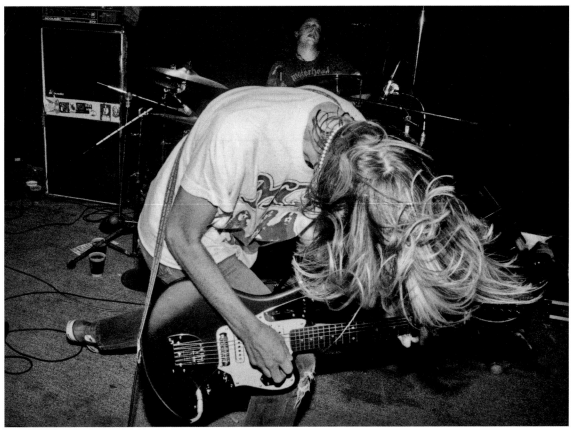

Guitarist Mark Arm of MUDHONEY | OCTOBER 24, 1989

It is impossible to discuss the Seattle music explosion of the early nineties without referencing Mudhoney. Relentlessly noisy, the band embodied what would eventually be associated with the corporate misnomer Grunge. The nucleus of the band, singer-guitarist Mark Arm and guitarist Steve Turner have been playing together since 1981, first in a band called Mr. Epp, then in Green River, which also included Pearl Jam bassist Jeff Ament and guitarist Stone Gossard. When Green River splintered and became Mother Love Bone, Arm and Turner founded Mudhoney.

Their first single, *Touch Me, I'm Sick* remains the anthem of the Seattle explosion, encompassing a dark sensibility with a laisse faire musical approach that was at once forthrightly atonal, but hideously loveable. Their EP SuperFuzzBigMuff, named for a unique blending of guitar pedals that reflected their raucous sound perfectly, Mudhoney were, without a doubt, the most authentic flag bearers of what would be the—now long discarded—Sub Pop sound of the era. Along with drummer Dan Peters, and bassist Matt Lukin, their entourage was unavoidable as the wave of Grunge swept across America and Europe in the early nineties. To this day, the name Mudhoney is uttered with equal parts reverence and smirk. Arm still holds down a job at Sub Pop records in shipping and receiving, while taking offers to reunite Mudhoney and appear at anniversary events.

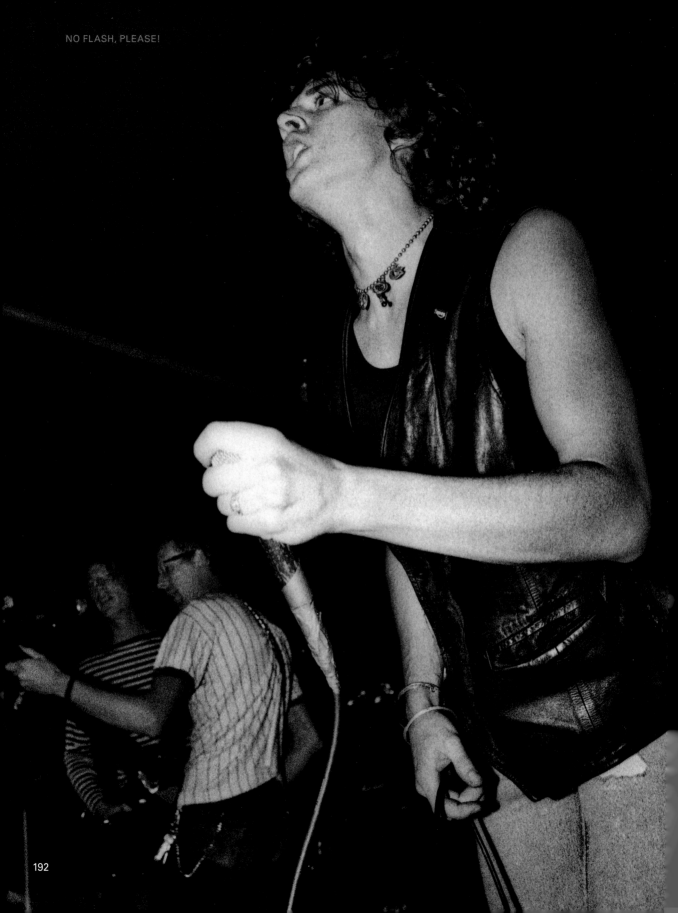

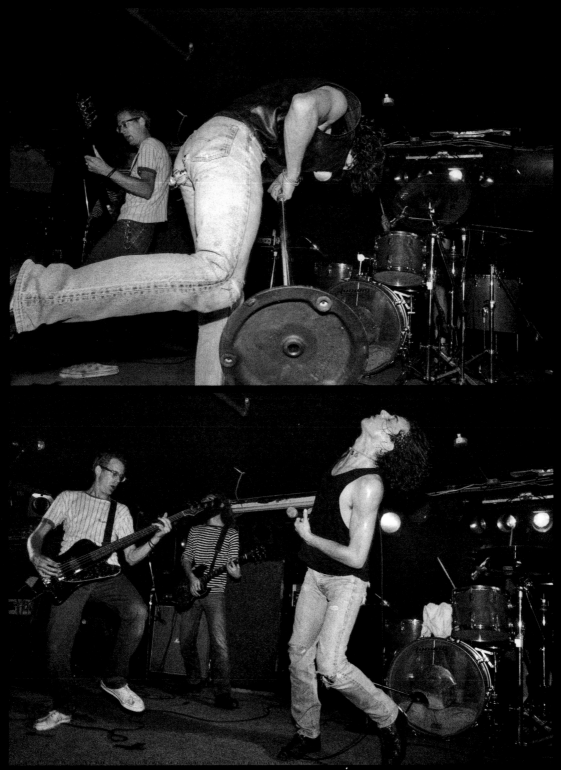

THE FLUID | OCTOBER 24, 1989

"Hey, is this Toronto?" asks Soundgarden vocalist Chris Cornell during an interview with CHRY-Radio York in 1988. "Isn't that where Rush is from?" "Yeah, we love Rush," says guitarist Kim Thayil.

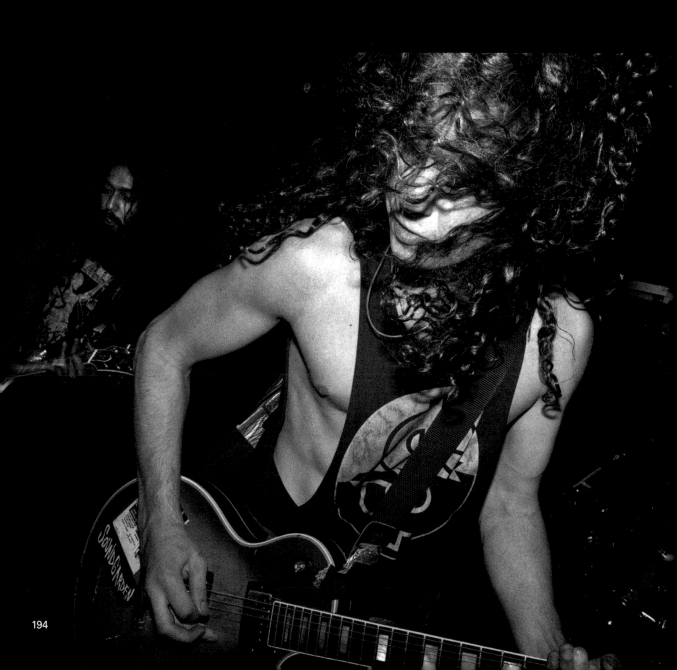

"Total Fucking Godhead" is how Sub Pop founder Bruce Pavitt described **Soundgarden** in a review of an early live show for *The Rocket*, a Seattle entertainment weekly. It is difficult to consider Soundgarden part of the Sub Pop Records explosion of the early nineties. Anthemic-posturing heavy-metal-tinged hard rock seemed anathema to what Sub Pop would eventually be associated with as it released recordings by Nirvana, Mudhoney and other lo-fi groups associated more with garage punk rock than arena rock. Nevertheless, Soundgarden was soon endearing itself to a legion of enormodome rock fans who would file Soundgarden's releases next to Led Zeppelin, Black Sabbath and, yes, Rush. The band's colleagues would soon refer to it as the band that made it big, which is likely why Soundgarden ended up putting out its first full-length album on Los Angeles-based SST Records, signing to A&M Records soon after and apparently heading straight to the big time. But it must be said, Sub Pop did Soundgarden well. While people were having a hard time hearing the growling of Nirvana and Mudhoney, Soundgarden offered up a recognizable though jarring cock-rock aesthetic and, at least in the early days, it was Soundgarden that was considered part of the first wave of bands that Sub Pop had apparently "discovered."

In this photo taken at Toronto's Apocalypse Club, you can see the beautiful Chris Cornell's pectorals slightly covered by an early rendering of a Sub Pop T-shirt. Notice the similarity to the dollar symbol in the now long-forgotten early logo? Now, that's not to say that Soundgarden didn't succeed, just that its success was always marked by the success of others who emerged from the same Seattle scene, namely Pearl Jam, Alice in Chains and others. Many still consider Soundgarden the most intelligent and sophisticated of the bands to emerge during the Seattle explosion. Despite the pitfalls of marginal commercial appeal, its sound is still among the most accomplished to come out of what will forever be remembered as the grunge music mecca that emerged from a community that was commoditized by an industry that simply could not deal with the true complexity that was the actual Seattle sound of the late eighties and early nineties. In fact, it is telling that a far less complex band, Audioslave, featuring Cornell backed by Rage against the Machine, outsold Soundgarden on an album-by-album basis.

In retrospect, Soundgarden outlasted many of the early Seattle bands. Their 2012 reunion release King Animal finds the group returning to their unique sound with timeless resilience. Soundgarden's catalogue is among the strongest to come out of the Seattle explosion of the nineties. In fact, it is not insignificant that the venerable Johnny Cash included their song *Rusty Cage* as part of an encouraged revival of the American troubadour's role in reimagining songs that are meaningful to the public's musical consciousness.

> "Soundgarden sold better in Canada, per capita, than any other region, including the U.S."
>
> —Dave Porter, former A&M alternative products marketing manager in 2015 reminiscing on his first pet project.

left: Kim Thayil & Chris Cornell of SOUNDGARDEN | NOVEMBER 4, 1989

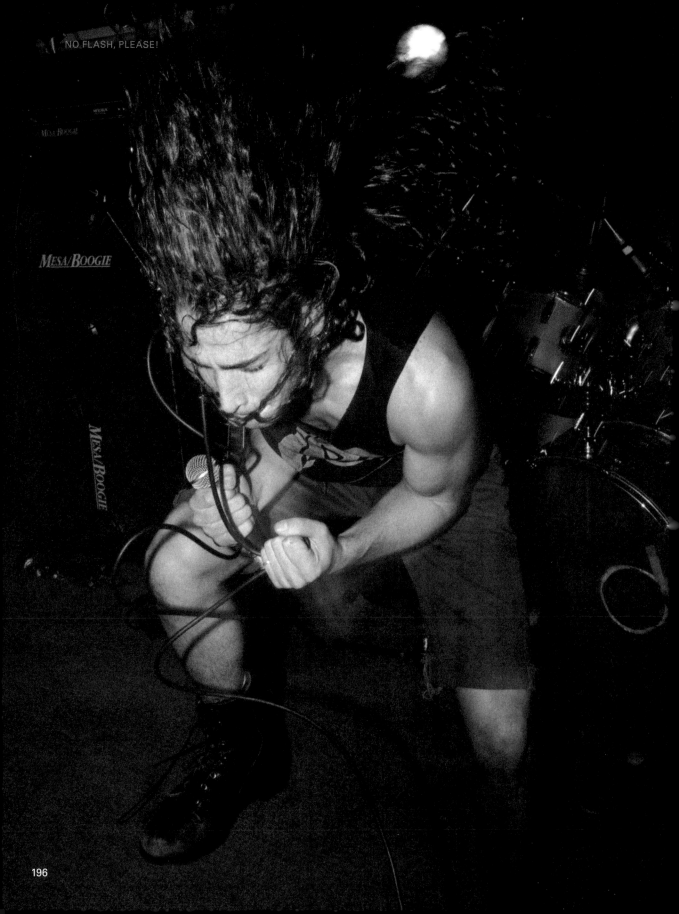

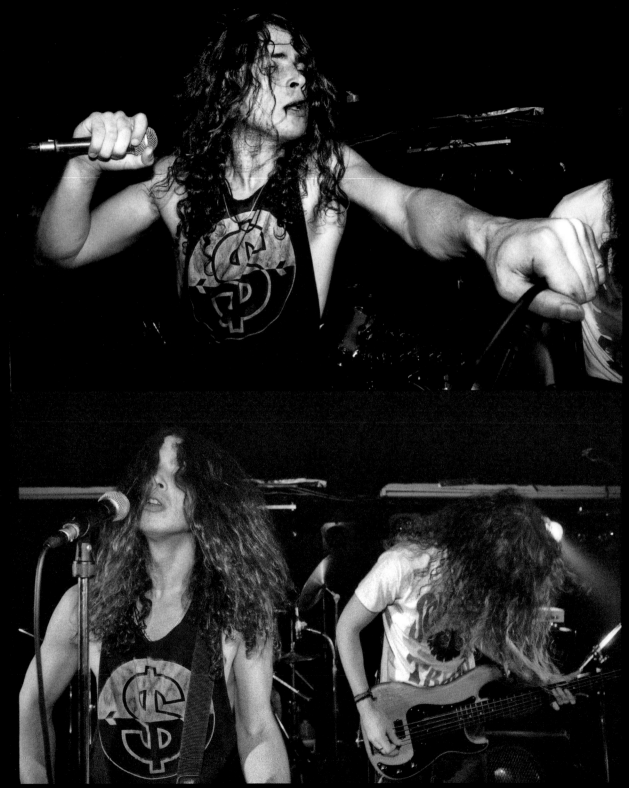

SOUNDGARDEN | NOVEMBER 4, 1989

Cheetah Chrome was the founding guitarist of one of the most legendary of the New York punk bands, the Dead Boys. Though he never eclipsed the great mess that was the Dead Boys and their punk anthem "Sonic Reducer" (co-written with Pere Ubu vocalist Dave Thomas), nor surpassed Stiv Bators's less-than-romantic death (not by a drug overdose, as many might have expected, but by getting hit by a taxi in Paris and succumbing to a concussion at his home the next day), Chrome is still the most enigmatic high priest of American hardcore punk rock. A founding member of the notorious (if not completely unknown) Rocket from the Tombs, he formed the Dead Boys with Bators on the encouragement of Ramones' vocalist Joey Ramone, and moved to New York, where the Dead Boys became the first band ever managed by then CBGB-OMFUG club owner and impresario Hilly Kristal. Their inevitable self-destruction has since been characterized in the troublesome film made about Kristal and his legendary club, starring the late Alan Rickman as Kristal and none other than Rupert Grint, the red-headed kid from the *Harry Potter* franchise, playing Chrome. Since then, Chrome has maintained an on-again, off-again music career, releasing a number of albums under his own moniker, and appearing as a guest on a number of recordings; most recently reforming with Rocket from the Tombs' members Dave Thomas and Peter Laughner and Voidoids' front man Richard Hell, albeit only playing a half-dozen dates before declining to tour further in 2012. When listening to the Dead Boys, it's hard not to immediately recognize the definitive sound that Chrome's guitar makes on those records (so iconic that it was sampled by the Beastie Boys in a song that is considered an homage to New York itself: "An Open Letter to NYC," from their album *To the 5 Boroughs*). The photo you see here includes John Brannon, former lead singer of Detroit's Laughing Hyenas, playing harmonica at a show they played with Chrome in Toronto. The reverence that Chrome enjoys among a generation of middle-American punks cannot be underestimated. As an example, when watching the Canadian punk-rock film homage *Hard Core Logo*, one of the songs you hear Hugh Dillon and his band bark out during their ill-fated reunion is "Sonic Reducer," played note for note as the Dead Boys did. It undeniably sets a tone for this film, just as this song set the tone for one of the most lasting cultural moments in American life, one that continues on to this day.

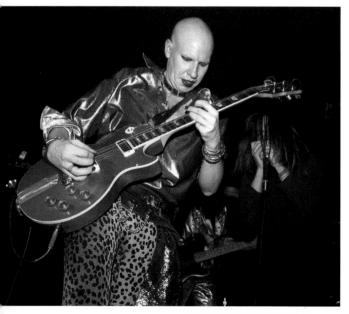

CHEETAH CHROME | NOVEMBER 24, 1989
with John Brannon from Laughing Hyenas

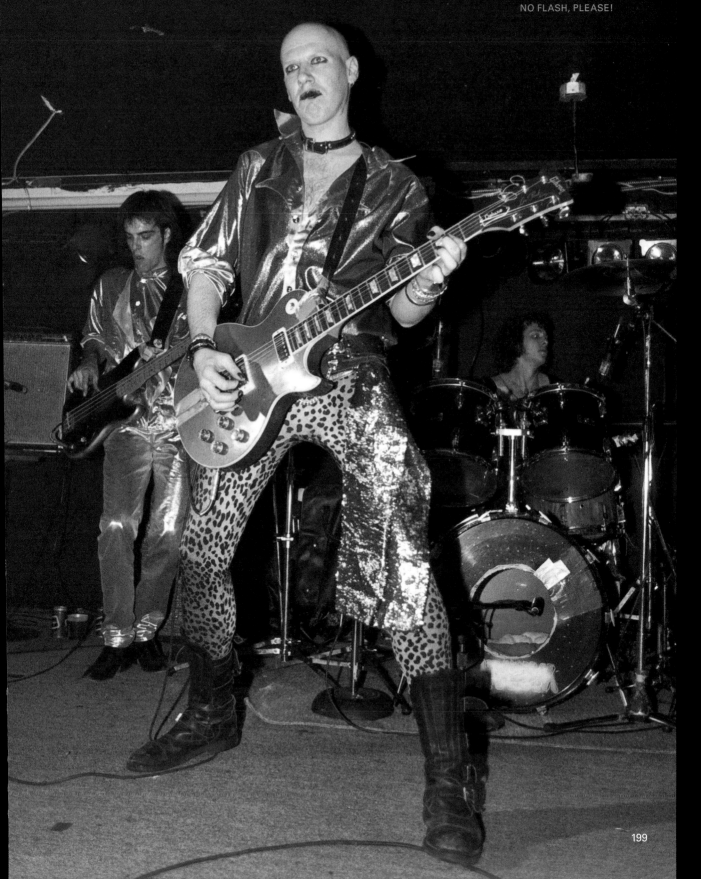

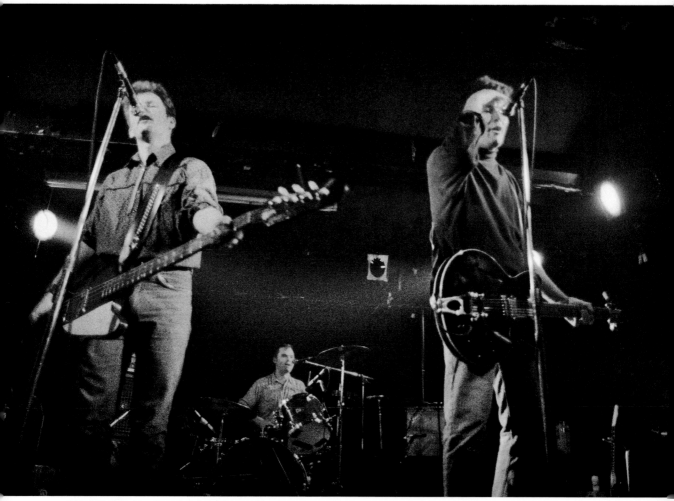

SHADOWY MEN ON A SHADOWY PLANET | NOVEMBER 17, 1989
(L-R) Reid Diamond, Don Pyle & Brian Connelly

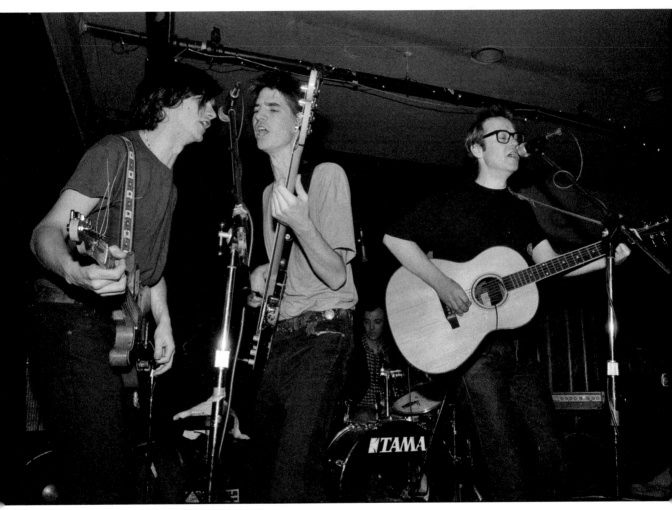

SCOTT B. SYMPATHY | DECEMBER 8, 1989
(L-R) Ian Blurton, John Borra, Terry Carter, Scott Bradshaw

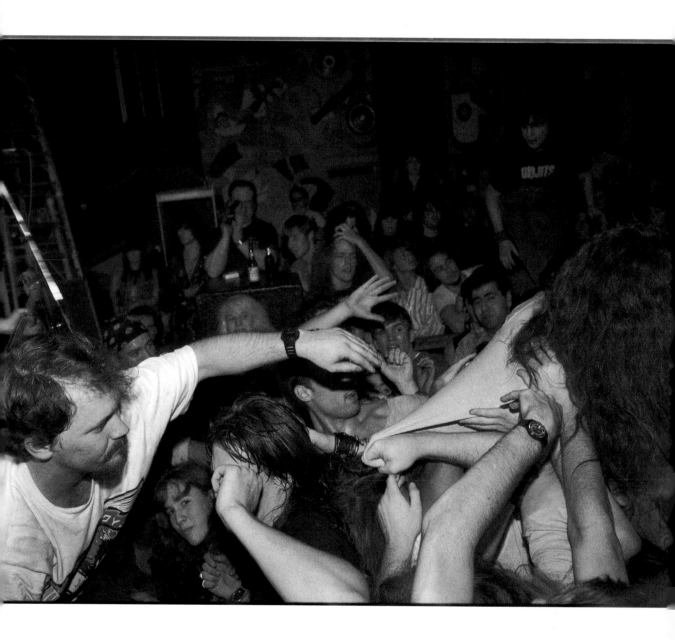

"I had the label telling me what to put on my set list."

— Ian Blurton, on his experience on a major label in the midnineties

History Lesson, Part 2

Toronto, just like every other major city in North America, was experiencing an explosion of live music. By the mideighties, what had blossomed in the midseventies came to full fruition. Technology for recording and distributing music was affordable, and a critical mass of Gen X and younger baby boomers was embarking on a creative journey. Toronto bands like The Woods Are Full of Cuckoos, Direct Action, Youth Youth Youth and others had already staked their claim to a new way of performing and hearing music. Along came CFNY, which, during the time of Program Director David Marsden, was described as a more professional-sounding version of a campus radio station. Students across the region were calling for their own broadcast outlets, including Ryerson Poly/University (CKLN), York University (CHRY) and the University of Toronto (CIUT), all volunteer-run radio stations with mandates to support new music, especially Canadian music, thanks to the Canadian-content rules imposed by the nationalistic Canadian Radio and Telecommunications Commission (CRTC). By the time the surge of independently run record labels began in the eighties, there was practically an entirely new audience, rabid for something other than classic rock and commercialized, overproduced arena rock.

Retailers became distributors, and the most prominent distributors—namely the Record Peddler in Toronto and Cargo Records in Montreal—inked exclusive deals to tap into a network of mom-and-pop record stores across Canada. Suddenly, a band with a demo had a network of consignment-based distribution for their music. Then came touring, and then, well, everything changed, or so many hoped.

The Record Peddler store—first located on Queen Street East (where it introduced punk to Toronto), then across from Maple Leaf Gardens on Carlton Street, then later Yonge Street, and finally on Queen Street West as it went into a slow and steady decline at the end of the last century—swiftly realized that creating and manufacturing products meant being able to collect more money through wider profit margins. Bands released by the Record Peddler's own Fringe Product imprint included Victoria, BC's Dayglo Abortions, Hamilton's Teenage Head, Toronto's Breeding Ground, Sacrifice, Slaughter, Corpus Vile, Razor, Vital Sines, UIC, TBA, Sudden Impact, Youth Youth Youth, The Demics, Guilt Parade, A Neon Rome, Change of Heart, Bunchofuckinggoofs and Random Killing. Fringe also picked up records they had previously sold in their stores by establishing relationships with labels like SST, Touch and Go, Taang! and Alternative Tentacles.

Local bands relied on a network of used and specialty records stores like Records on Wheels, Vortex and Driftwood. Bands would come by the stores with their latest tape, often produced on a consumer-grade tape deck and copied from a four- or eight-track version of their songs, leave them on consignment and thus began distributing their music. People began to snap up these tapes and play them on the newly introduced portable cassette players, the precursor to the modern digital music player—and a subculture was born. This led to singles, records and, eventually, CDs.

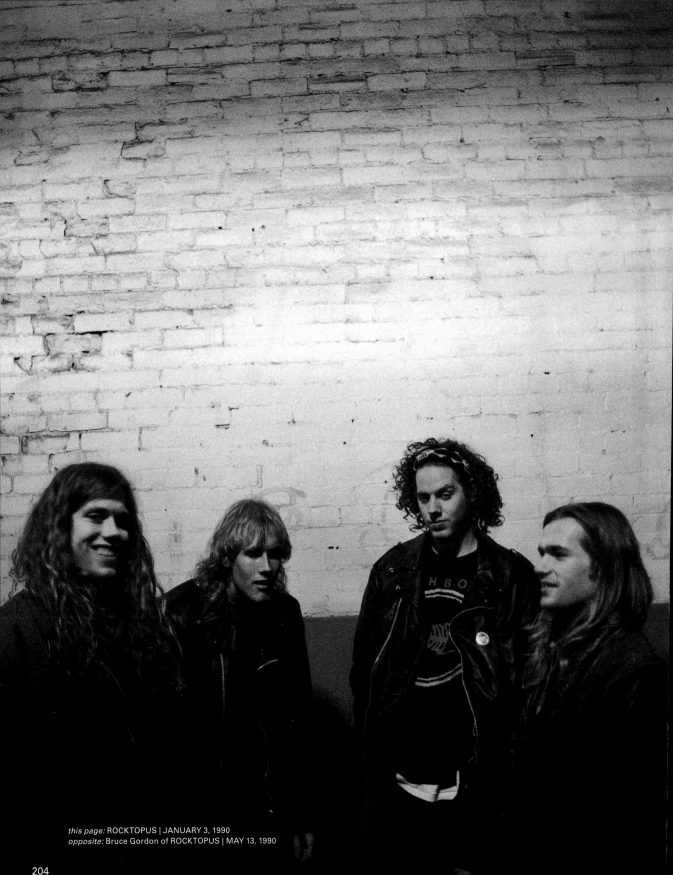

this page: ROCKTOPUS | JANUARY 3, 1990
opposite: Bruce Gordon of ROCKTOPUS | MAY 13, 1990

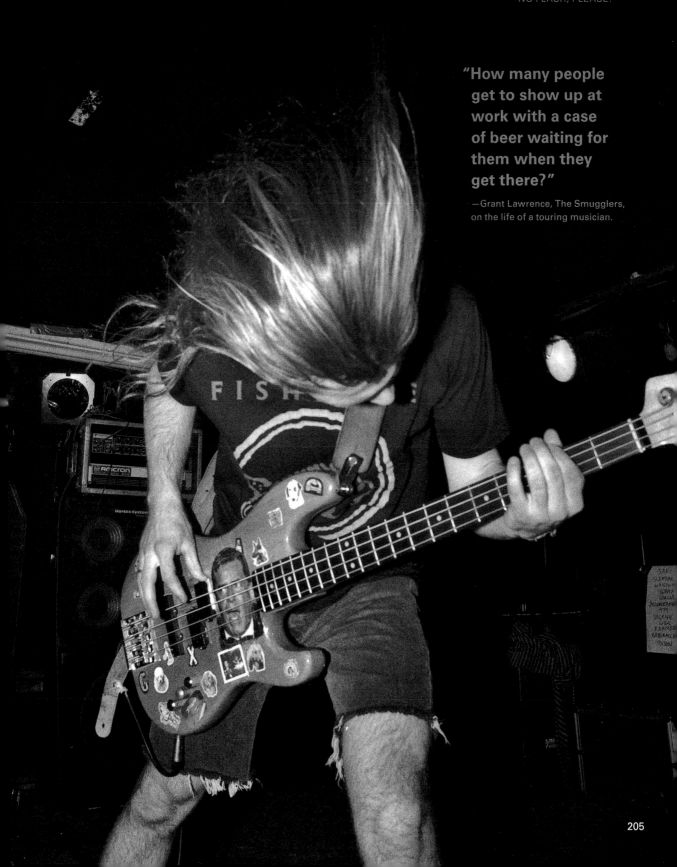

"How many people
get to show up at
work with a case
of beer waiting for
them when they
get there?"

—Grant Lawrence, The Smugglers,
on the life of a touring musician.

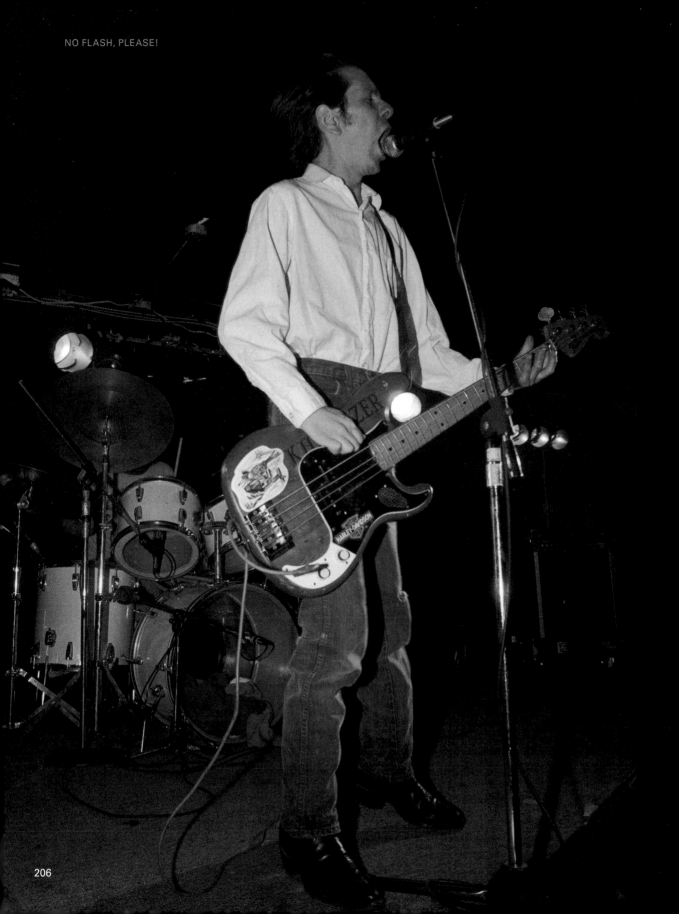

Imagine those guys who got drunk on cheap beer on Friday nights, after a long week of reading philosophy and attending seminars at Madison, Wisconsin's premier post-secondary institution, while watching reruns of *Candid Camera*, *The Flintstones* and *The A-Team*. Then you'd probably land on **Killdozer**. It was among the most cultish bands to emerge in the late eighties from Chicago's Touch and Go Records, and nothing these guys did was about selling records or making money. Their prescient dirge was coupled with a pointedly baritone snarl, courtesy of bassist Michael Gerald, and paired with a comedic love of atonality and Neanderthal rhythms, courtesy of Dan Hobson and his brother, drummer Bill Hobson. During a show at Toronto's Silver Dollar, Dan Hobson famously soloed by dragging his guitar across the stage. Their first release was named after an often-quoted Noam Chomsky statement: *Intellectuals Are the Shoeshine Boys of the Ruling Elite*. None of this is to say that the band wasn't also among the best of the underground, paving the way for those such as the Laughing Hyenas, Cows, The Goats and other Midwestern bands pushing the envelope of sonic assault. It's been said that it was Butch Vig's work on the band's influential *Twelve Point Buck* that inspired Nirvana to seek out the celebrated producer to record *Nevermind*. Probably most notable for its cover versions of latent seventies' hits, Killdozer's *For Ladies Only* captured the imagination of Generation X with such luminous versions of classics like Neil Young's "Cinnamon Girl," Joe South's "Hush" and Neil Diamond's "I Am…I Said." Killdozer's songs more frequently chose the absurd, even trite renderings of serial killers like Ed Gein and those less intellectually capable and thus restricted from reaching the seemingly high bar set by the rest of society (or something like that). A celebration of the proletariat, its fouls and omissions, Killdozer remains a humorous, satirical take, symbolizing the overeducated and underemployed, and a wonderful footnote to the hallmarks of being born in the late sixties. At once blue collar and intellectual, it had an audience.

KILLDOZER | JANUARY 19, 1990

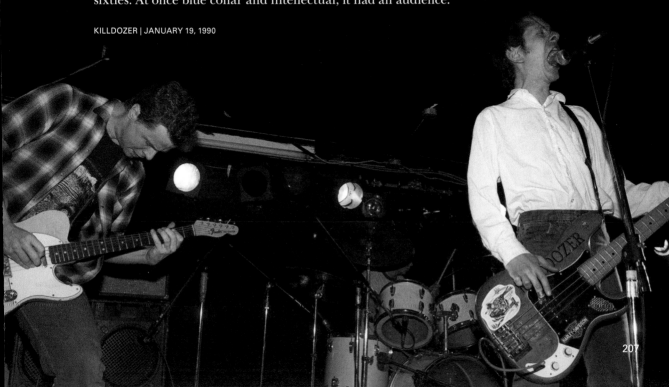

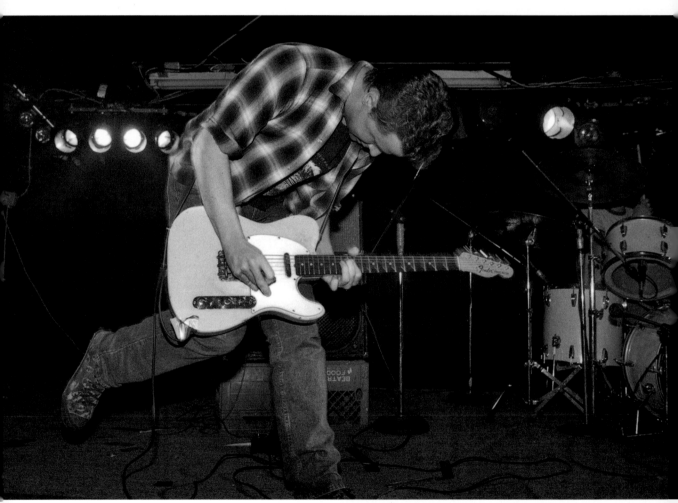

KILLDOZER | JANUARY 19, 1990

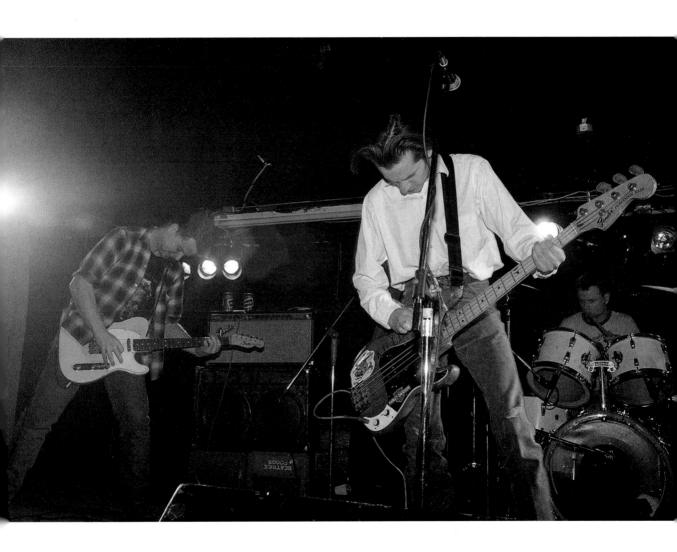

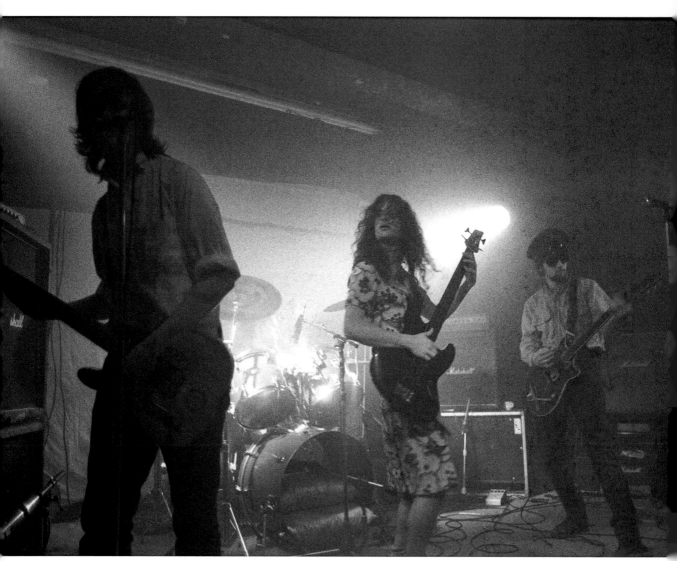

THE DRUG CREEPS | FEBRUARY 9, 1990

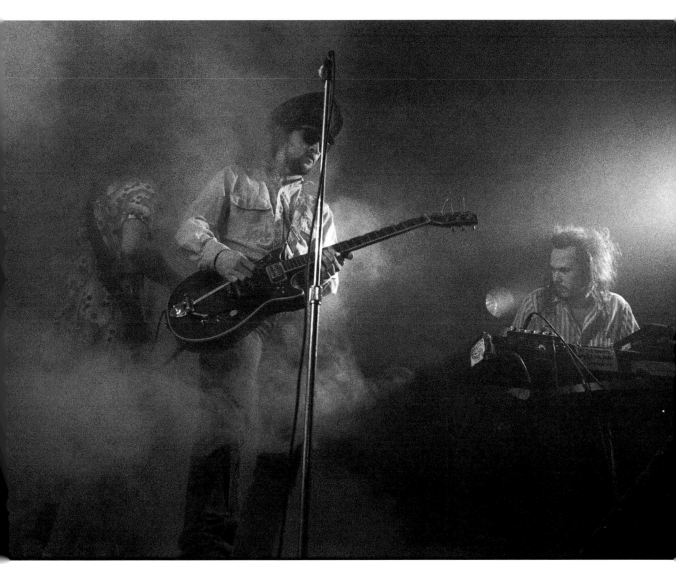

THE DRUG CREEPS | FEBRUARY 9, 1990

"We got to open for bands like the Butthole Surfers, Sonic Youth, Nirvana, Soundgarden, Soul Asylum, Hüsker Dü, Black Flag, Dinosaur Jr.... I mean these were bands making a splash and we got to play with them and got to know them." —Joel Wasson, drummer (Fifth Column, Snowdogs, Big Daddy Cumbuckets)

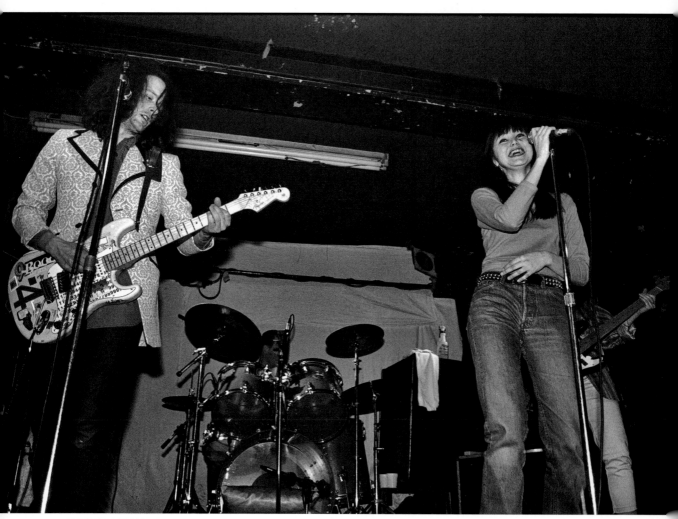

THE SNOWDOGS | FEBRUARY 9, 1990

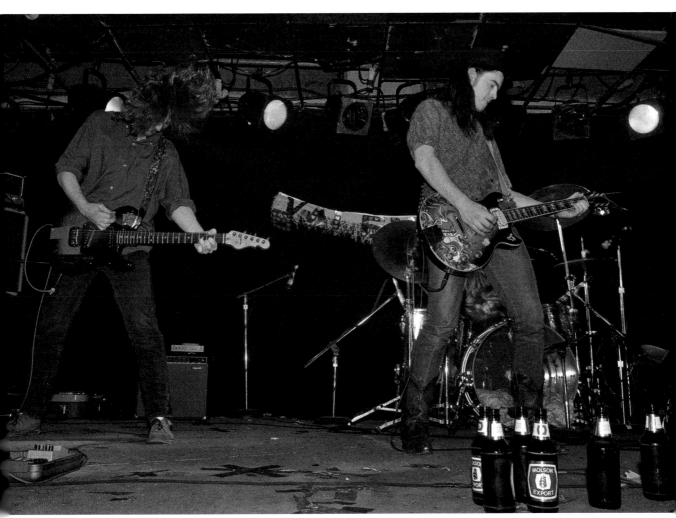

JR GONE WILD | FEBRUARY 14, 1990

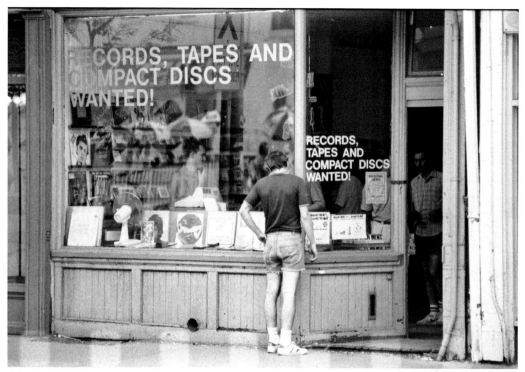

A Saturday was not complete without a trip to the record shop. This was the day I found out Shadowy Men's drummer, Don Pyle worked at Driftwood Music on Queen Street.

P.T. Barnum: A sideshow becomes an industry

"The mainstream music industry (in the nineties) was facing a grassroots shake-up and the term "alternative" was absorbed by so-called in the know marketing departments—it was like a fuzzy security blanket. In Canada, without strong sales, cash flow, or the marketing influence this newly minted genre received in the US, Canadian labels trying to make a go of it often left artists hanging in a kind of marketing limbo with under-financed campaigns. This effectively left independent bands stuck at the border."
—Mark Smith (co-manager of DOA, co-founder of Cattle Prod and DMD Entertainment)

By 1990, the inevitable started to happen: the major labels started to realize that their business model of reselling people new formats, most significantly the compact disc, wasn't enough to sustain a lazy and admittedly confused industry as bands like Fugazi, Mudhoney, Green Day, Sonic Youth and Nirvana were moving hundreds of thousands of units without their help. So innovative brands like Virgin and David Geffen's DGC Records started to consider looking for new talent.

Soon labels such as Sub Pop, which had written formal contracts with artists like Mudhoney and Nirvana, were being offered huge sums of money to release their bands, as well as marketing dollars, vast distribution networks and, yes, tour support.

"It seemed like everybody we ran into after Nirvana was supposed to be an A&R guy…it was kind of ridiculous. They were just scouting for the next Nirvana, whatever that was… Nirvana ruined everything."

—Michael Gerald, Killdozer

The music industry, fearful of showing the whites of its eyes, created a new genre. They called it alternative, and that is how any marginally popular bands would be categorized. Then the most surprising thing happened: the so-called alternative bands began outselling the traditional artists. Nirvana was atop the *Billboard* magazine revered weekly one hundred by January 1992. The entire so-called alternative genre was suddenly not so alternative anymore. The indie hordes had taken over the castle (thanks to such new sales measurement technologies as SoundScan, which allowed independent stores to register their sales along with the larger chain stores), and the castle had no idea who they were, what they were doing or how to reach their audiences any better than the bands already had.

Canadian bands like The Pursuit of Happiness and Montreal's Doughboys, as well as Seattle's Soundgarden and its more accessible twin, Pearl Jam, were all getting chart action and significant radio play before and after "the Nirvana moment," as radio stations struggling in a classic-rock-hit format quickly adopted the new sounds and created formats such as new-alternative-hit radio (or any combination of the aforementioned).

"We asked the label to pay for our trip to New York to play the CMJ conference in the late eighties [*Campus Music Journal*—the bellwether publication for independent bands charting on campus radio]. They refused. So we did it ourselves. They were visibly upset with us."

—Jeff Rogers, manager,
The Pursuit of Happiness

"You ended up being surrounded by people who you didn't really enjoy being around."

—G.B. Jones, Fifth Column

The term "alternative" was always specious at best in the late eighties and early nineties. At first it was a catch-all for anything that wasn't classic rock, charting pop, blues or jazz—but originality was the first victim. Truly alternative bands not seeking huge audiences but generally exploring music and finding themselves as artists were soon prevented from accessing the established networks for touring. Venues previously open to booking any band that could draw a crowd were suddenly offered larger-drawing bands by independent promoters or directly by the labels, at the same price as an unsupported band, but with the promise of marketing and promotional support that the independent groups could not guarantee. The DIY efforts, by virtue of splintering audiences,

were consolidated, and the era of the package tours came along. Lollapalooza, Edgefest, and various and sundry imitators became the places for young bands to get attention. Also, the highly ghettoized Warped Tour, sponsored by the skateboarding community, featured bands like Green Day, Sum 41 and Bad Religion, while the alternative ghettos gave rise to groups like Nine Inch Nails, Ministry, Metallica, Jane's Addiction, and others already mentioned became bigger and bigger in range and popularity. The rest of the bands simply carried on or fizzled out, or burned out trying to access a career in the big leagues on their own terms.

"Corporate Rock Still Sucks"

—SST Records marketing campaign started in 1990

Before the nineties, the business model for a young upstart band was fairly simple. Make your own records or cassettes and T-shirts, sell them at shows, use that revenue plus a cut of the door money to get to the next show. Although there is purity in that lifestyle, there is also burnout, frustration and constant instability. So the music industry, buoyed by its mass extraction of dollars via the 1,000-or-more-percent profit margins generated by the compact-disc phenomenon, decided that it could get access to some of these thousand-selling groups on an indie such as Touch and Go, SST or Twin/Tone by simply offering them tour, marketing and promotional support, sometimes with a million-dollar advance based on current sales. Why not jump at the opportunity to buy a house, tour in a nice van or bus and play for bigger crowds, after years of doing it all yourself and starving between tours?

"There is no difference between an indie record label and a major."

—Buzz Osborne, the Melvins, after signing to Atlantic Records in the late eighties

"It's true, I've been ripped off by as many indie labels as major record labels."

—Ian Blurton, 2015

"See, I'm really against that. It's like toilet paper. Everybody's gotta wipe."

—Mike Watt, when asked about the creeping success of indie rock in 1989

But something inevitably gets lost in this perilous transition. In some cases, it's just normal human behaviour: people get sick of each other. In others, it's the rise of addiction and emotional and psychological challenges that makes the music what it is, as raw creativity gets frustrated or lost. Personality disorders that were once cute become amplified, and internal conflicts, once tolerable, become less so. Bands stop having fun, perhaps because they no longer have to put up with each other to continue what was once a hobby and is now a job, or so they think, and so it goes. Victims of this perilous transition include Hüsker Dü, Nirvana, The Replacements, Blondie (despite being hugely successful), Talking Heads and Television; even the Ramones survived only after several personnel changes, a drug overdose and Johnny Ramone's legendary rudimentary no-nonsense approach to the job at hand.

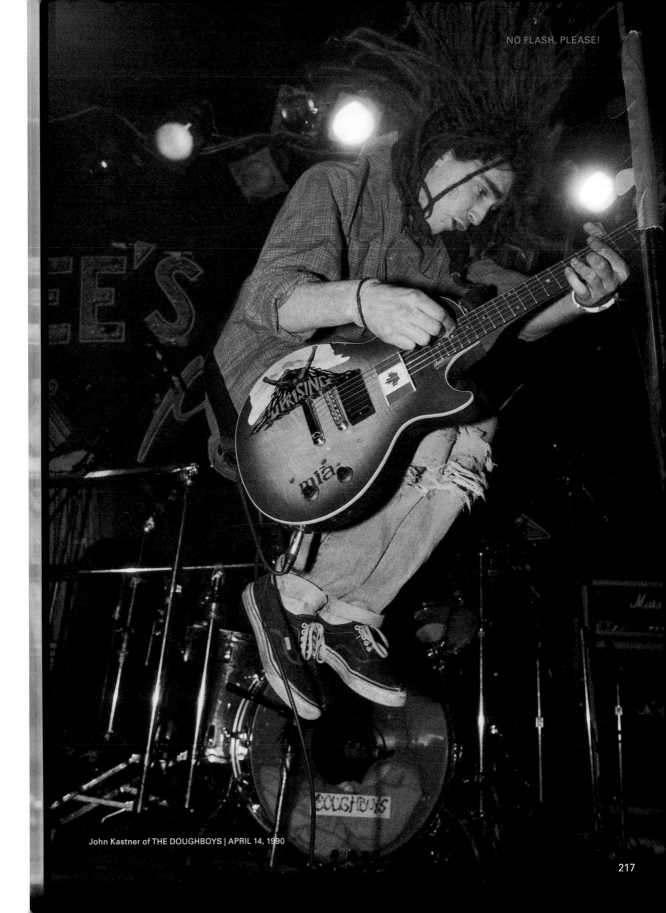

John Kastner of THE DOUGHBOYS | APRIL 14, 1990

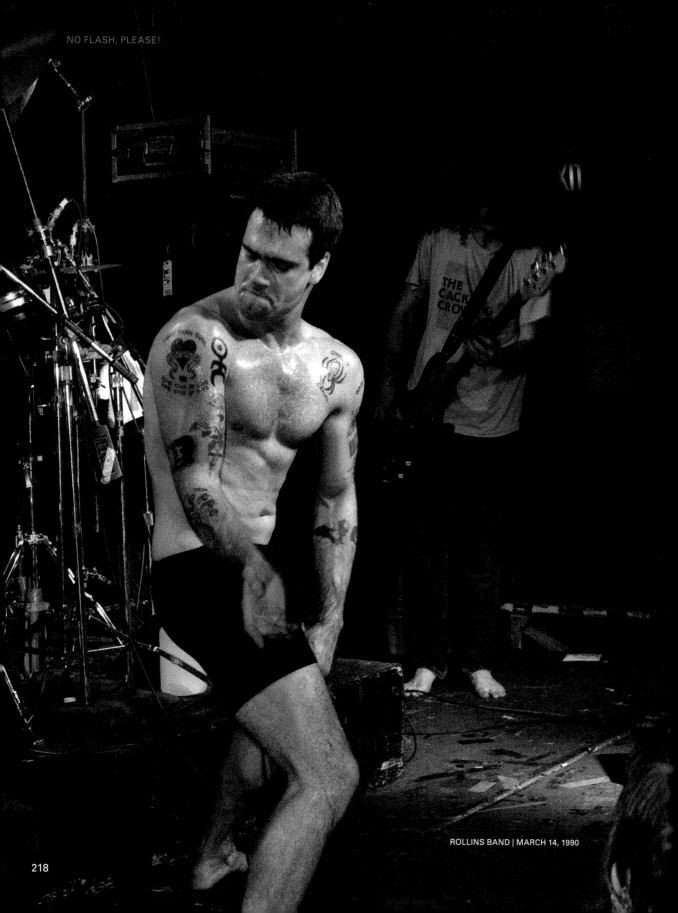

ROLLINS BAND | MARCH 14, 1990

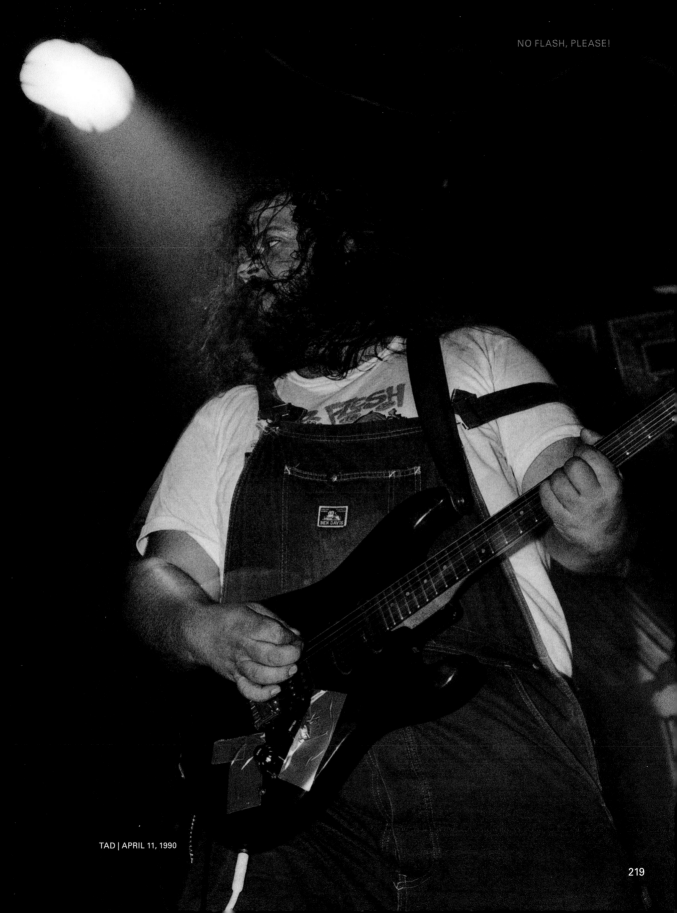

TAD | APRIL 11, 1990

Quiet, introspective, snarly yet polite, **Kurt Cobain** was one of the most combustible performers to hit the stage during the hard rock renaissance of the midnineties. It seemed as though he resented the attention, rebuffed the popularity and yet had some inner desire to hurt himself, sometimes his bandmates and even his audiences. Why? We can only speculate or, worse, read the copious amounts of text spilled over this short-lived, iconic figure in the indie/ alternative/punk music scene of the era. His sudden death at the peak of his creativity will remain among the scene's most tragic moments. Compared to everyone from Sid Vicious to John Lennon, Cobain was clearly disturbed, and probably using a variety of drugs; some prescribed, but others given to him by friends and fans. His death, although shocking, was sadly predictable. His suicide note reads like a damning testament to the perils of corporate rock that would emerge shortly after. But the note also exposes the pain of growing up in the eighties and realizing that fame and its inevitable trappings couldn't be survived. That said, Cobain's contributions to the postmodern era, particularly Nirvana's last release, *In Utero*, the album he produced with his wish-list engineer, Steve Albini, remains an alarming record of self-loathing and, to some extent, a testament to his love of his audiences, which though perhaps questioned was clearly present throughout his short career. Perhaps his death would serve as a warning of the perils of celebrity. Certainly he set a tragically low bar by taking his own life the way he allegedly did: by shotgun blast to the head through the mouth, when many of those he was associated with did so through excess and drug use.

Kurt Cobain of NIRVANA | APRIL 16, 1990

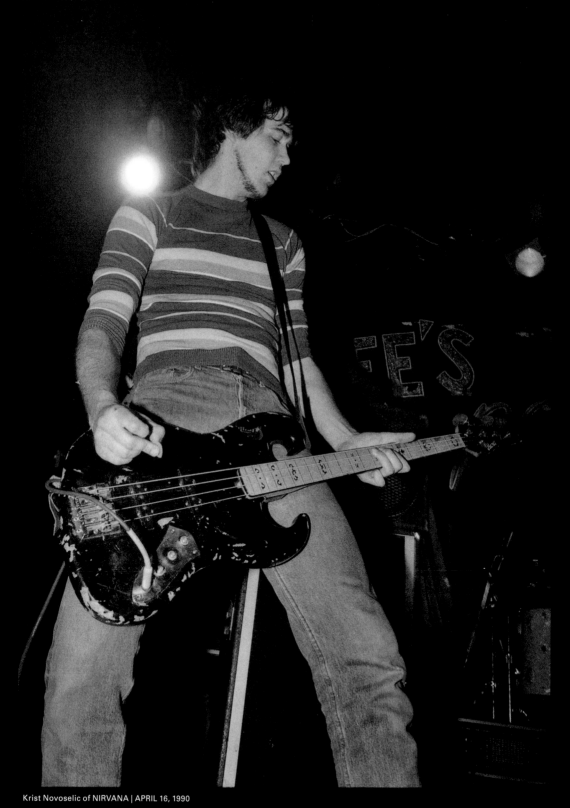

Krist Novoselic of NIRVANA | APRIL 16, 1990

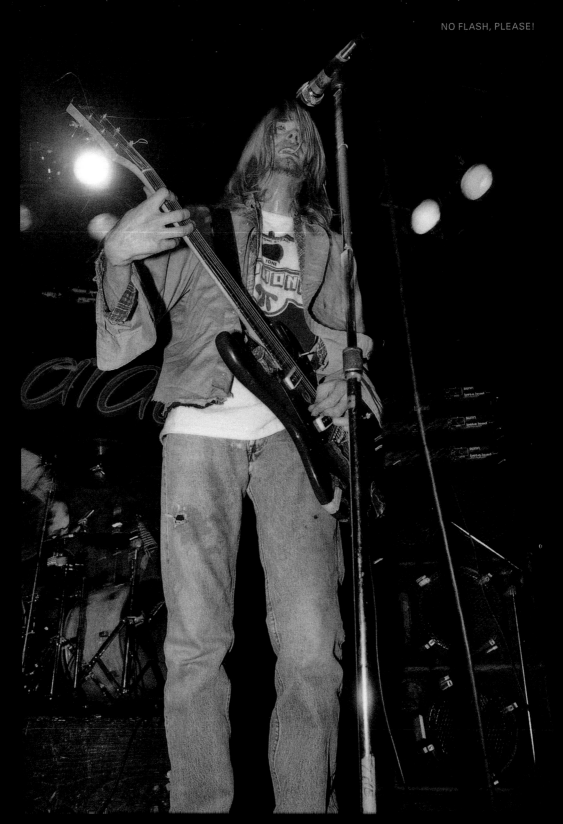

Kurt Cobain of NIRVANA | APRIL 16, 1990

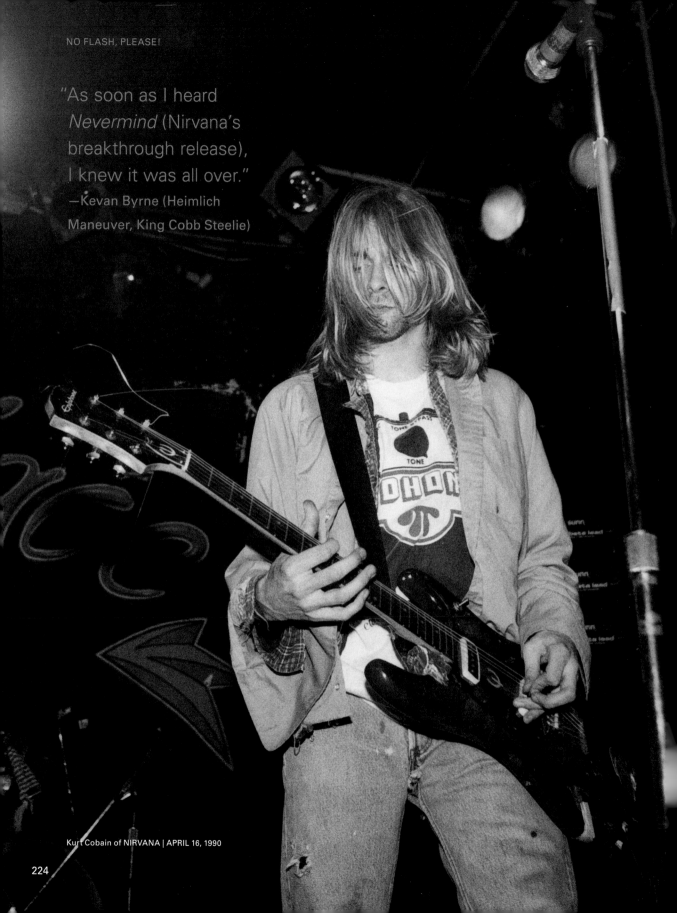

"As soon as I heard *Nevermind* (Nirvana's breakthrough release), I knew it was all over."
—Kevan Byrne (Heimlich Maneuver, King Cobb Steelie)

Kurt Cobain of NIRVANA | APRIL 16, 1990

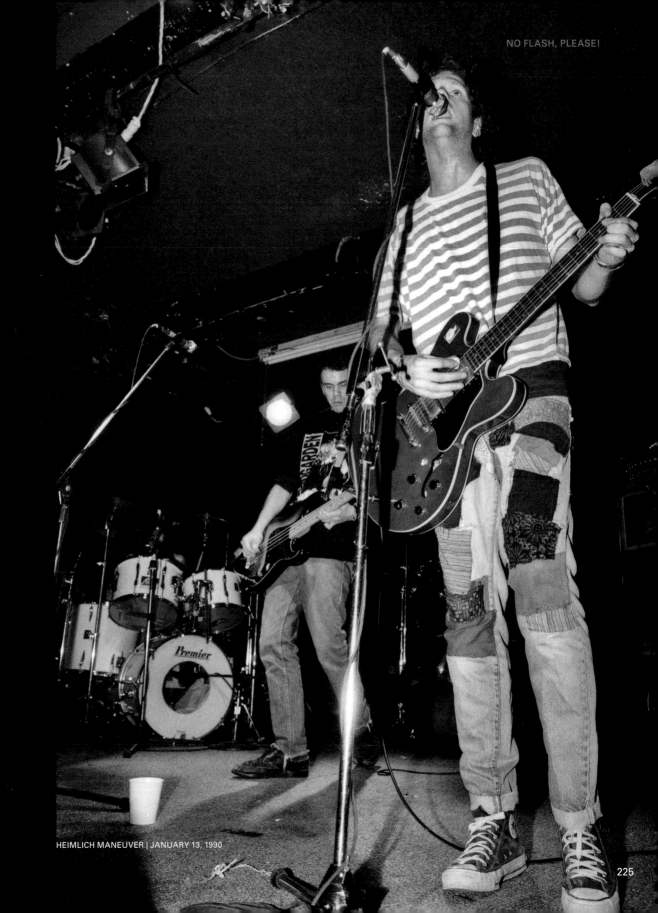

HEIMLICH MANEUVER | JANUARY 13, 1990

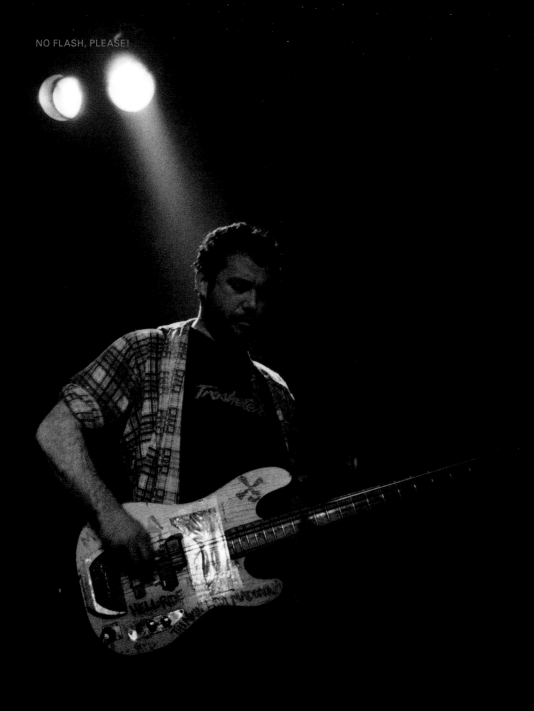

As one of the founding members of Minutemen, whose childhood friend and Minutemen co-founder D. Boon died tragically in 1985 in a van accident outside Tucson, Arizona, **Mike Watt** has become a kind of guru for the indie-rock generation of the late eighties and early nineties. Like Allen Ginsberg was for the Beat Generation, Watt's angular vision of life, drawing on the work of Richard Hell, Bob Dylan and Che Guevara, his literary prowess coupled with an approach to bass that can only be considered outside the textbooks, if not completely unintelligible, influenced virtually every bassist to emerge in the punk-funk movement, from Red Hot Chili Pepper's Flea to Fishbone's Norwood Fisher, to Primus's Les Claypool. But along with his seemingly devout dedication to remaining untouched by popularity and his shunning of the trappings that come with celebrity, Watt likes to especially repeat his mantra "We Jam Econo," among many that his unique takes on street slang has produced, such as (and not least of all) *Double Nickels on the Dime*, the title of the band's seminal release of forty-five cuts, named for the highway and speed limit (fifty-five on Highway 110) from their home base San Pedro to Los Angeles, where they found their on-again off-again fan base. Watt's some- what recalcitrant project fIREHOSE (started in part on the encouragement of his co-conspirators Thurston Moore and Kim Gordon of Sonic Youth) and the bizarre decision by guitarist Ed Crawford to take a bus from Columbus, Ohio, to San Pedro to audition for what he was told would be a reunited Minutemen, led to the release *Ragin', Full-On*, an album that is as import- ant as anything released by Minutemen, if for no other reason than it put closure on what Minutemen had started. In 2004, after what he describes as a near-death experience when an abscess turned into a life-threatening infection, Watt was enlisted by Iggy Pop to play in a re- formed Stooges. Watt says it was this simple playing that helped him regain his chops after atrophy had set in from not playing for a long period. Watt credits The Stooges with helping him reclaim his career in music.

Mike Watt of fIREHOSE | MAY 2, 1990

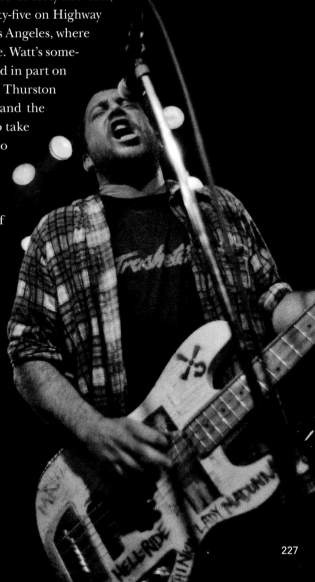

Frank Daly & Bob Thomson *(right)* of BIG DRILL CAR | MAY 13, 1990

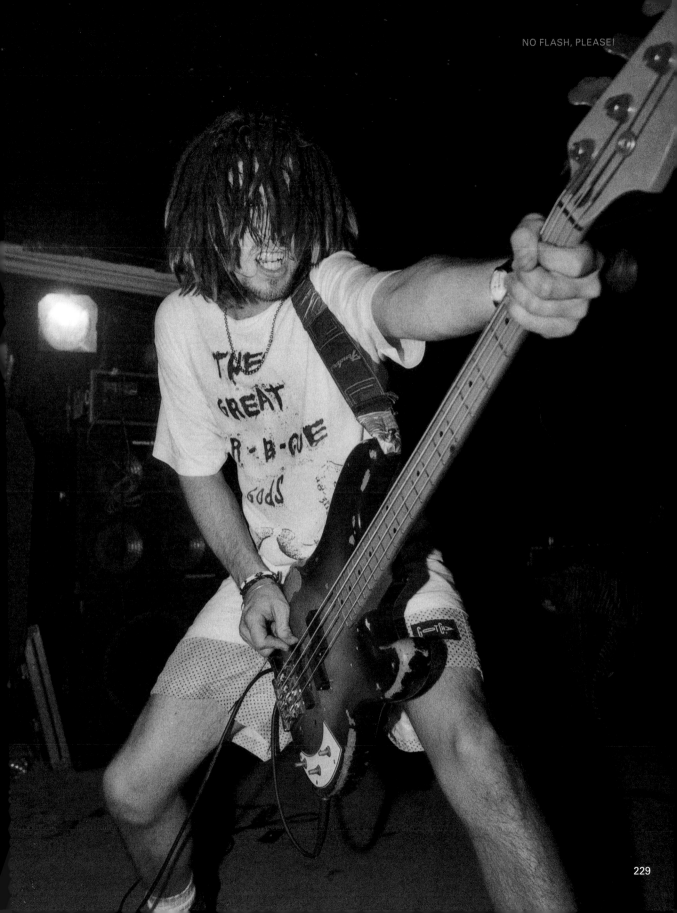

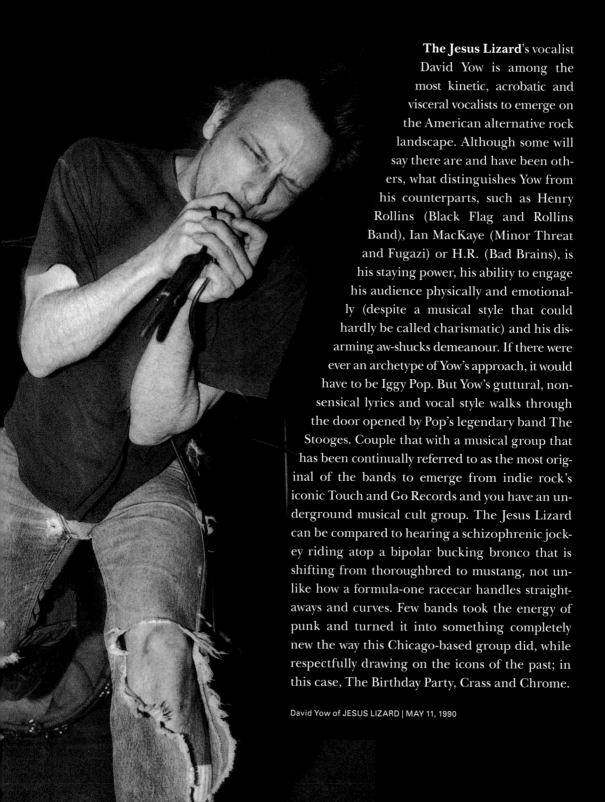

The Jesus Lizard's vocalist David Yow is among the most kinetic, acrobatic and visceral vocalists to emerge on the American alternative rock landscape. Although some will say there are and have been others, what distinguishes Yow from his counterparts, such as Henry Rollins (Black Flag and Rollins Band), Ian MacKaye (Minor Threat and Fugazi) or H.R. (Bad Brains), is his staying power, his ability to engage his audience physically and emotionally (despite a musical style that could hardly be called charismatic) and his disarming aw-shucks demeanour. If there were ever an archetype of Yow's approach, it would have to be Iggy Pop. But Yow's guttural, nonsensical lyrics and vocal style walks through the door opened by Pop's legendary band The Stooges. Couple that with a musical group that has been continually referred to as the most original of the bands to emerge from indie rock's iconic Touch and Go Records and you have an underground musical cult group. The Jesus Lizard can be compared to hearing a schizophrenic jockey riding atop a bipolar bucking bronco that is shifting from thoroughbred to mustang, not unlike how a formula-one racecar handles straightaways and curves. Few bands took the energy of punk and turned it into something completely new the way this Chicago-based group did, while respectfully drawing on the icons of the past; in this case, The Birthday Party, Crass and Chrome.

David Yow of JESUS LIZARD | MAY 11, 1990

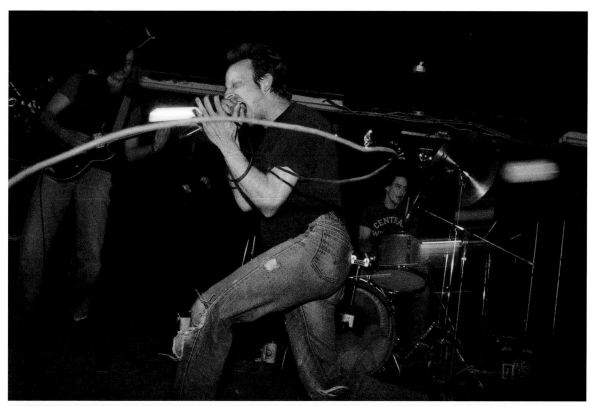

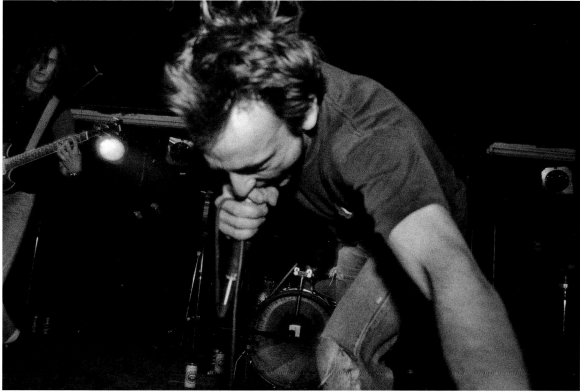

Melvins, long regarded as the band that may have inspired Kurt Cobain to play guitar, given that members played in Cobain's first band Fecal Matter, has somewhat miraculously surpassed all of the Seattle so-called grunge bands, both in its staying power and by its members managing to maintain lasting careers as musicians. Although commercially unsuccessful, they have slowly established themselves as the elder statesmen of not only punk, but also hardcore, metal and what has since emerged as stoner rock, despite the fact that all members are remarkably sober and committed to a unique musical style. In this photograph, you see what may have been the band's most endearing quality to any male between ten and fifteen years of age in the midseventies. Their undying love of glam rock, in particular the work of Alice Cooper and KISS, was probably the most charismatic aspect of their early popularity. In the midnineties, the band famously imitated KISS by releasing three solo albums, complete with posters and art mimicking the KISS solo records of the late seventies. Without an inch of satire—apart from the fact that guitarist Roger "King Buzzo" Osborne decided that the spirit of Gene Simmons resonated with him the most, while drummer Dale Crover decided on KISS drummer Peter Criss and then bassist Joe Preston (also known for his work with the seminal dirge-rock group Earth) but somehow settled on KISS guitarist Ace Frehley—we can only assume that Paul Stanley's flamboyance was too much for the more solemn Preston. But enough about KISS. This is about the Melvins, and although Buzz is considered one of the guitar heroes of the nineties, it cannot be emphasized enough that it was the collaboration of Crover and Osborne that gave the Melvins its unique and lasting sound. This was the sound that inspired not only Nirvana's early work, but also the equally unique take on classic rock espoused by Seattle's Soundgarden. In fact, it is widely recognized that Osborne and Crover opened sonic doors for a wide number of alternative bands in the nineties, most notably those associated with Amphetamine Reptile Records. So it is fitting that that the Melvins still find a home there, despite having released recordings on Alternative Tentacles, Boner Records and Atlantic Records, among others.

MELVINS | MAY 11, 1990

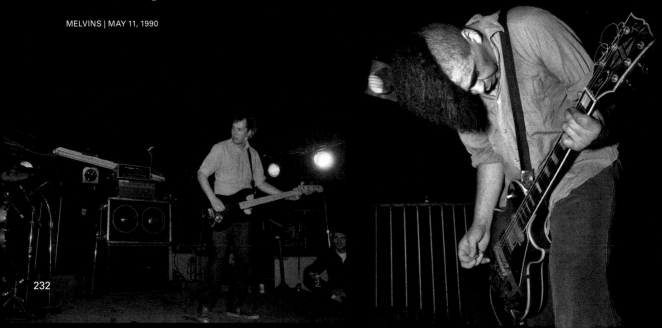

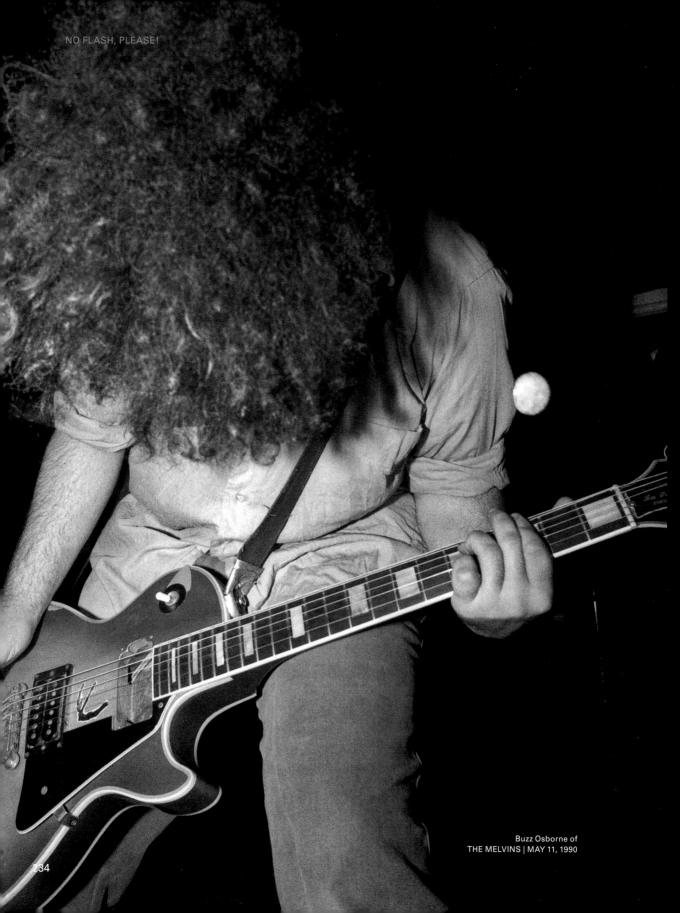

Buzz Osborne of
THE MELVINS | MAY 11, 1990

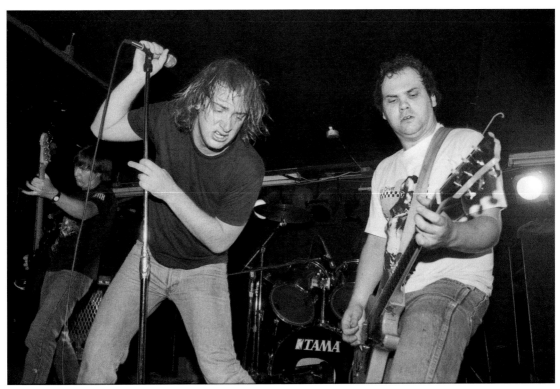

NINE POUND HAMMER | MAY 7, 1990

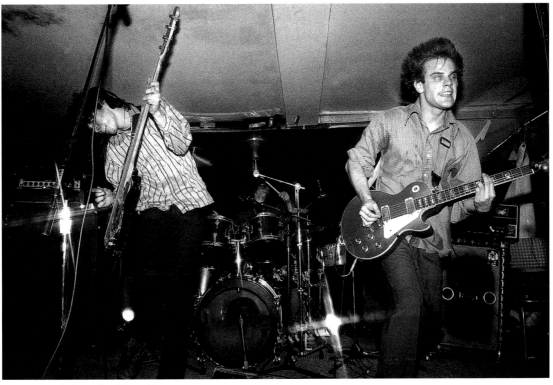

NICE STRONG ARM | MAY 20, 1989

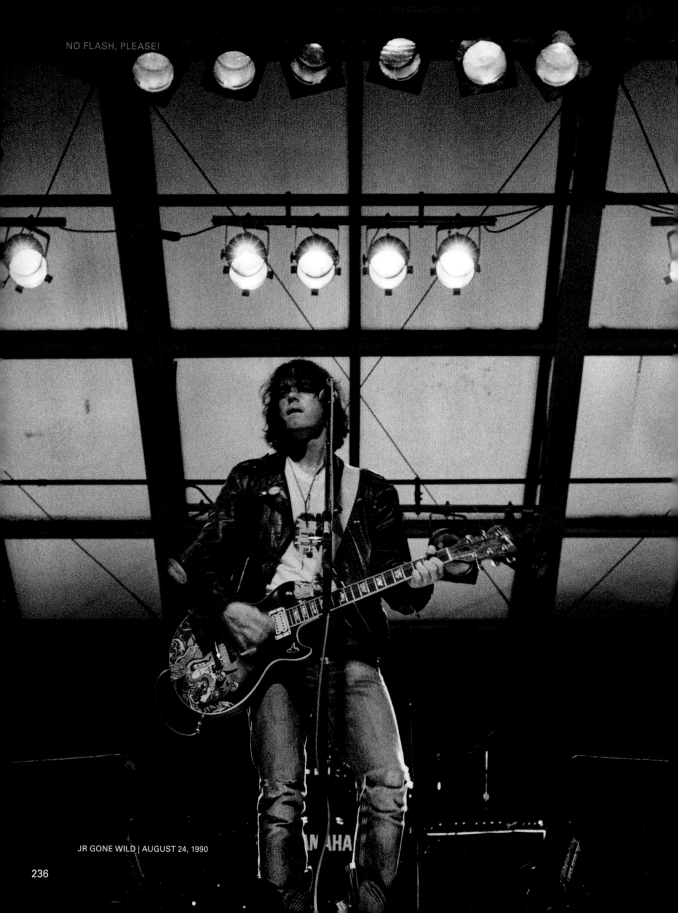

JR GONE WILD | AUGUST 24, 1990

"You've never heard of them," Paul Westerberg (The Replacements) to MuchMusic host Christopher Ward in 1986. "They're called The Pursuit of Happiness."

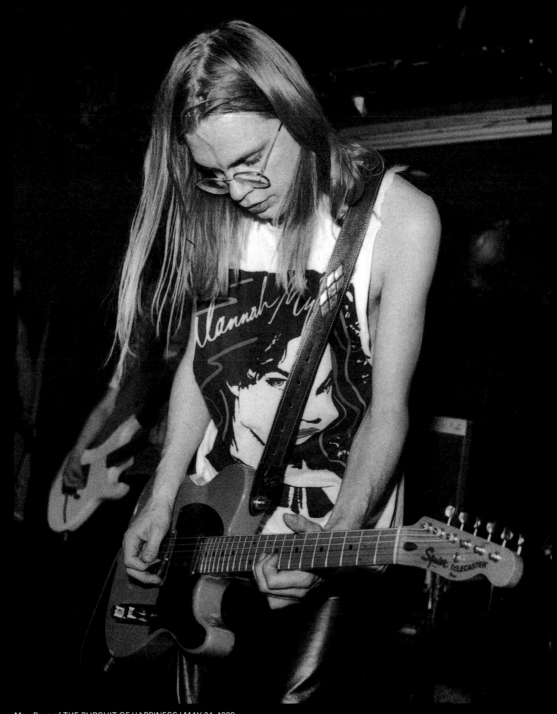

Moe Berg of THE PURSUIT OF HAPPINESS | MAY 24, 1989

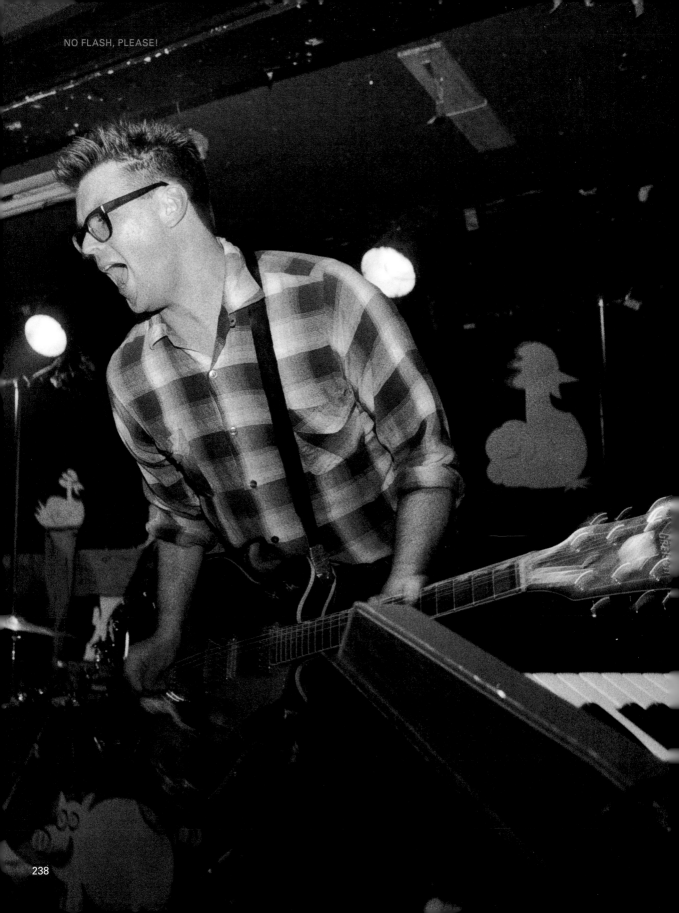

above: Miguel Salas & Peter Kesper of THE TOUCHSTONES | NOVEMBER 29, 1990
left: Brian Connelly of SHADOWY MEN ON A SHADOWY PLANET | JUNE 28, 1990

"I think **Dave Pirner** is a god," a fan is overheard saying outside New York's Irving Plaza in 1988. "That's bizarre to hear," says Minneapolis ex-pat Jennifer Roth, "He's that scrawny kid that used to come over to my house with my brother after school." That is pretty much who Dave Pirner was when his band, **Soul Asylum**, went from releasing records on Replacements' manager Peter Jesperson's Twin/Tone to putting out records with A&M Records and having its albums produced by such rock legends as Steve Jordan and Ed Stasium. There was a lot of expectation for Soul Asylum after its landmark release *Made to Be Broken* caught the attention of college radio in the mideighties. It even managed to get a distribution deal from old-guard labels like Attic Records in Canada. Sounding like a more tuneful Hüsker Dü or a less aggressive Replacements, Soul Asylum wouldn't really hit its peak until the early nineties, when it jumped to Columbia Records and put out its bestselling *Grave Dancers Union*. Columbia A&R director Benjie Gordon signed the band during a period when the indie credibility had been waning, with rumours swirling that Pirner himself had tinnitus irritated by three years of non-stop touring to support the band's A&M releases. Soul Asylum's lack of commercial success was not for lack of a work ethic. The band played Toronto at least three times during that period. What was supposed to be its biggest release, *Hang Time*, was followed by an equally great, but markedly exhausted, *And the Horse They Rode in On*. Music nerds will recall that each format featured a different cover. The cassette was a wooden horse, the CD a pony or donkey, while the vinyl—on blue vinyl, no less—featured an intact stallion. Perhaps a well-deserved rest and a sweeter record deal led to the success of the band's Columbia release and a Grammy Award for the single "Runaway Train," but few of Soul Asylum's fans from the early days remained by the midnineties, and its success was welcomed with resentment from its diehard fans, while the mainstream continued to sing along to "Runaway Train." Soul Asylum, however, remains a symbol of the iconic Midwestern guitar rock, and a kind of exclamation point to punctuate the bands that preceded and followed it: namely, the Goo Goo Dolls, The Lemonheads, Run Westy Run and Buffalo Tom, among others who benefited from Soul Asylum's door-crashing respect and undying love of the song before the sound.

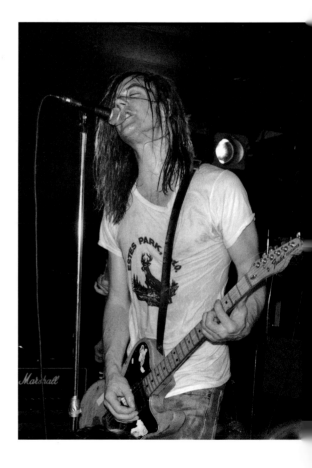

right: Dave Pirner of SOUL ASYLUM | JULY 22, 1988
opposite & following page: SOUL ASYLUM | OCTOBER 30, 1990

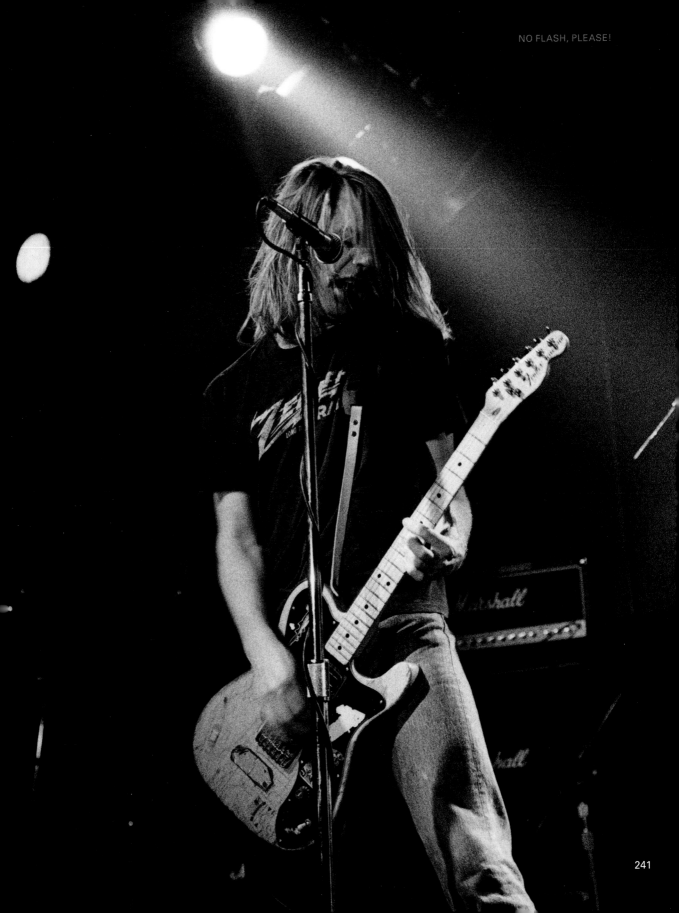

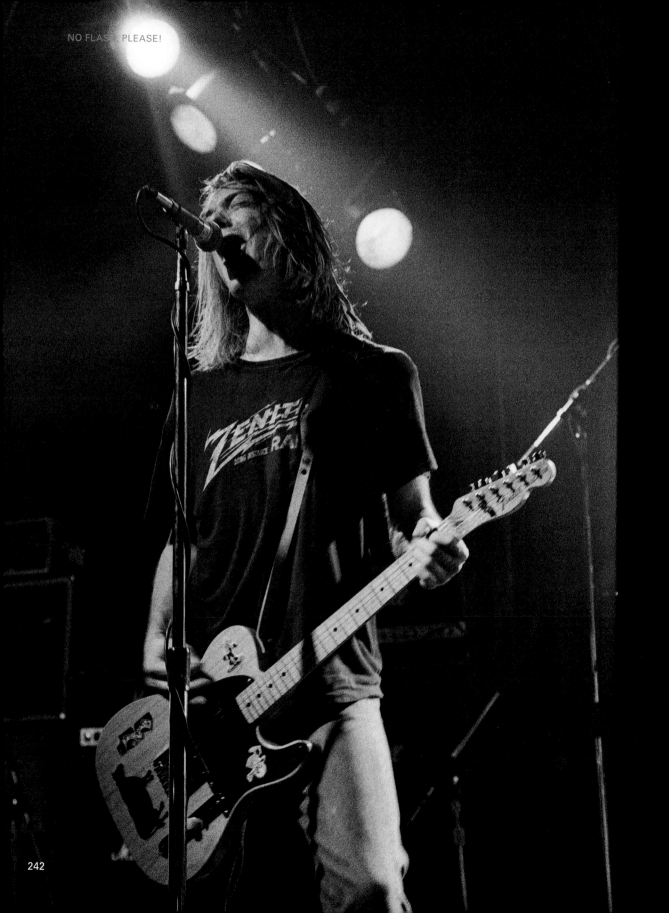

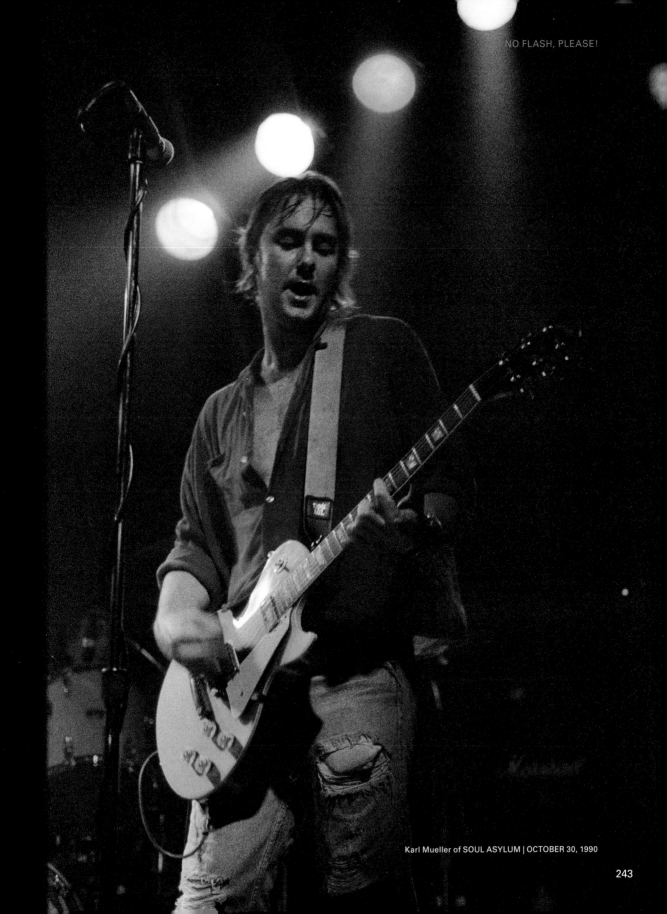

Karl Mueller of SOUL ASYLUM | OCTOBER 30, 1990

CHANGE OF HEART | NOVEMBER 27, 1990
(L-R) Bernard Maiezza, Ian Blurton, Ron Duffy & Rob Taylor

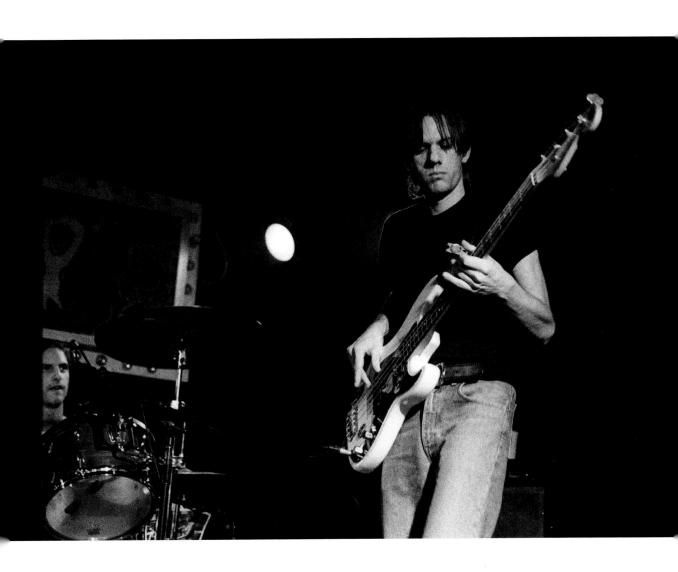

King Cobb Steelie rose suddenly in the early nineties bridging a rising trend in indie alt rock merging with a more esoteric World music encouraged by such producer musicians as Adrien Sherwood, Brian Eno and Bill Laswell. King Cobb Steelie's third release Junior Relaxer, produced by Guy Fixsin (Laika, My Bloody Valentine, Moonshake), captured the imagination of international audiences and remains among the more interesting releases to come out in Canada on a major label during this period. It is easy to place King Cobb Steelie alongside Fugazi, Tortoise and Godspeed You Black Emperor! in terms of contribution to the musical lexicon of the time.

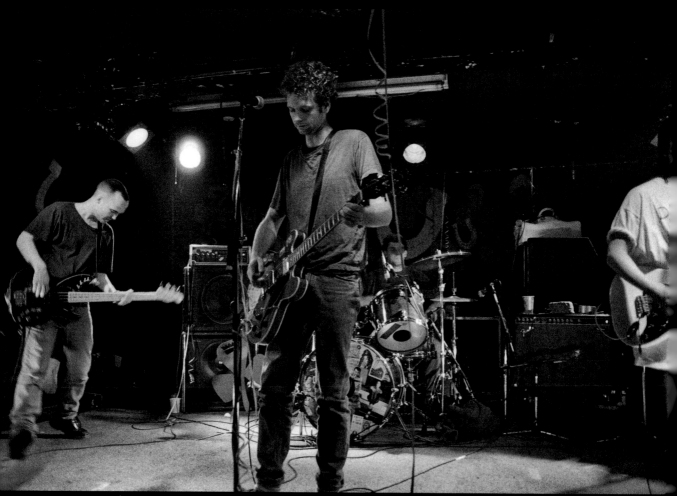

KING COBB STEELIE | OCTOBER 11, 1991

THE HENRYS | APRIL 24, 1992

Spawned from a punk rock DIY aesthetic, and with a tendency to perform with his back to the audience, drummer Don Pyle emerged as a recalcitrant figurehead in Toronto music as the singer in his own band, Crash Kills Five (with future Shadowy Men bandmates Reid and Brian, among others). After the demise of Crash Kills Five, he was invited to play drums with **Shadowy Men on a Shadowy Planet**. With his ability to hide behind the drum kit while lobbing quips from his live microphone—an odd arrangement, given that the band was largely instrumental—he seemed a good fit, despite the fact that he'd never played drums. Bassist and Alberta transplant Reid Diamond was a visual artist with a penchant for set design (often using those skills in staging performances), and his friendship with comedy group The Kids in the Hall helped fortify the group's presence to huge audiences in the U.S., as the comedy show earned late-night syndication courtesy of Canadian-born television executive Lorne Michaels.

Rounded out by guitarist Brian Connolly, whose twang-guitar style seemed to be drawn from the vibrant sixties' garage and psychedelic renaissance percolating in the early eighties in Toronto and Montreal, joined with a style that could be called quaintly cartoonish, it wasn't long before Shadowy Men had indie luminaries K Records founder Calvin Johnson (who'd heard of them all the way out in Olympia, Washington) enamoured with its decidedly unique sound and vision. Between 1988 and 1993, Shadowy Men released three full-length records. But its steady production schedule had started in 1985, ending in 1994 with thirteen singles, or EPs, put out in the 7" single format, through a variety of labels from Canada and the United States.

Attending a Shadowy Men show was always special. There were door prizes, which sometimes required knowledge of pop trivia, dangling cartoon characters, glitter, costumes both on stage and in the audience, the occasional guest musician and normally some dancing from the enigmatic and charismatic Diamond, whose style was not unlike a dance lesson in how to groove to music riddled with catchy melodies and stop-and-start syncopation, like a cross between the Ventures and Link Wray, with a dash of lounge-act panache. Of all the bands to emerge from Queen Street during this period, none were as forthrightly independent, original and, in the end, more broadly popular than this band. Its *Savvy Show Stoppers* collection of singles, released internationally in 1988, remains a document

> "A lot of what we did was trying to outdo each other. Trying to be funnier than the other guy in the band."
>
> —Don Pyle, Shadowy Men

of a band that made an indelible mark without the support of major labels or, in fact, mass marketing or promotional campaigns (aside from the fact that *The Kids in the Hall*'s television success in the U.S. certainly helped the band infiltrate the collegiate sphere that every band of this period sought). Shadowy Men remains the emblem of what was wonderful about this era in Toronto's thriving music scene.

(L-R) Reid Diamond, Don Pyle & Brian Connolly of SHADOWY MEN ON A SHADOWY PLANET | MARCH 6, 1992

"For me there are three names that have a certain continuity through that period in the Toronto scene. It's Ian Blurton, Pete Hudson and Gord Cumming. And the Shadowy Men, the way they put out their product and self-released their stuff. That was a big influence, I think. "

—Robert Lawrence, Owner, Vortex Records, Queen West Toronto

SHADOWY MEN ON A SHADOWY PLANET | NOVEMBER 3, 1990

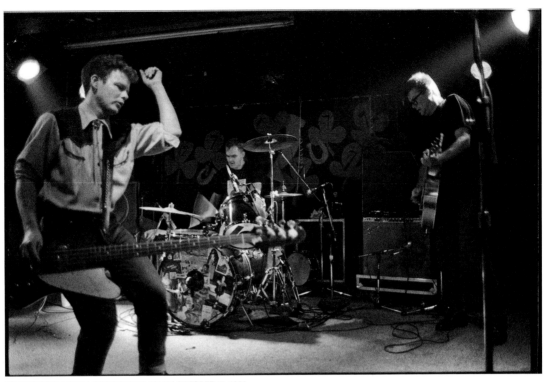

SHADOWY MEN ON A SHADOWY PLANET | OCTOBER 11, 1991

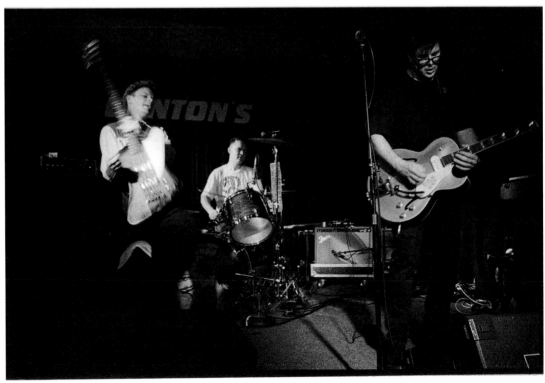

SHADOWY MEN ON A SHADOWY PLANET | APRIL 24, 1992

SHADOWY MEN ON A SHADOWY PLANET & THE FLESHTONES in Austin, Texas | MARCH 11, 1992

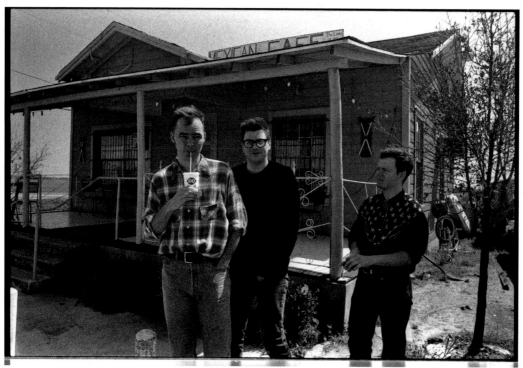

SHADOWY MEN ON A SHADOWY PLANET in Italy, Texas | MARCH 11, 1992

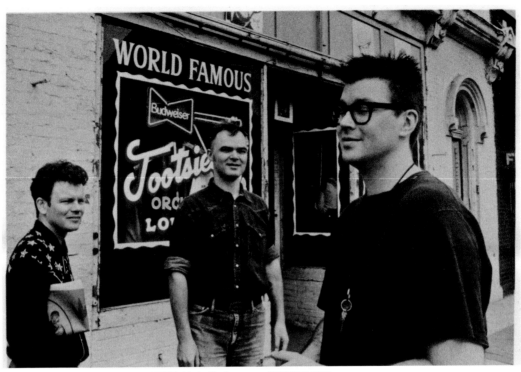

SHADOWY MEN ON A SHADOWY PLANET in Nashville, Tennessee | MARCH 1, 1992

SHADOWY MEN ON A SHADOWY PLANET in Washington, DC | MARCH 19, 1992

First and foremost, I want to thank all the bands in this book who had the guts to get on stage and often do the impossible—perform to and entertain an audience with their own music. Especially the young and local musicians who, on occasion, had to bravely face a near-empty room, yet still managed to give it everything they had. Thanks to The Dundrells (Garry, Peter, Ashley, Richard, Terry, Andy) for being my "guinea pig band" while I stood stagefront and learned to get over the fear of shooting performers only inches away; apologies to all the bands I shot with a flash on high settings before figuring out that it blinded and disoriented them, but thanks because it led me to discover Kodak's T-Max 3200 film which enabled me to shoot without a flash; Shadowy Men on a Shadowy Planet (Don, Brian, Reid) who I shot more than any other band and who took me on the road through twenty-eight American states; Heimlich Maneuver (Kevan, Peter, Iain) for being the first band I nervously shot off-stage.

There are many individuals to thank, starting with Leslie Ann Burgess who gifted me the first of many 35mm cameras I own and would often shoulder the camera bag and hold the beer at shows, and her bro Steven Burgess who instructed me in my first darkroom; my sister Sandy for taking me to that first concert that changed my life; Don Pyle for being the first member of any band to approach me to purchase photos and for decades of friendship and fantastic collaborations; and special thanks to Pete Hudson, Ian Blurton and Gord Cumming for always being in at least one band at any given time.

Thanks to the real-world friends who accompanied me to shows: Greg Stobbs, Aron Vinegar, Melanie Tanaka, Suzette Fitt, Anita Hurley, Jacqueline Tanner, Stephanie Cheatley, John Smialek, Troy Cheong, Cam Mitchell, Sean d'Andrade; and to the band-world folks I met solely because of these amazing shows: Debra Lary, Kevan Byrne, Kevin Lynn, Dave Kiner, Louise Kiner, Jennifer Lewis, Beverly Breckenridge, Rebecca Diederichs, Nancy Lanthier, Bruce Gordon, Melonie Ceresne, Simon Nixon, Dallas Diamond, Alisdair Jones, Neal Arbic, Peter Kirkpatrick, Mike Armstrong, Mike McDonald, Al Okada, most of whom are pictured on these pages. Huge thanks to way too many friends to list here, who I met after 1992 and encouraged me to put this book together.

Thanks to Phil Saunders for the words of *No Flash, Please!* but especially his enthusiasm for this book project and his passionate love of music in general. His encyclopedic knowledge of bands, names, dates, and trivia brings me back to all the best over-the-counter record store conversations I had in the 80s and 90s.

Thanks to my wife Odette Hidalgo for encouraging and offering honest critique of photos and design, and for always being there and always lifting me up.

Thanks to Kato and Astra because their love and presence in my life has always given it purpose.

Thanks to my parents for bringing me into this world and who, at the time, never understood why I spent so much time and effort shooting for no money, yet it made me want to shoot more (rebellious twenty-something). And for buying me my first stereo and not complaining [much] when I cranked it!

A big shout out to the Anvil Press team: publisher and friend Brian Kaufman who consistently publishes outstanding and sometimes challenging bits of Canadiana culture, Catherine Plear for copy-editing, and Karen Green for making sure those ducks are in a row and everyone knows about it.

And thanks to Jim Marshall for always being *the* rock photographer who inspires me.

—Derek von Essen

I could not have written these words without Derek von Essen (A god-sent photographer who came to my rescue), my best friends Jerome McIntyre, Brett Clubbe, David Whitton, Andrew Johnson (and Elise), Amber Ellis, Corinne Culbertson, Joel Pylyshyn, Frank Canacari, Christopher Hartley, Stan Fister, Ben Portis, Christopher Butterfield, Hannah Maria Ma, Tyson Haller, Zev Asher (RIP), Tim Glasgow, Davin Michael Stedman, and the musicians, writers and editors who inspired me, including (in no particular order) Howard Druckman, Peter Tangredi and Lisa Patterson, Ian Blurton, Glenn Milchem, Scott Bradshaw, Gord Cumming, Adam Faux, R J Guha, Greg McConnell (RIP), Carson Foster, Greg Bottrell, Neil and Ewan Exall (and Janet Walker), Sara Montgomery, Tony Lima, Jonathan Cummins, John Kastner, Brock Pytel, Jon Bond Head, Dave Bidini, Tim Vesley, Martin Tielli, Richard and Patrick Gregory, Mike Duggan, Mike Robbins, John Critchley, Simon Nixon, John Borra, Bernard Maiezza, Robert Lawrence, Stephen Perry, Shawn Chirrey, Jill Heath, Dave O'Halloran, Dave Bidini, Dave "Rave" Macintosh, Rick McGinnis, Scott Woods, Lisa Roosen-Runge, Tim Powis, Myke Dyer, Phil Dellio, Mary Dickie, Paul Gott, Warren Campbell, Lisa Ferguson, Brian Taylor, Jack Freimanis, Ben Hoffman, David Roeder, Scratch Anderson, Nick Smash, Michael Gibbs, Jonathan Poneman, Kevan Byrne, Kevin Lynn, Al Okada, Don Pyle, Amy Hersenhoren, Jeff Beardall, Ken Huff, Beverly Breckenridge, Caroline Azar, GB Jones, Mark Smith, Jeff Rogers, Walter Sobczak, Lesley Rankine, Michael Gerald, Peter Hudson, Louise Kiner, Joel Wasson, Glynis Ward, James Booth, Grant Lawrence, Phil Klygo, Craig Laskey, Gary Topp, my partner Casaundra Saunders and my daughters Taylor and Mimi and sons David and Elijah, Lisa Dutton, Bernie and Judie Worrell, Lee Ranaldo, Thurston Moore, Kevin Munro, Barry Hennsler, Phil Durr, Ian Astbury, Paul Myers, Mark Dancey, Gerard Cosloy and the countless musicians who changed the way I listen to music: I can't begin to list them all here, or thank them enough. They have all contributed to this book in some way. My mom Mane Arratia, my Dad Michael Saunders and my big sister (Step-Mom) Maxine Saunders and my brothers Ian and Chris.

—Phil Saunders

THANKS

CALVIN JOHNSON | SEPTEMBER 8, 2010 | VANCOUVER